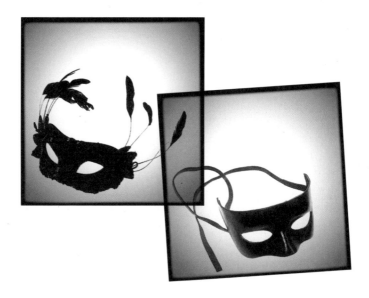

SOHO
DIVAS

RIAN HUGHES
DRAWS
LONDON'S
BURLESQUE
ARTISTES

DEVICE

SOHO DIVES, SOHO DIVAS

First printing of this edition: 2013
Published by Image Comics, Inc.
Office of publication:
2001 Center Street, 6th Floor,
Berkeley, CA 94704
This edition copyright ©2013 Rian Hughes

TP ISBN: 978-1-60706-638-5
LTD ED HC ISBN: 978-1-60706-639-2

Printed in South Korea

Set in DF Broadside, a Device font

For foreign licensing and international inquiries:
foreignlicensing@imagecomics.com

A selection of images are available as limited
edition prints. Email info@devicefonts.co.uk for
details.

Thanks to:
Dolly Blowup, Lily Olé, Hotcake Kitty, Victoria,
X Factor, Rita Furey, Gaby, Papillon et Chocolate,
Paola Rocchetti (aka Urdigital), Mistress Eva,
Sophia Disgrace, Lotta, Lene Lovich, Marianne
Cheesecake, Nadine, Cassandra, Serina del
Fuego, Melinda Barrie, Sophie Tralala, G. O'R.,
Mamselle X, Sophia de Villiers, Fifi Fatale,
Anonymous, Anna London, Fleur Papillon,
Natascha, Ginger Blush, Ruby Deshabille, Tony,
Soho House, LVPO.

Sketches drawn directly from life took from 2 to
20 minutes, and were executed between 2010-
2012. Additional illustrations were executed
between Summer 2011-Summer 2012, except p151
taken from the Wallpaper* magazine "Tart Card"
font project; p167 adapted from a print from the
"Toybox" show at the Conningsby Gallery, 2001;
p186-189, 2001; p190, 2004; p194 taken from
f-Stop's "Old Skool New Skool" series, 2001;
Photographic images 2005-2010, except p158-
159, 52-53 and 220-221, 1984. Some images
incorporate collaged public domain vintage
type and other elements, by unknown designers
unless noted.

Science Service approved

IMAGE COMICS, INC

Book design - Rian Hughes at Device

www.imagecomics.com
www.rianhughes.com
www.devicefonts.co.uk

ALSO BY RIAN HUGHES

Lifestyle Illustration of the 50s
Goodman Fiell, 2013
Tales From Beyond Science
written by Mark Millar, Alan McKenzie and John Smith
Image Comics, 2013
Hardware: The Definitive SF Works of Chris Foss
Titan Books, 2011
Cult-ure: Ideas can be Dangerous
Fiell, 2010
Custom Lettering of the 40s and 50s
Fiell, 2010
On The Line
written by Rick Wright
Image Comics, 2010
Yesterday's Tomorrows
written by Grant Morrison, John Freeman,
Raymond Chandler, Tom DeHaven, Chris Reynolds
Image Comics, 2010
Lifestyle Illustration of the 60s
Fiell, 2010
Custom Lettering of the 60s and 70s
Fiell, 2010
Ugenia Lavender
written by Geri Halliwell, six volumes
Macmillan, 2009
Really Good Logos, Explained
with Margo Chase, Ron Miriello, Alex White
Rotovision, 2009
Yesterday's Tomorrows (deluxe edition)
Knockabout Gosh, 2007
Ten Year Itch
Device, 2005
Art, Commercial
Die Gestalten Verlag, 2001
Firewords
Ed. John Foster
Oxford University Press, 2000
Dare
written by Grant Morrison
Xpresso/Fleetway, 1992
The Science Service
written by John Freeman
Magic Strip/Acme/various publishers, 1989

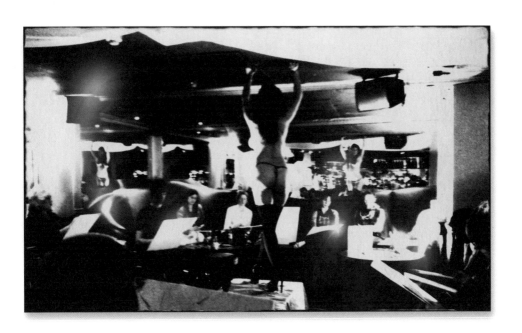

LONDON

I'm sure that, like me, you're wary of unsolicited emails offering strange and seductive promises. But, sometimes, curiosity can get the better of you. That's how adventures usually begin.

This is how I find myself using a large Rowney sketchbook to carve my way through the evening crowds around Piccadilly Circus, following Eros' arrow up to the narrow streets of Soho, London's notorious sleaze quarter. Though now gentrified by hip bars, advertising agencies and fancy restaurants, there still exists the occasional corner that the new broom has missed.

Here is Archer Street's cul-de-sac, where what passed for something else was once snorted off the rear spoiler of a cherry-red Toyota Supra, the only flat surface available; over there the Windmill Theatre, now a tawdry clip joint, where friends from long ago were caught in a tabloid sting that got them suspended from their elite girls' school.

Turn right into Chinatown and Wardour Street, where, situated between the Brain Club and The Wag, I shared a studio above a Chinese bakery with a group of comic artist and illustrator friends: Steve Cook, Kev Hopgood, Pauline Doyle, Kim Dalziel, John Tomlinson, Brian Williamson, Andy Lanning and Lucy Madison.

It was there, one oppressively hot afternoon, that some intimidating thugs turned up looking for our landlord. He apparently owed these Triad types several tens of thousands of pounds in rent, and they had come to collect. We pleaded honest ignorance, and they eventually left.

When confronted, our "landlord" swore innocence and then, that night, changed the studio's locks. Coming in on Saturday morning to collect material for a Tundra Comics launch, I was faced with a new heavy-duty drillproof steel lock and a note demanding advance rent money in return for the keys. A few calls later, the other studio members and I convened in the Falcon pub opposite.

An ask-no-questions locksmith was quickly found. "It's a drillproof lock", he observed. My hopes evaporated. He opened a large plastic case and pulled out something resembling a pneumatic demolition drill. "Should take me ten minutes". We hired a van and, in relays, during the height of the Saturday rush when we couldn't park outside for more than three minutes without blocking the street back to Leicester Square, managed to move all our stuff to a friend's studio in Brixton. I got off lightly — the "landlord" had just taken my airbrush and the cover for Fantagraphics' Dare issue I. Kev Hopgood lost an entire issue of Iron Man pencils. If you see these for sale on eBay, please pass on the details. We have some 'friends' that might want to take a professional interest.

Now, heading further north, I pass the discreet unlabelled door of Soho House, a private club that made me a lifetime member in return for a set of drawings of their manorhouse retreat in Kent. Above Shaftesbury Avenue, just off Old Compton Street, I find an entrance under a gold and black awning. A man in a boxy dinner jacket with a neck wider than his forehead sees

CALLING!

me approach and, with the uncanny sixth street-sense all bouncers seem to possess, decides I don't look like trouble. It's probably the sketchbook. A red silk rope is lifted and a panelled Victorian door that has been repainted so many times it no longer properly fits its frame is held open.

Once inside the tiny lobby, I part a heavy velvet drape and enter a dimly-lit bar. Candles dance in dimpled red glass holders on darkly polished tabletops. A pinch-cheeked barman from some distant and underdeveloped country is polishing glasses by the cadaverous light of a glass-fronted refrigerator. "Is this the right place for the burlesque life drawing?", I ask, trying to sound like I know what I'm talking about. He stops what he's doing, raises his eyes to look at me, then, with an absolute economy of motion, imperceptibly tilts his head back towards the function room at the rear. I thank him and press on.

I pass small knots of people with their heads bent together conspiratorially, entwined couples on leather settees whose armrests are worn through to the coarse fabric musculature underneath. The wood panelling and heavy gilt-framed mirrors give way to a shabbier, loucher decor. To the left is a pair of unpainted chipboard saloon doors with a handwritten sign taped to them. This is it.

I'm late, and the class has already started. In a solo spotlight, on an ornate cast-iron stool, sits a burlesque dancer dressed (barely) in vintage, tasselled and feathered and frozen in an angular danc-

er's pose. Around her attentively sit a ring of silent acolytes, bent in supplication over the drawing boards propped on their knees or the edge of a barstool. I find a space, and set out my materials. The girl next to me is drawing with one finger on her iPad, but there's no pixels for me here, not tonight — just the nostalgic analogue art-school mess of graphite, brush and Indian ink. It's as if I'm a student again.

The other attendees, I discover, are illustrators, artists and hobbyists, many drawn from Soho's local animation and special effects houses, and their work turns out to be of a very high standard indeed.

Intermittently attending over a couple of years, I accumulate several hundred drawings, and eventually decide to scan them, clean them up and produce, via the wonders of online digital print, a small black-and-white book. This sells a few dozen copies, mainly to friends in illustration and comics. Image's Eric Stevenson eventually sees a copy, and very kindly offers to publish it. Now with the option of colour, I revisit some of the drawings and develop others into finished digital illustrations in Illustrator or Photoshop. Here they are.

I hope I don't physically resemble Toulouse Lautrec, but like him, and more by accident than by design, I've produced a particular record of a particular slice of London's burlesque scene, frozen — just like that model — in a timeless vintage now.

Rian Hughes
Kew Gardens, 2012

7

WELCOME

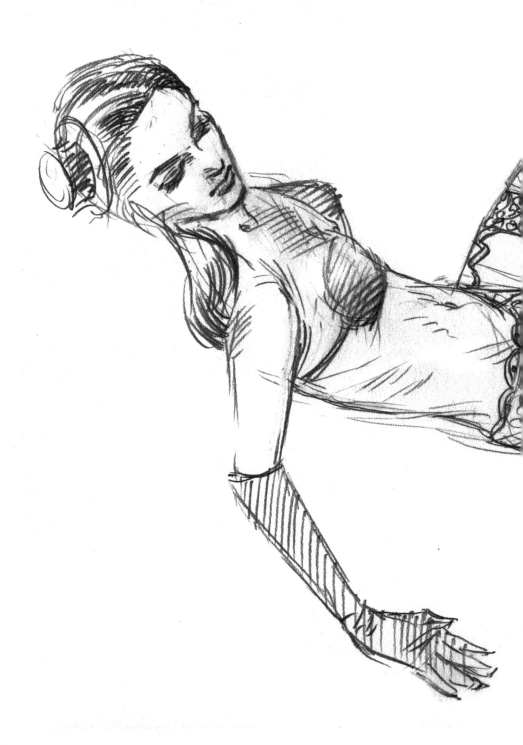

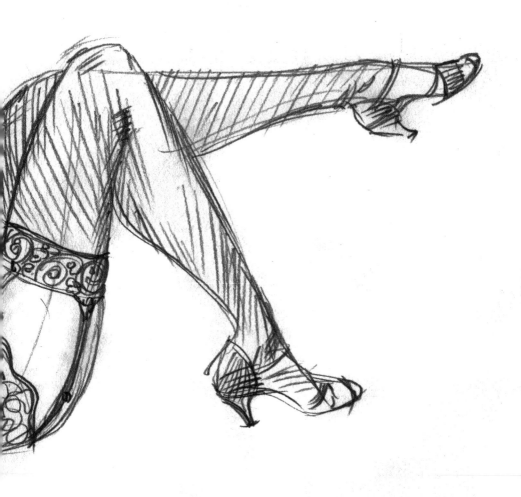

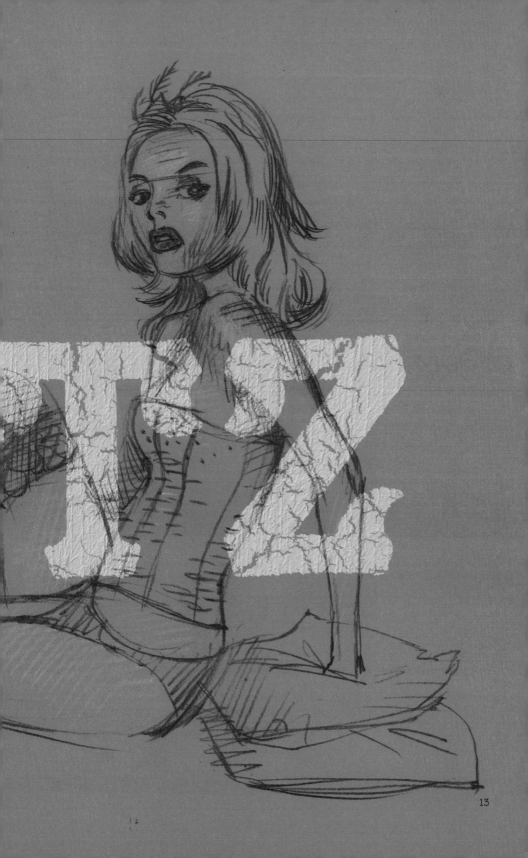

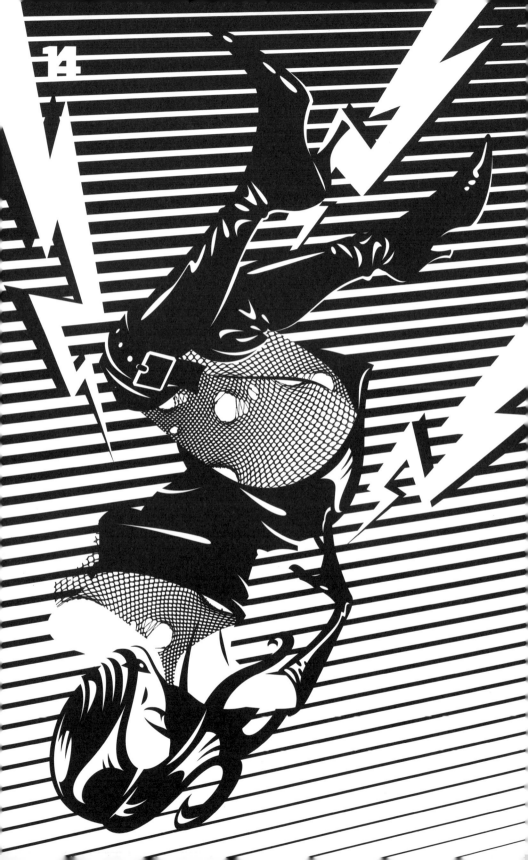

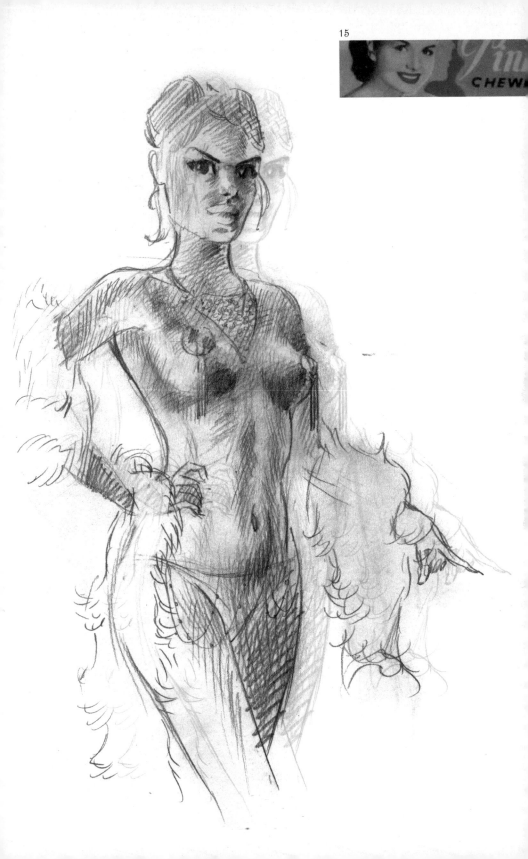

CHARMAINE
valse

Editions
FOX·SAM
PARiS

après
Raymond Feny 1927

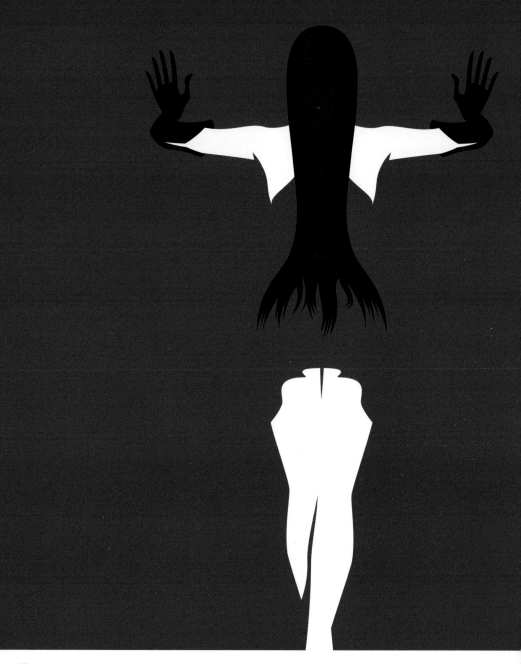

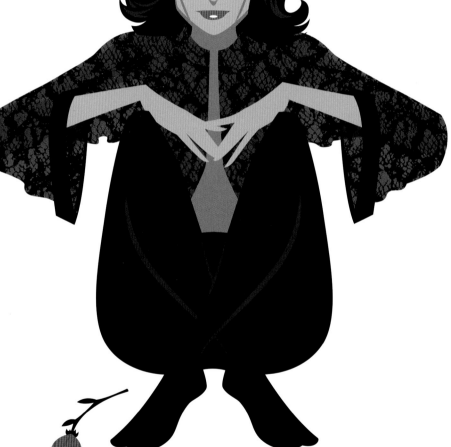

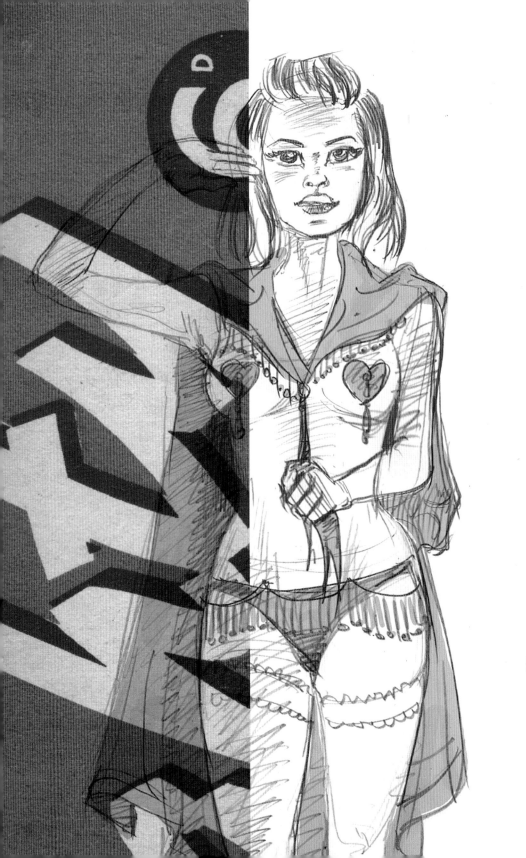

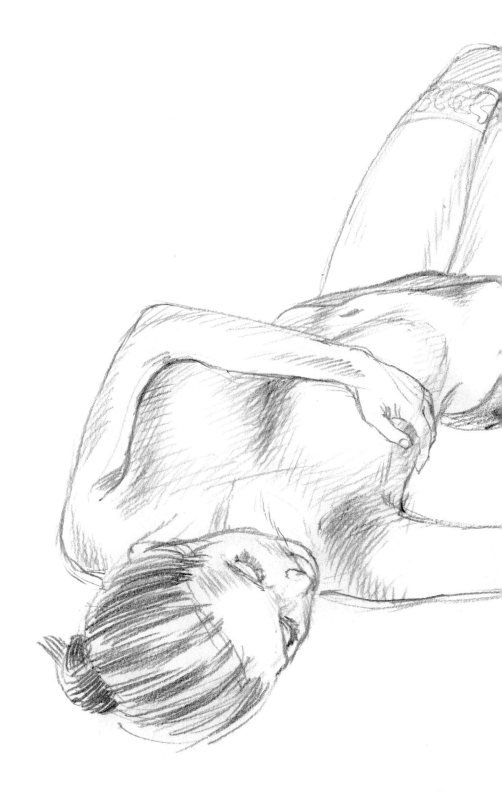

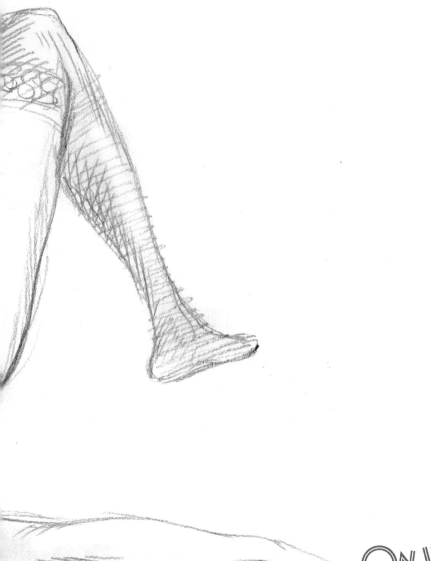

On With the Show

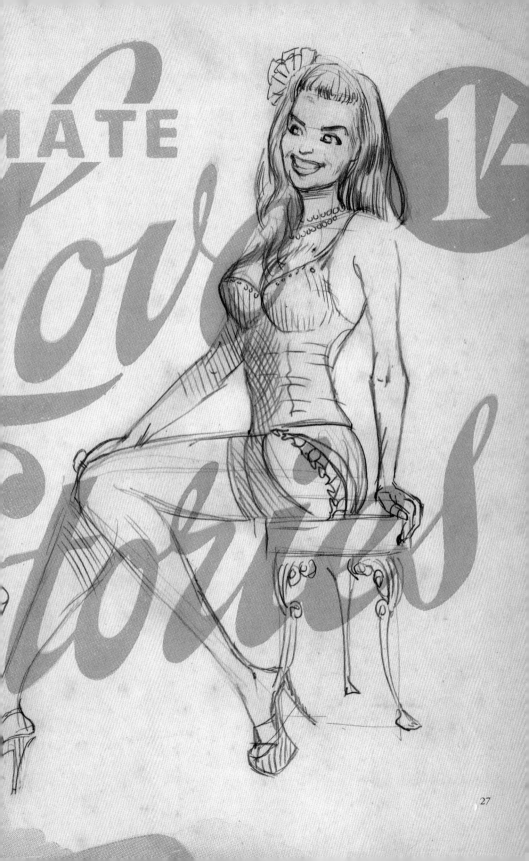

27

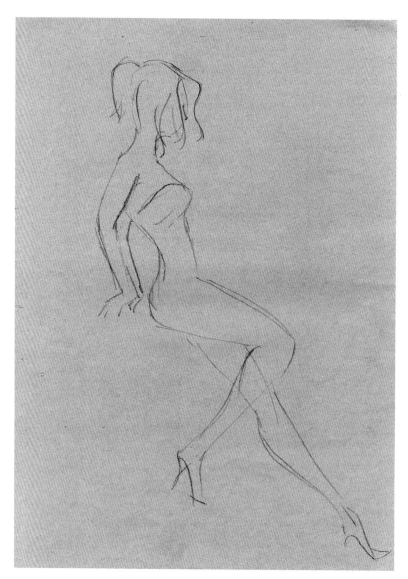

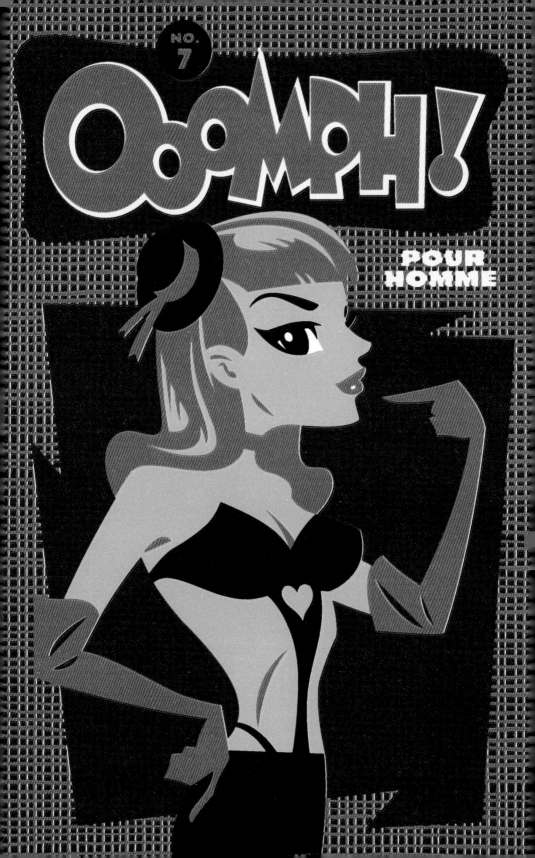

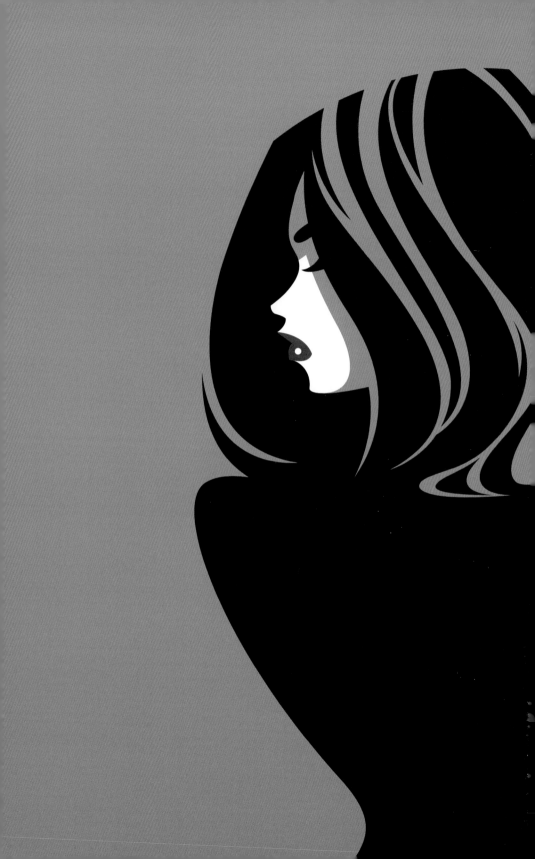

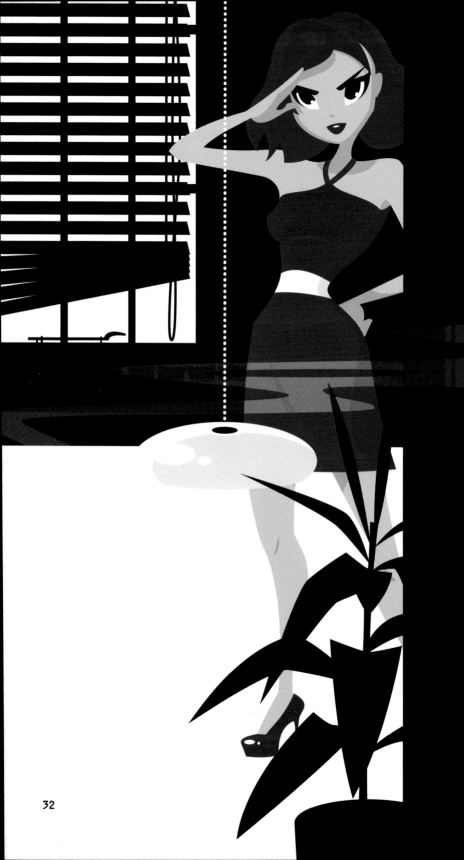

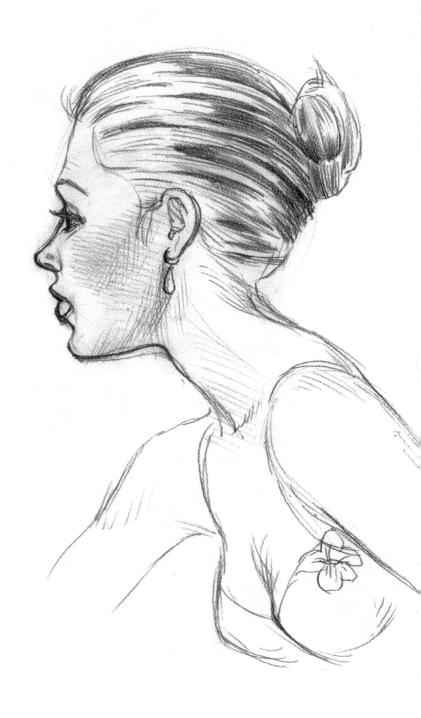

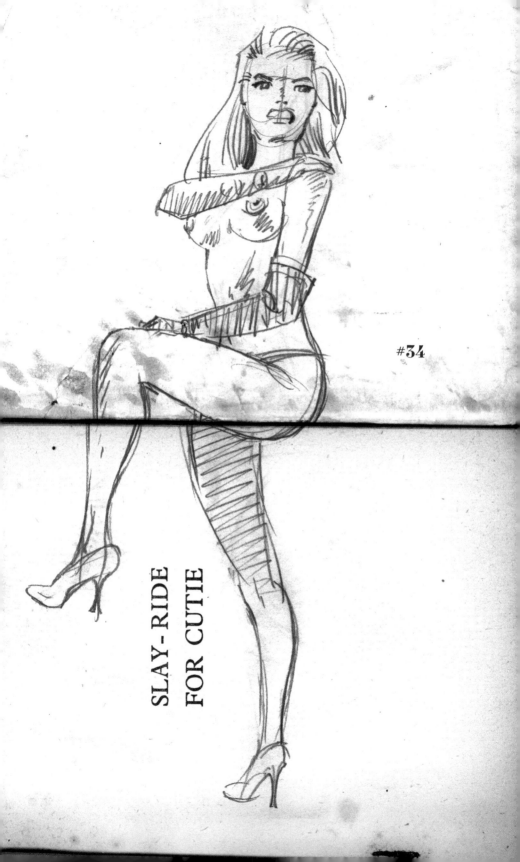

#34

SLAY - RIDE
FOR CUTIE

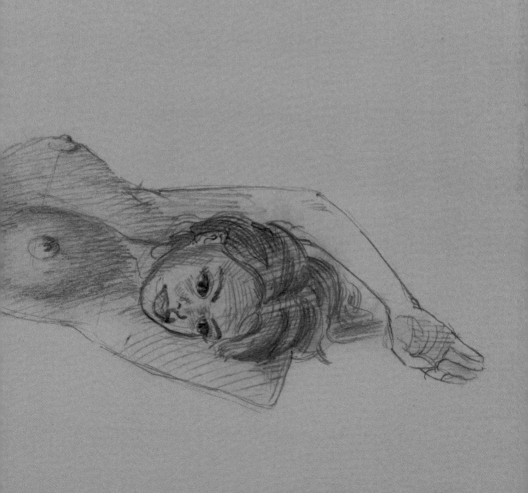

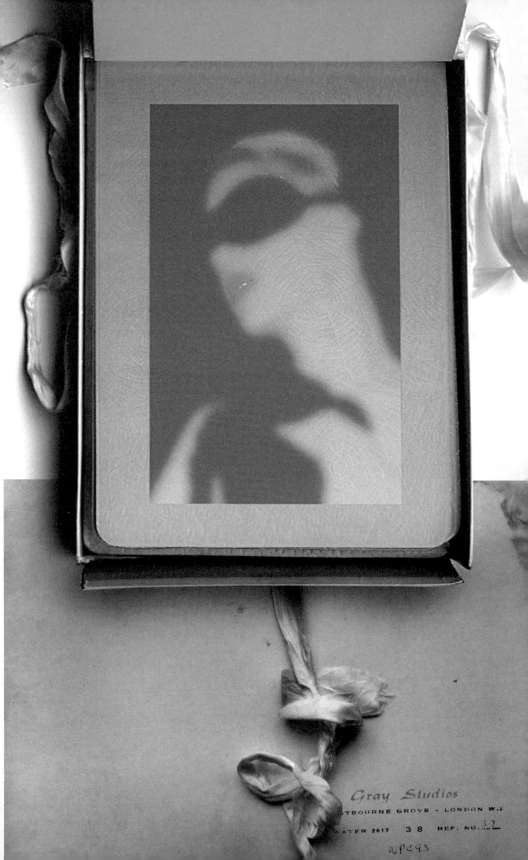

Gray Studios

TBOURNE GROVE · LONDON W.I

ATER 2817 38 REF. NO. 37

WPC93

MONTHLY • THREE SHILLINGS

SIREN

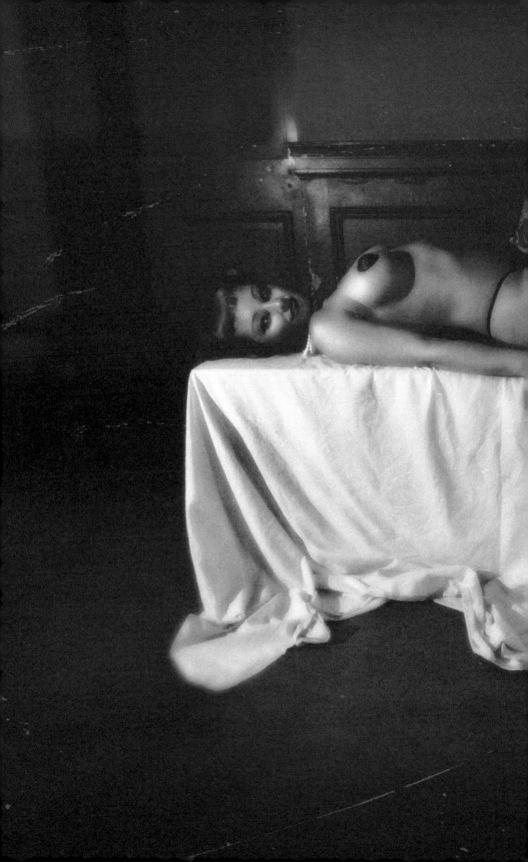

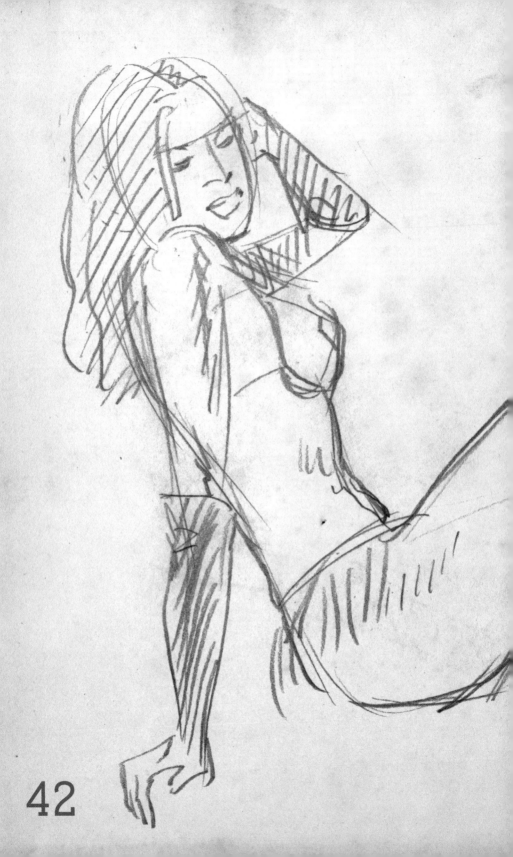

42

"LADY OF THE BOULEVARDS"

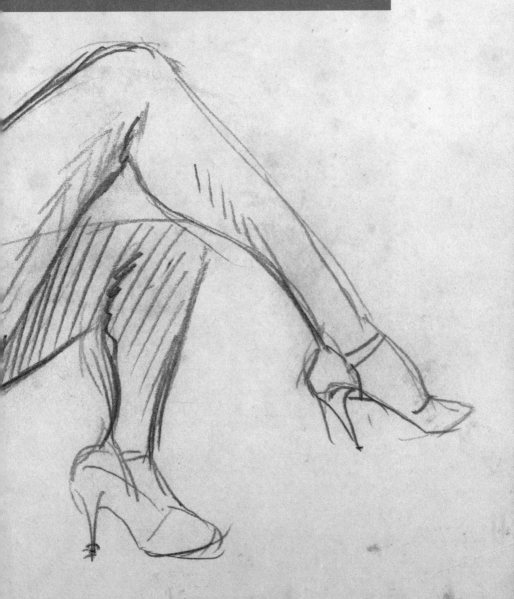

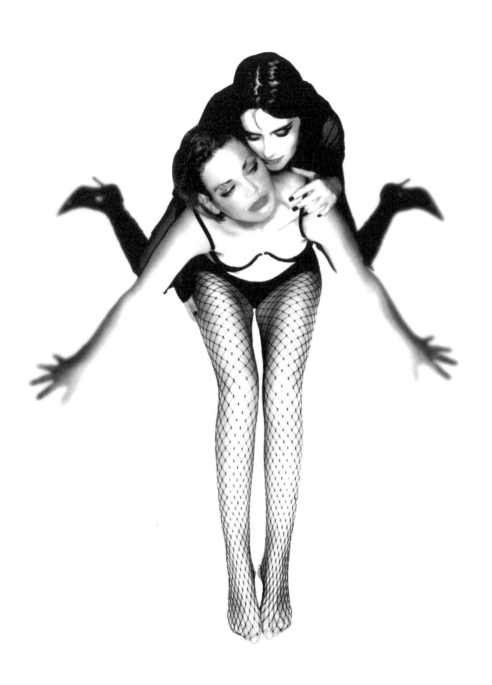

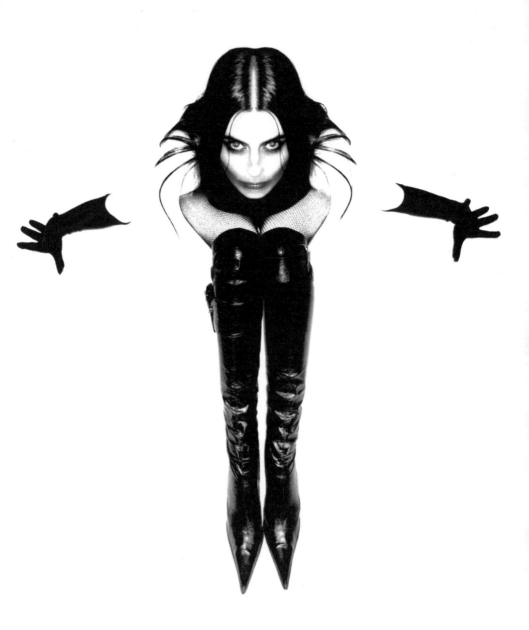

THE LAST ROS

of SUMM

47

SPRING EXTRA #49

BOUDOIR and SPICE

2/6

A BRIGHT NUMBER FOR THE NEW SEASON

MELODY SPARKLE

GLAMOUR!
HUMOUR!
Fun!

PHOTOS CARTOONS STORIES

THE WORLD'S LOVELIEST

PIN-UPS IN COLOUR

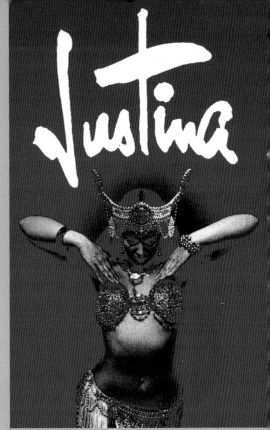
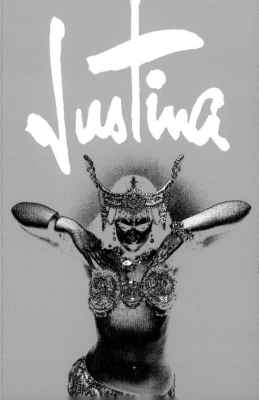

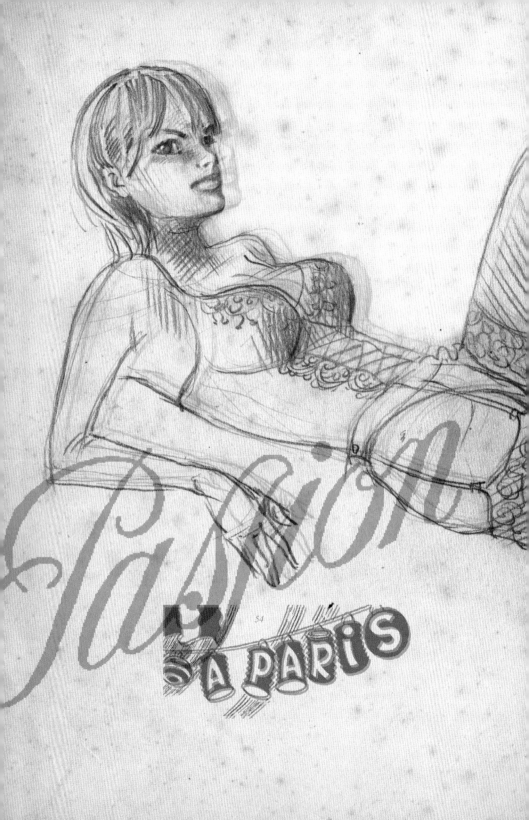

54

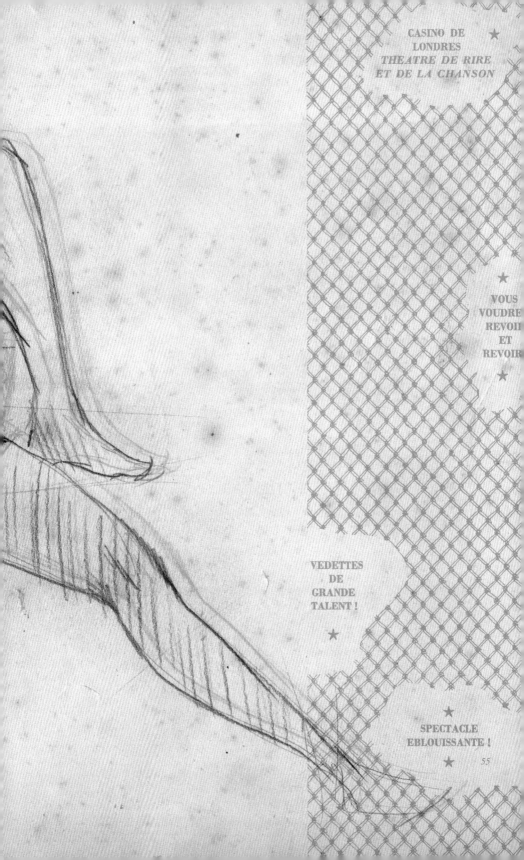

CASINO DE
LONDRES ★
THEATRE DE RIRE
ET DE LA CHANSON

★

VOUS
VOUDRE
REVOII
ET
REVOIR

★

VEDETTES
DE
GRANDE
TALENT !

★

★

SPECTACLE
EBLOUISSANTE !
★ 55

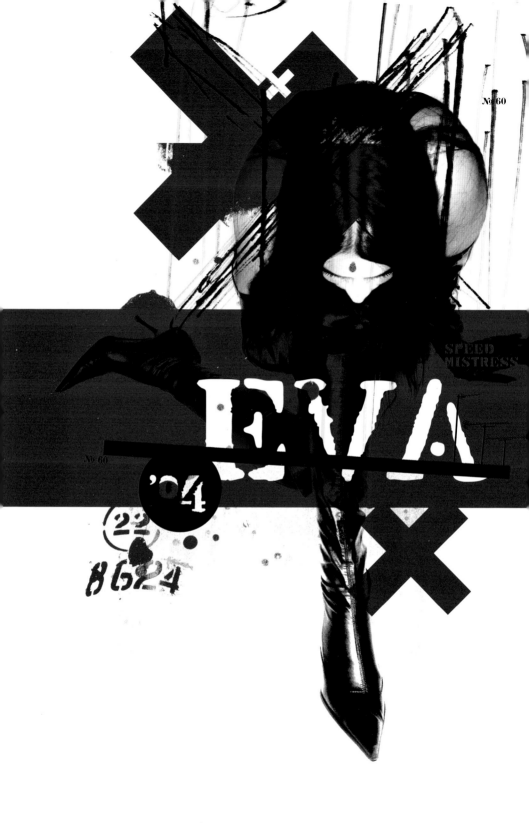

SPEED
MISTRESS

EVA.

'04

22
8624

Club
SO-HO
DINE
DANCE

4
SHOWS NIGHTLY
First Show at 8:30 p.m

no cover charge

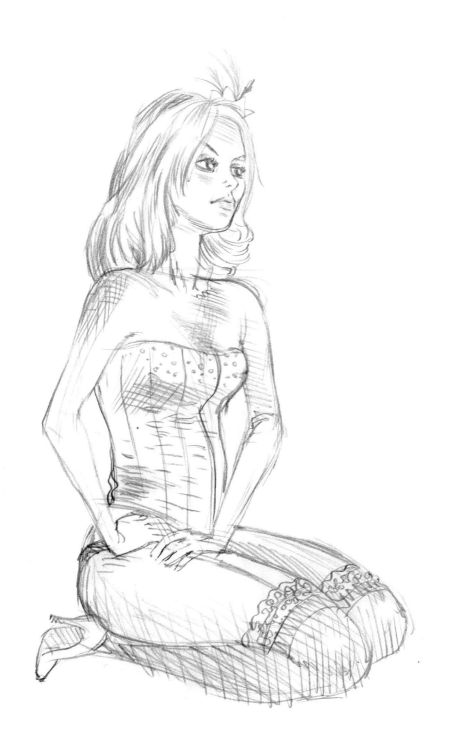

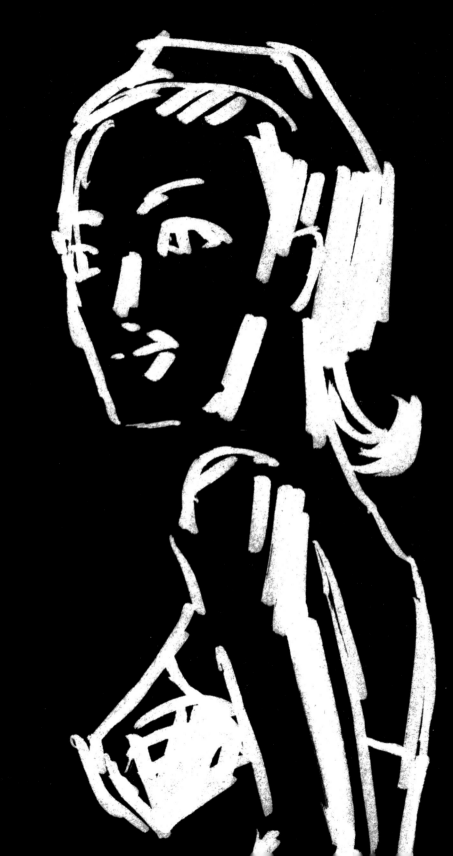

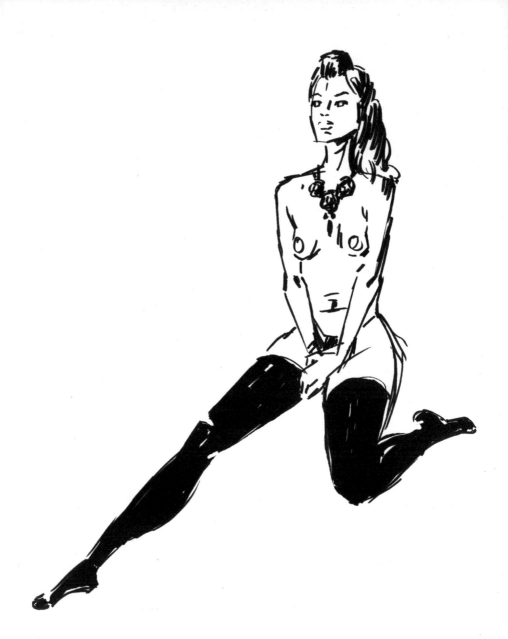

65

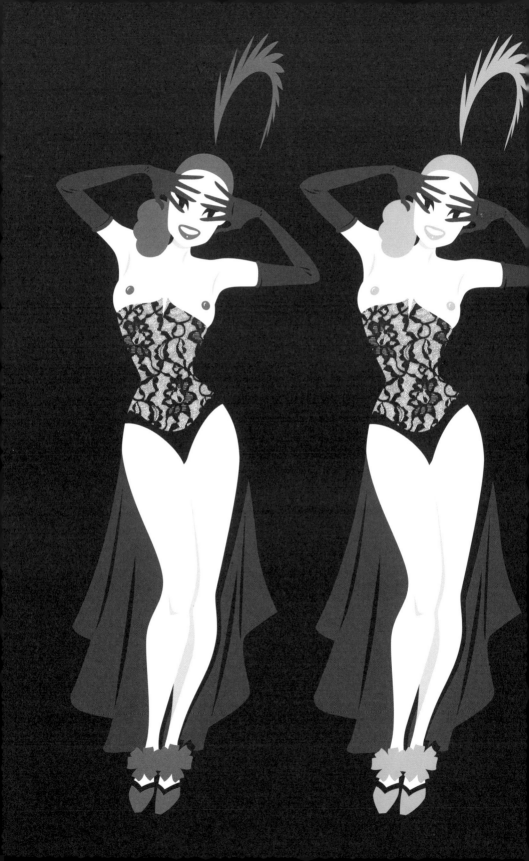

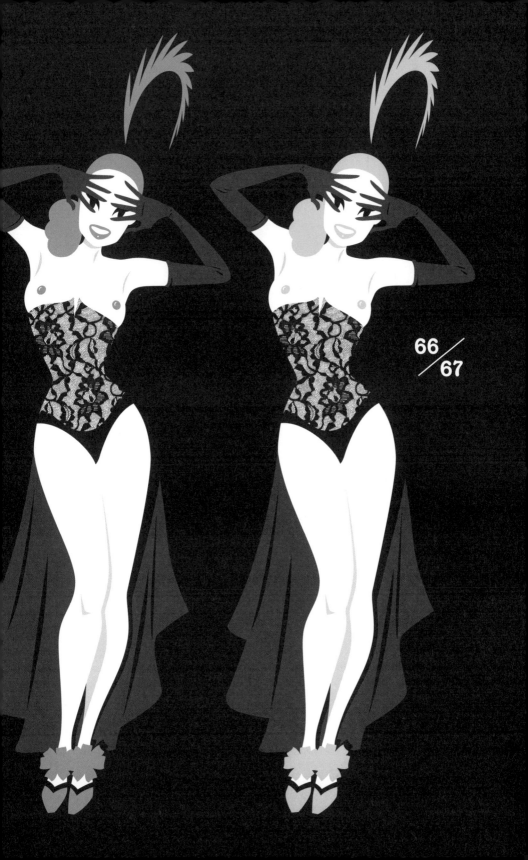

PICCADILLY
BURLESQUE
club · cabaret · dancing

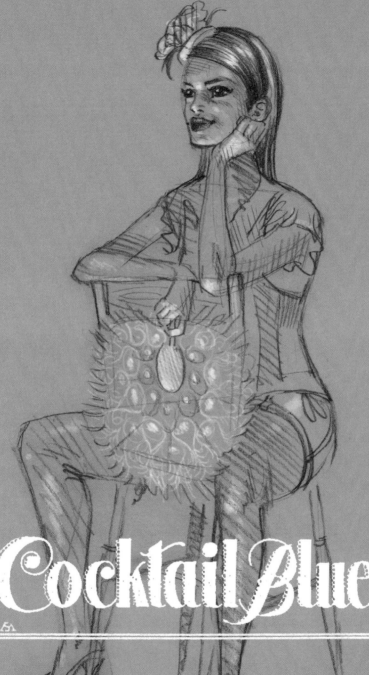

Cocktail Blue

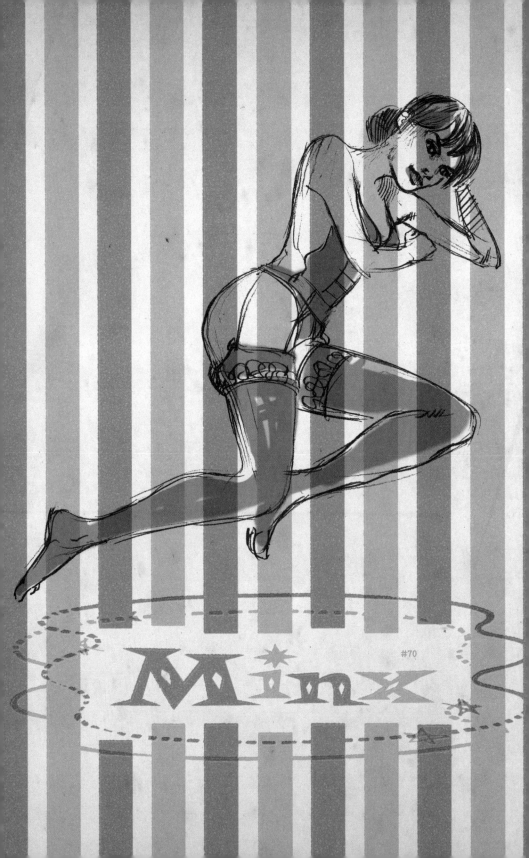

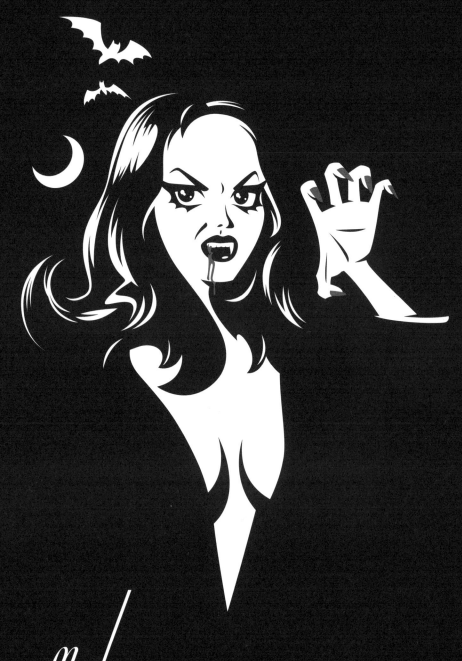

Madame DRACULA

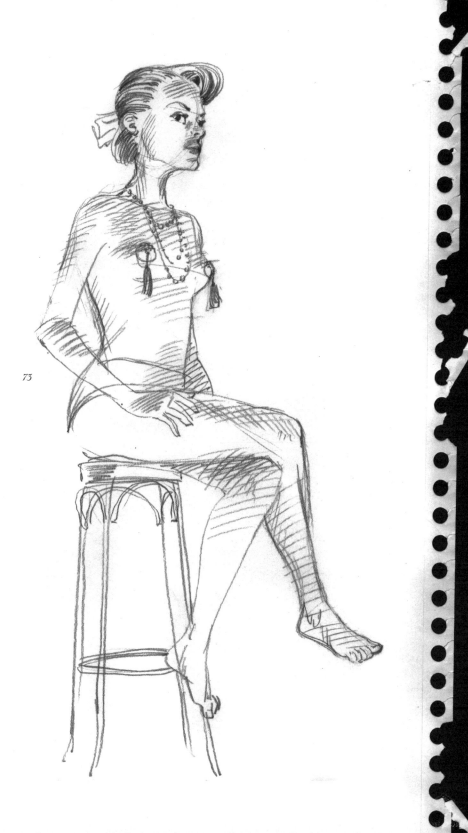

73

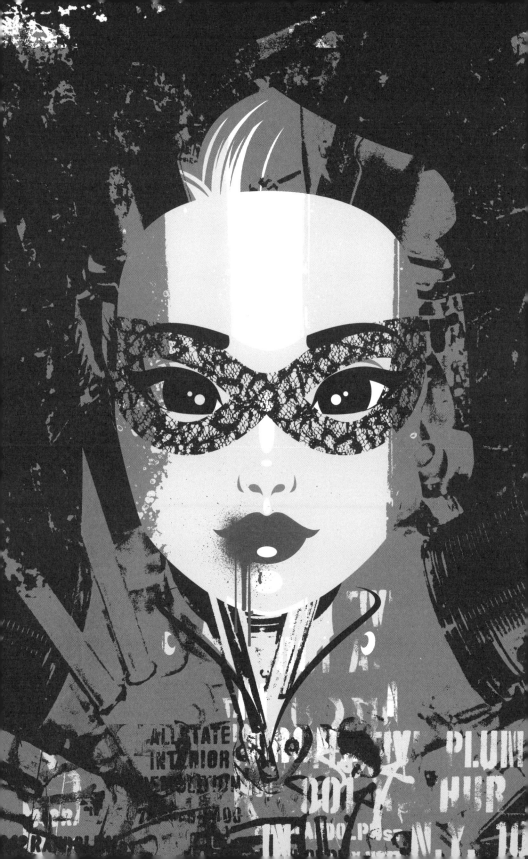

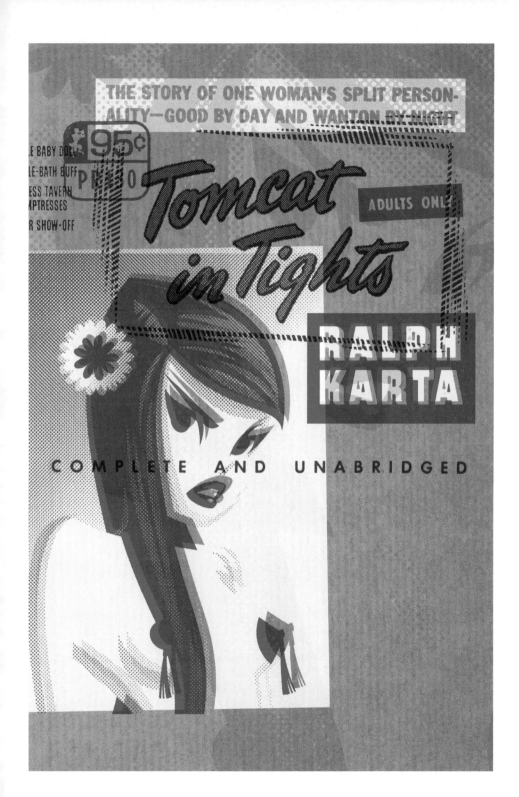

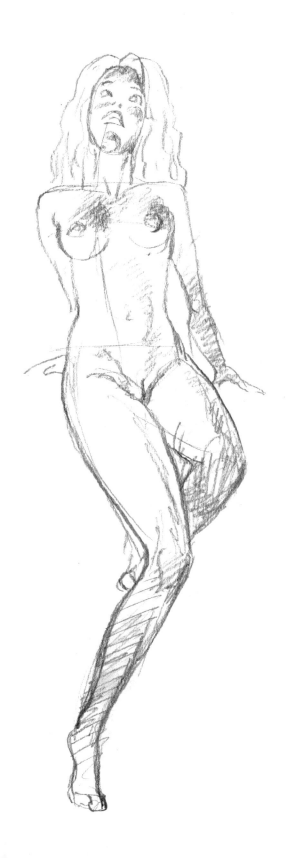

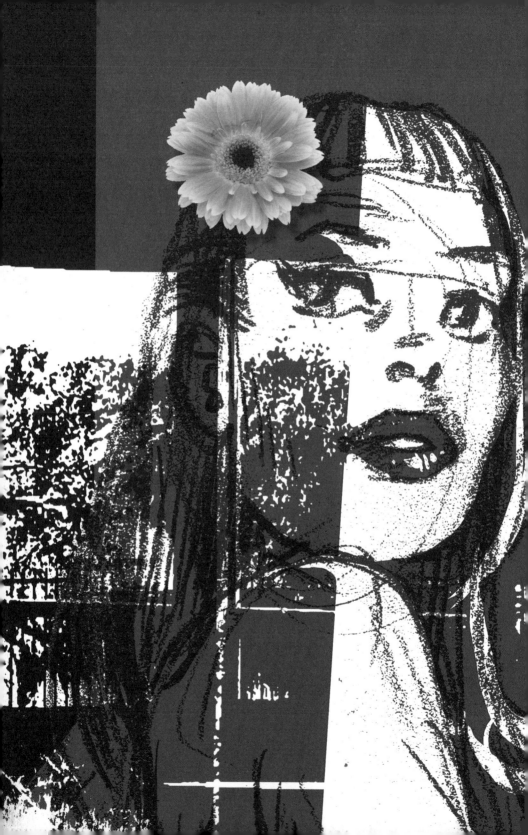

FOR THE Lady of Affairs

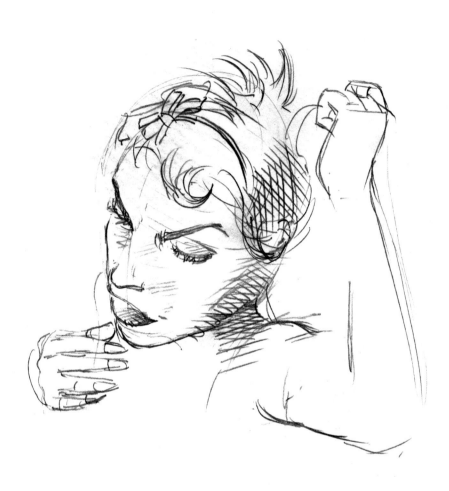

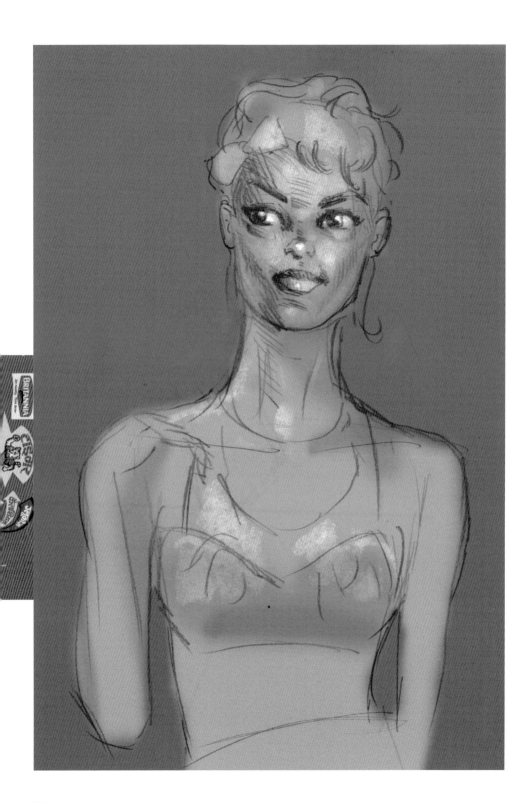

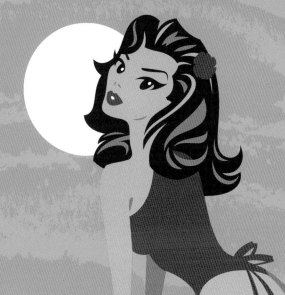

GIRL
ON THE
LOOSE

Blondes Beware!

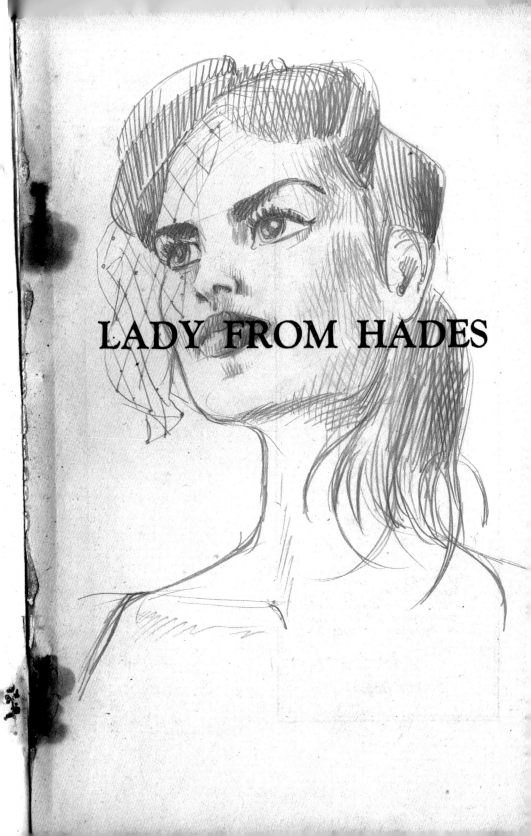

LADY FROM HADES

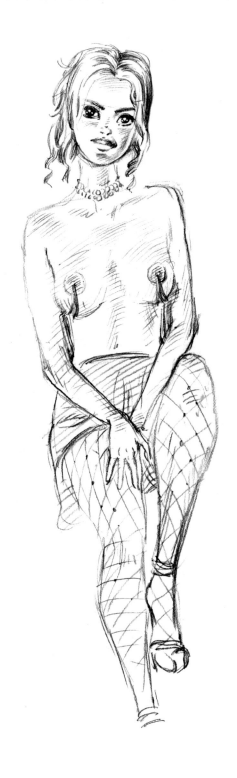

AN ESSENCE OF *glamour*

 SOHO HOUSE RED

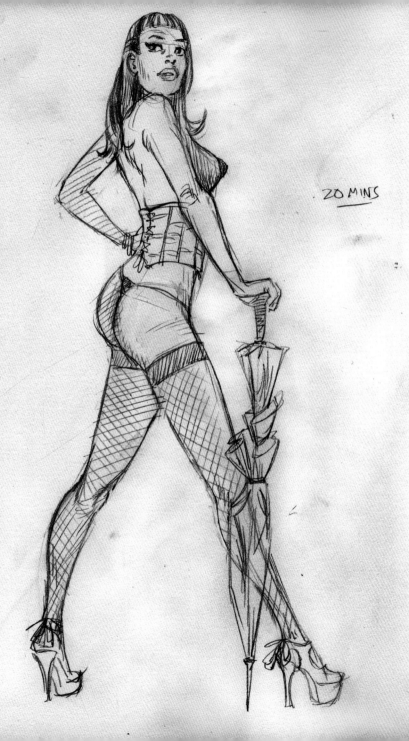

20 MINS

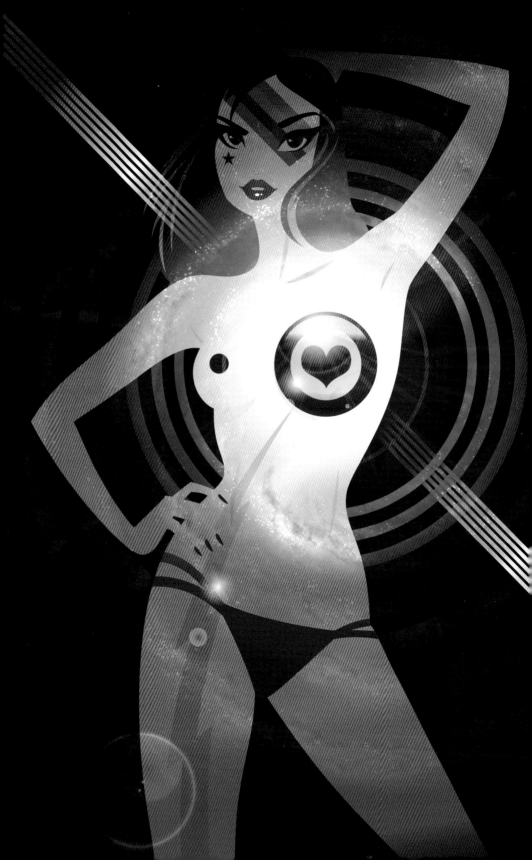

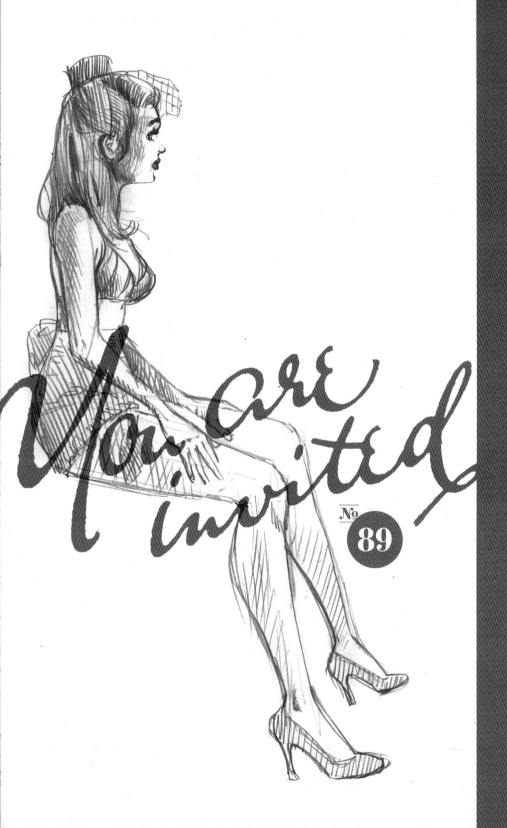

You are invited

№ 89

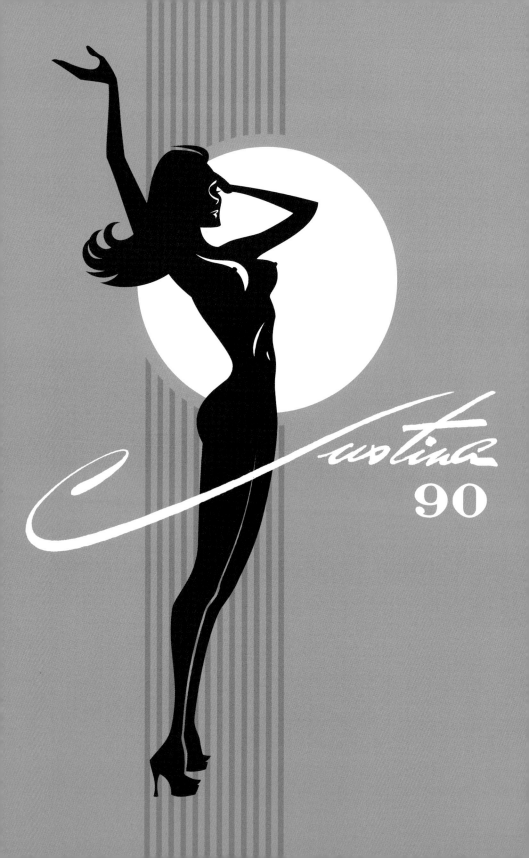

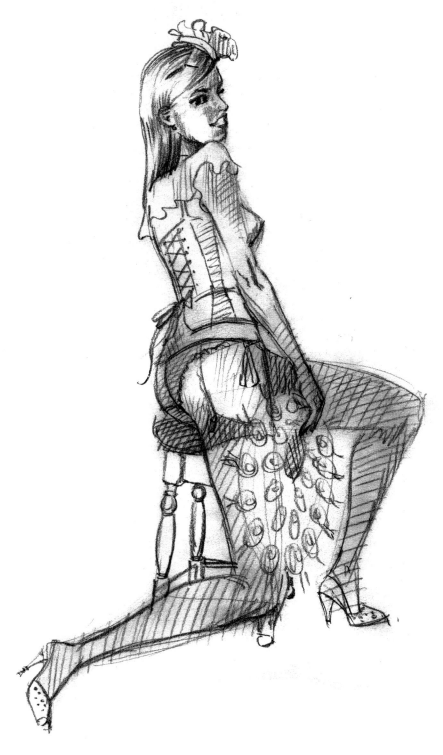

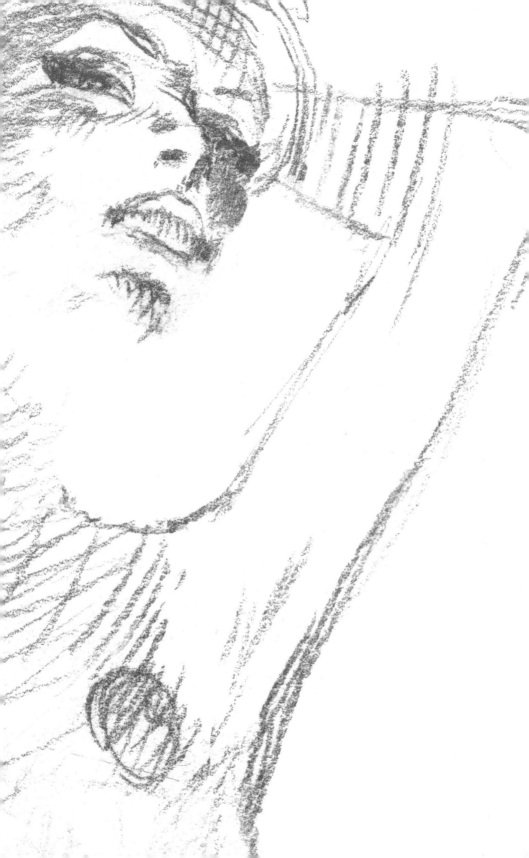

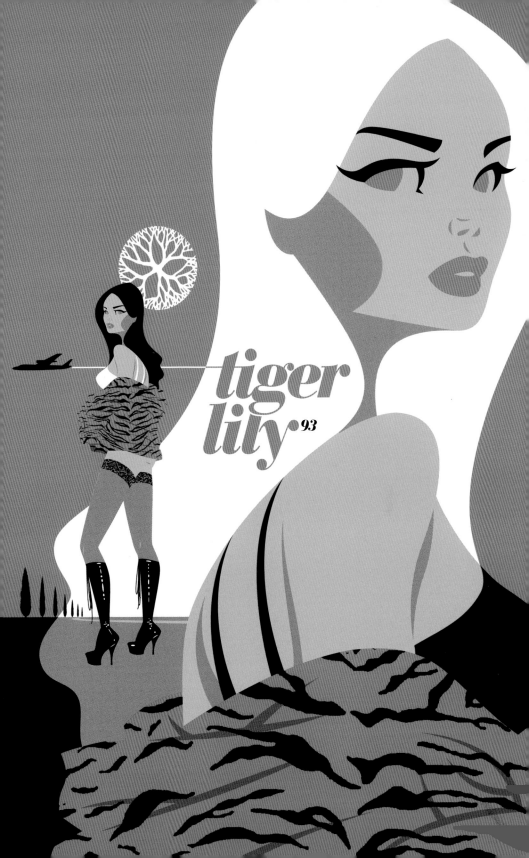

tiger
lily 93

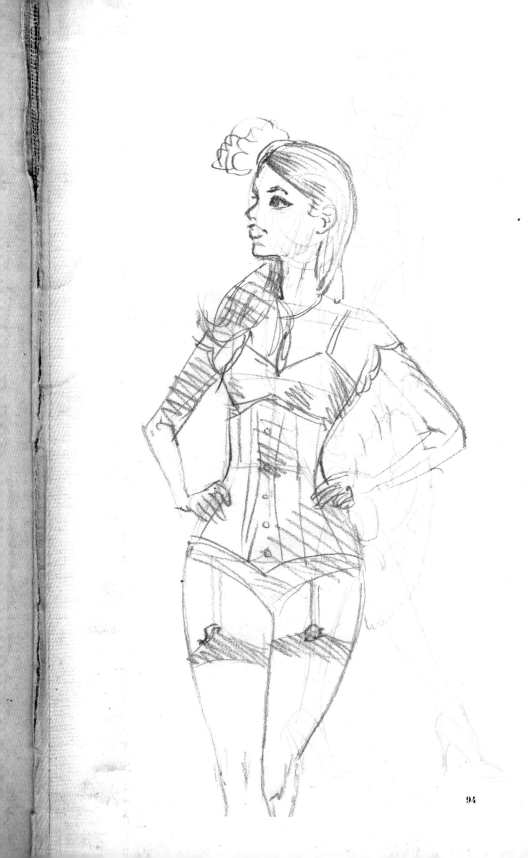

94

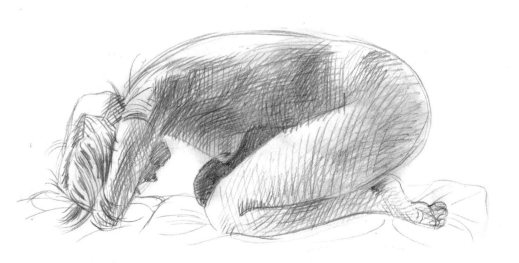

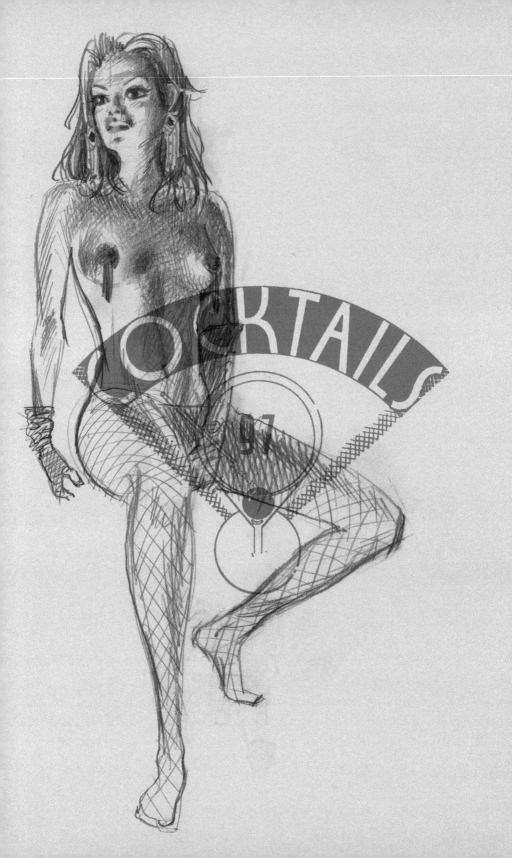

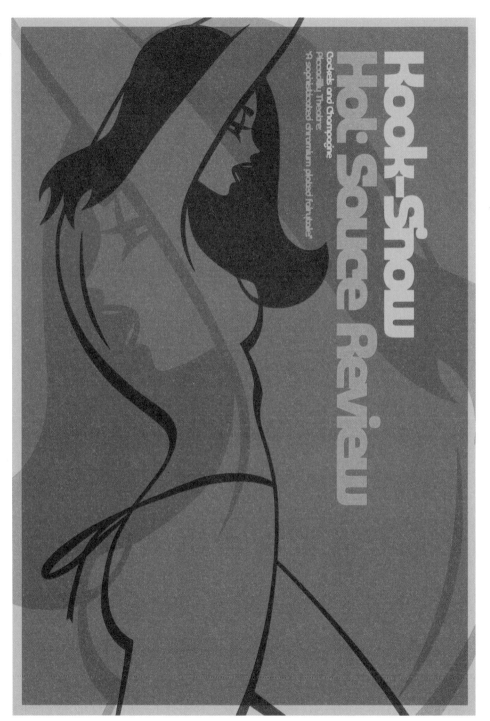

Kook-Show
Hot-Sauce Review

Cocktails and Champagne
Piccadilly Theatre
'A sophisticated chromium plated fantasia'

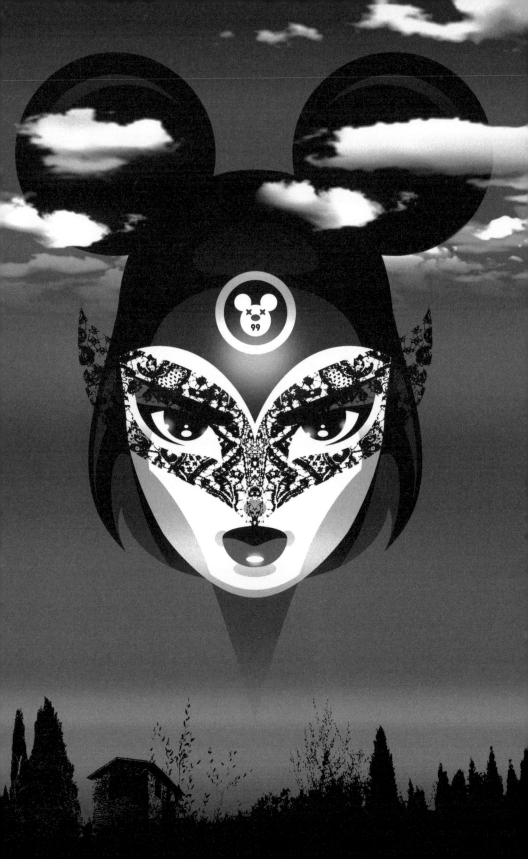

100

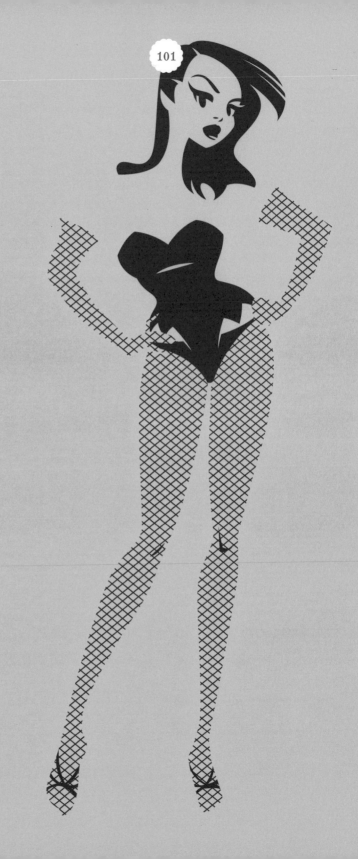

2 MINS

8.8.2010

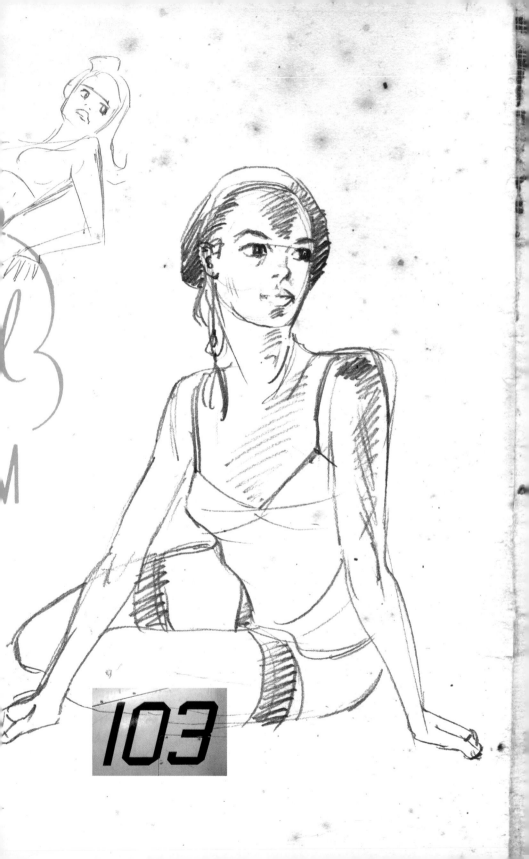

103

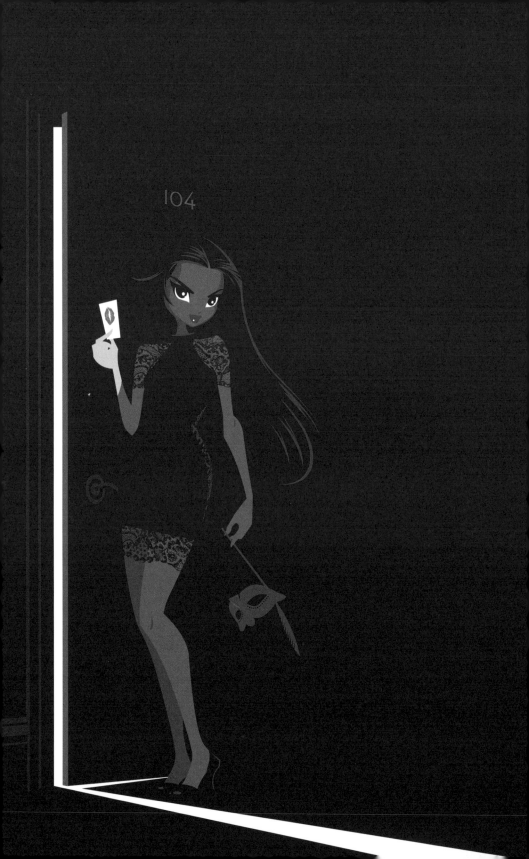

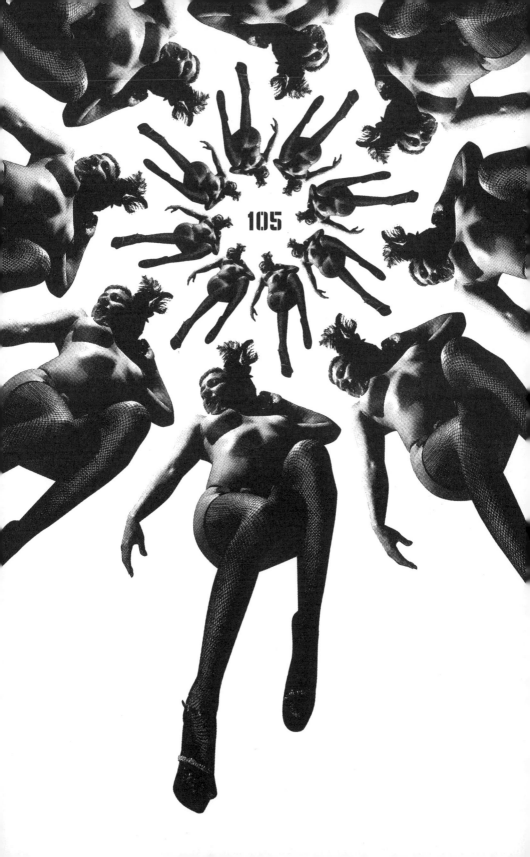

105

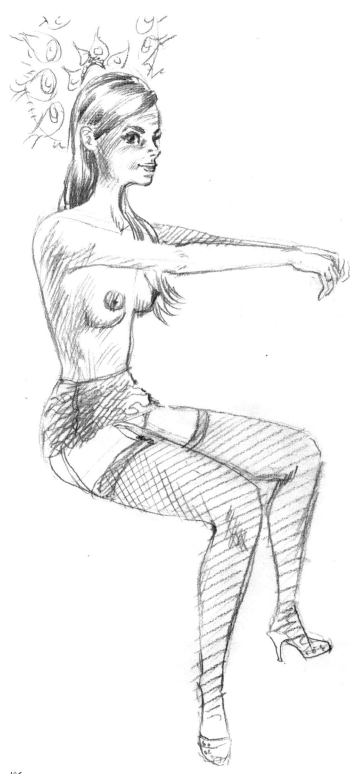

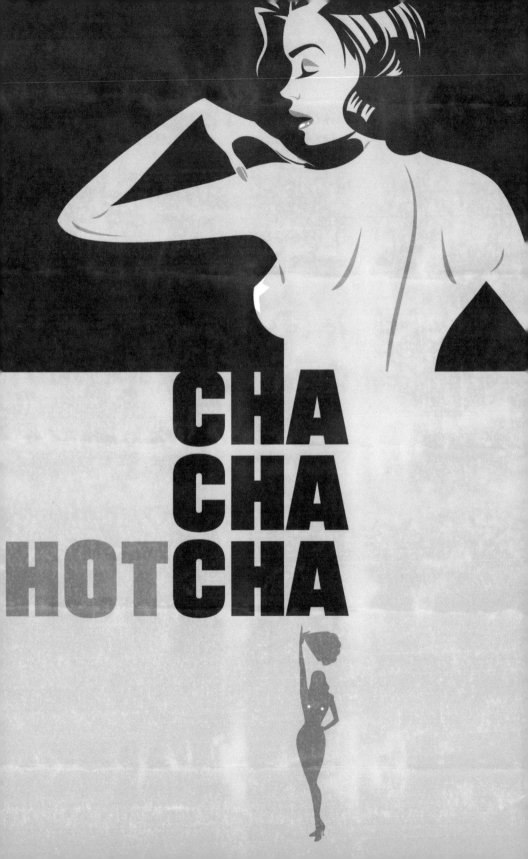

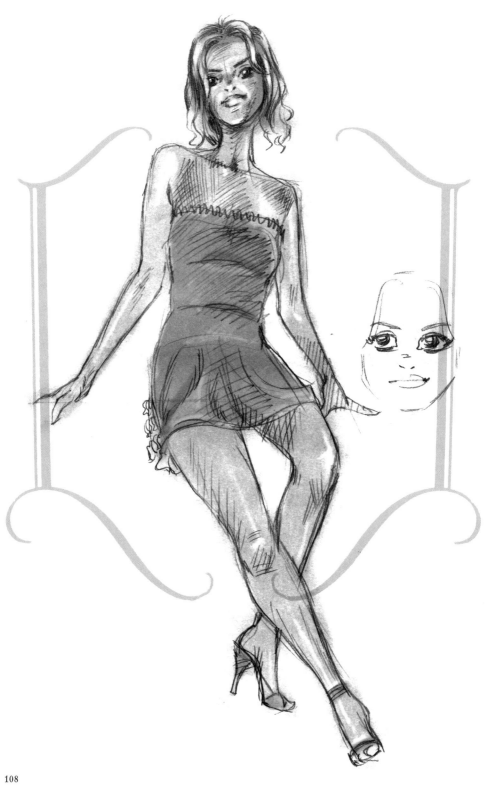

SOHO'S
Butterfly LOUNGE

Cocktails
Fine Food

SHOWS DAILY AT 9 AND 12 PM

OPEN TUESDAY TO SUNDAY

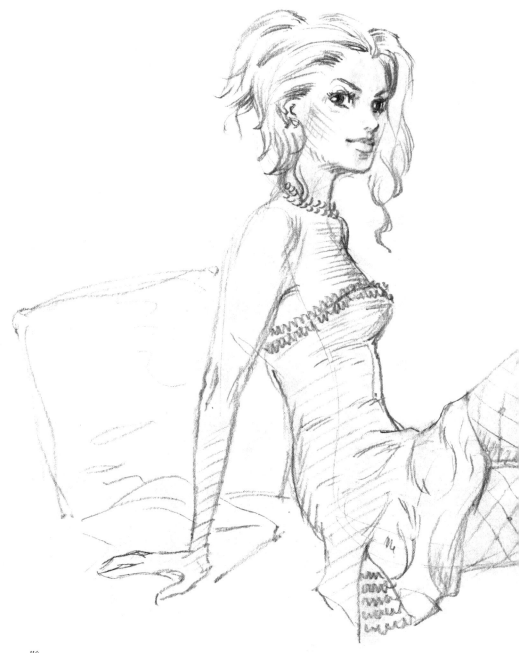

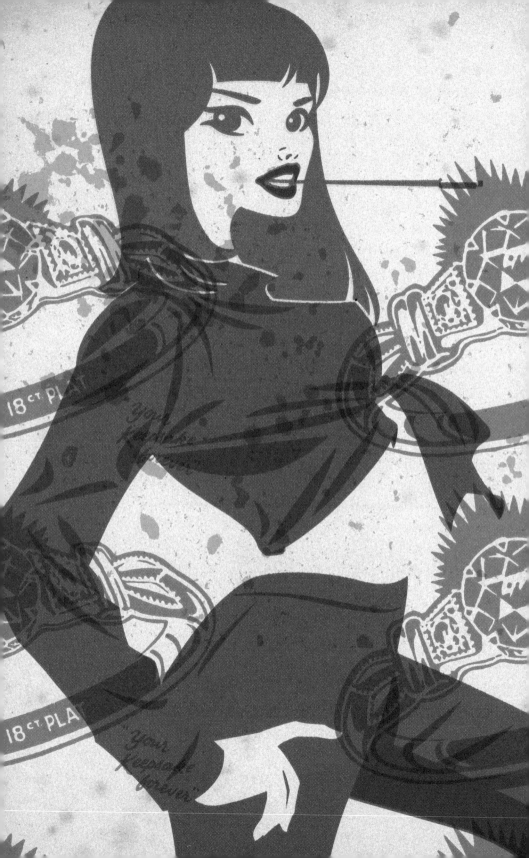

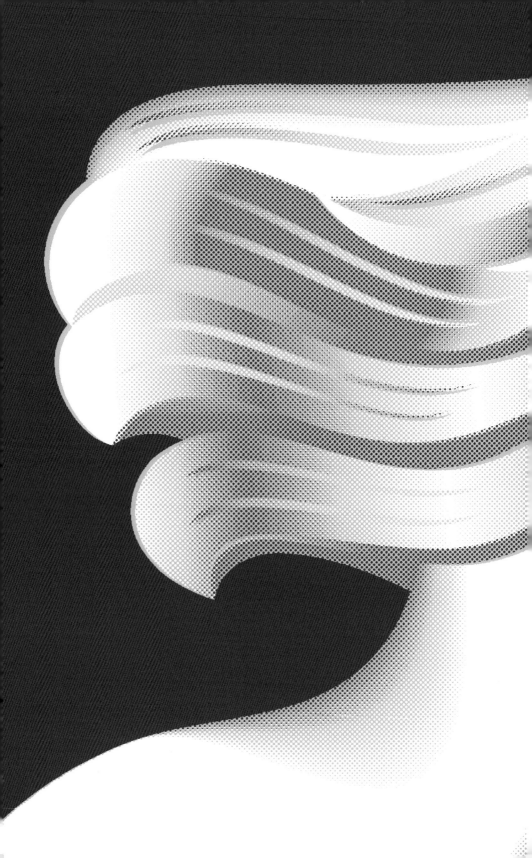

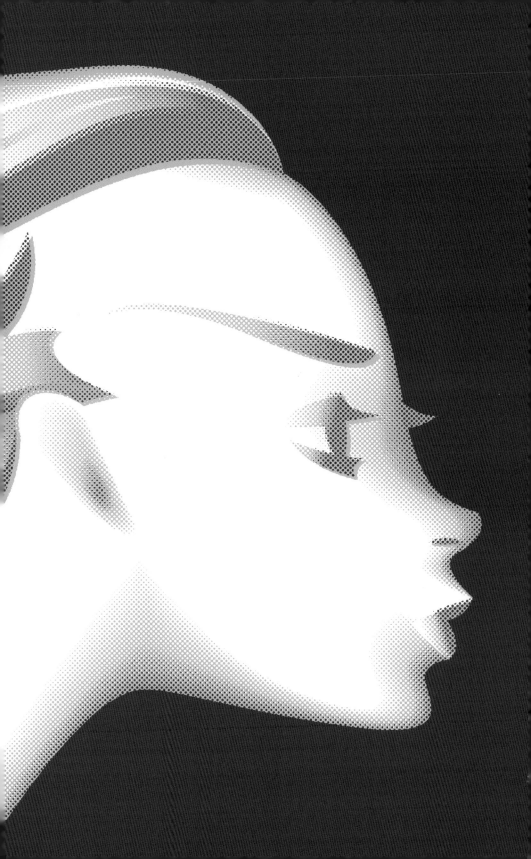

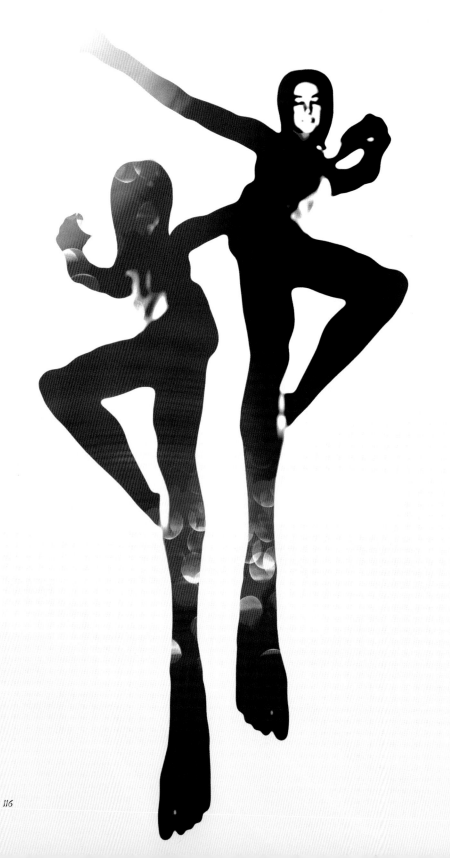

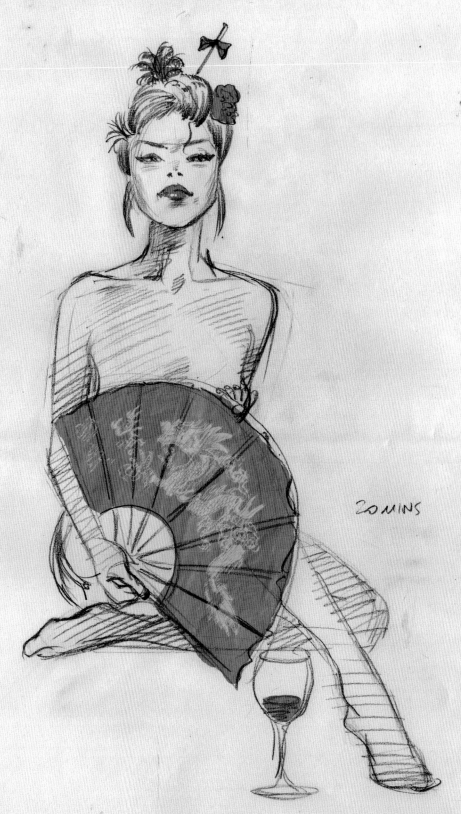

20 MINS

MASQUES

FANTAISIE 23,405 A 27,450

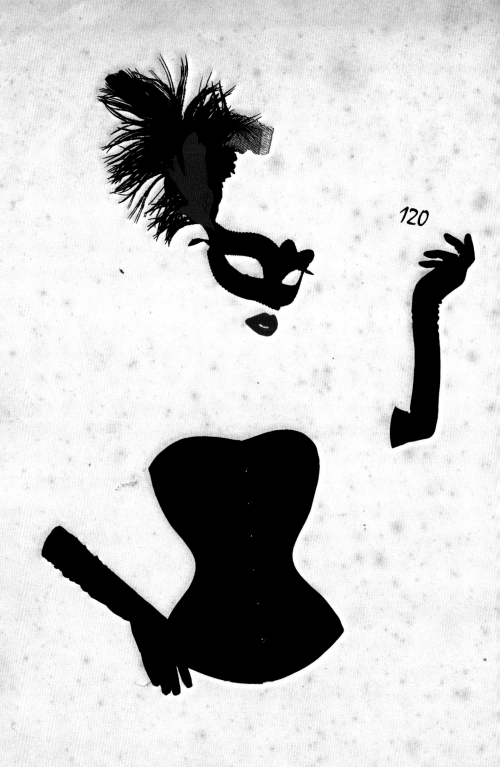

120

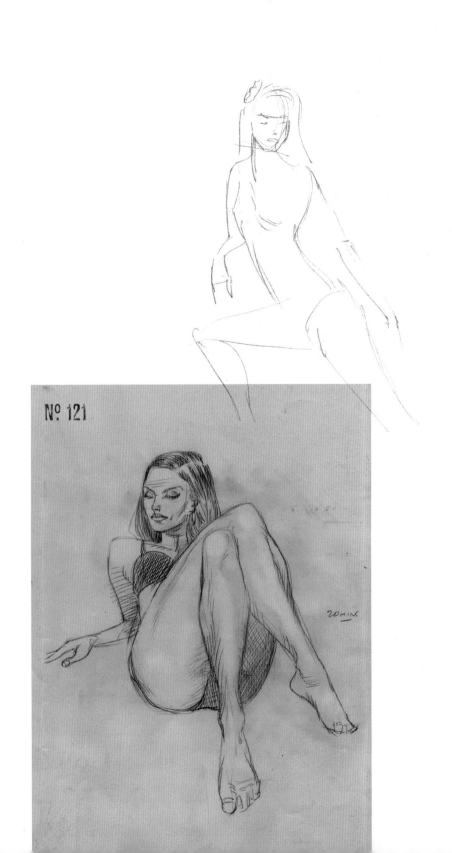

Nº 121

20MINS

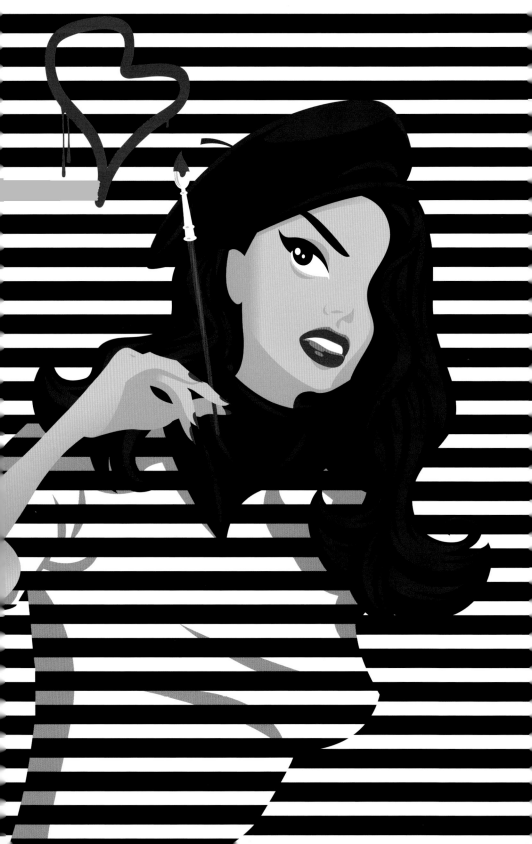

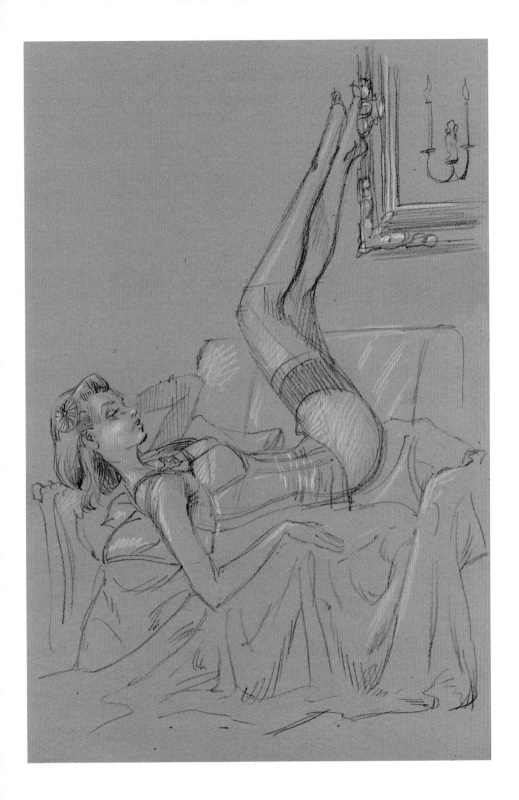

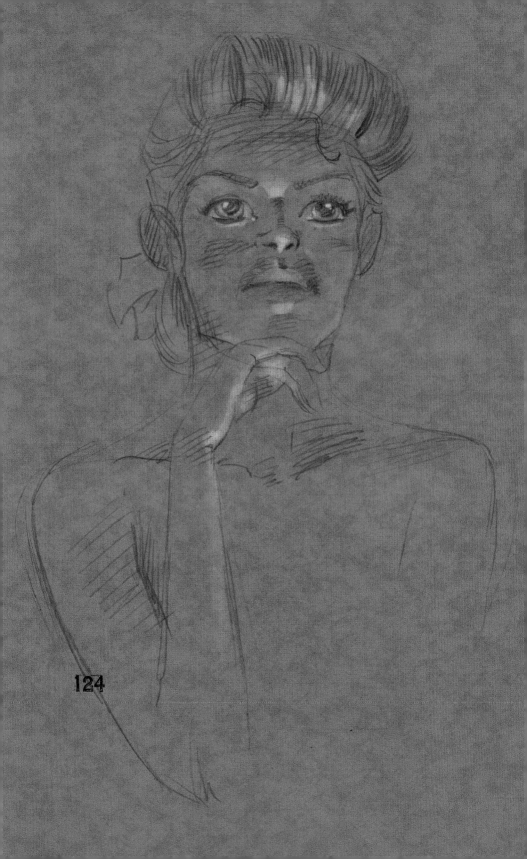

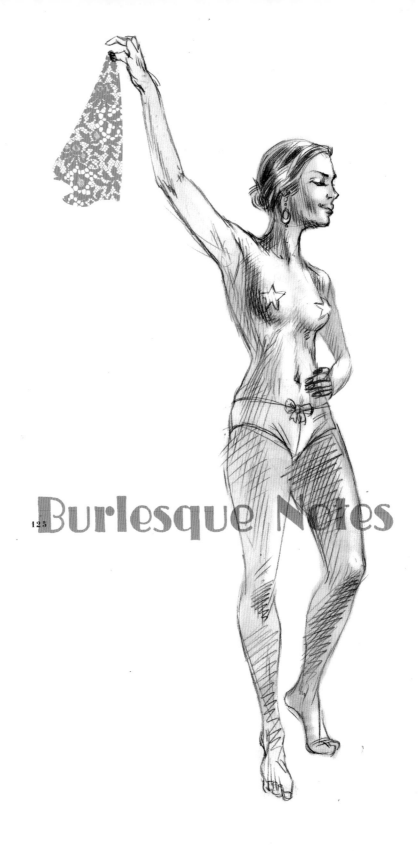

Burlesque Notes

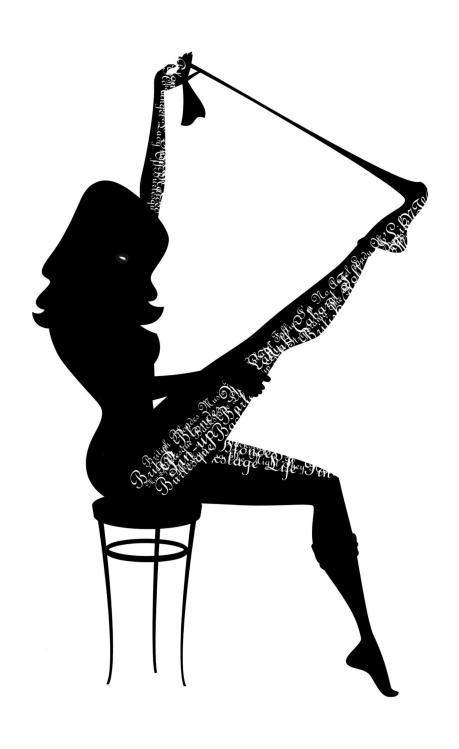

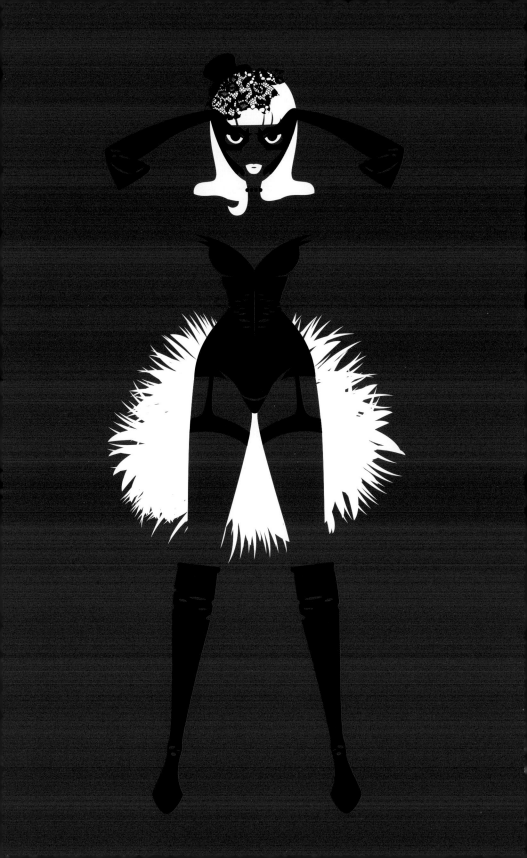

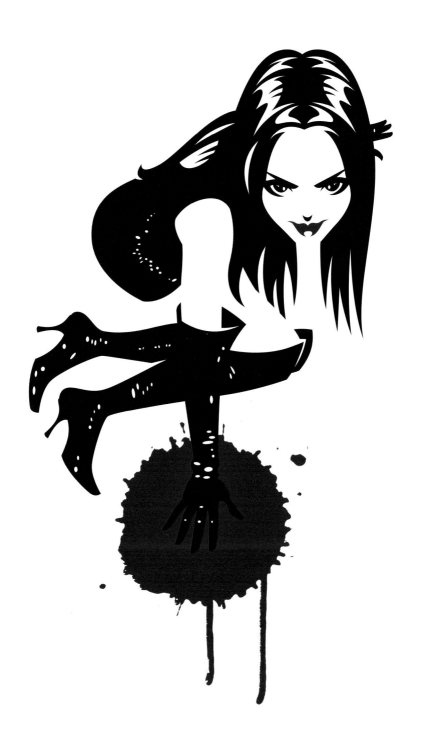

SEASIDE
SPECIAL

PIN-UP
Parade

July No. 129

3/-

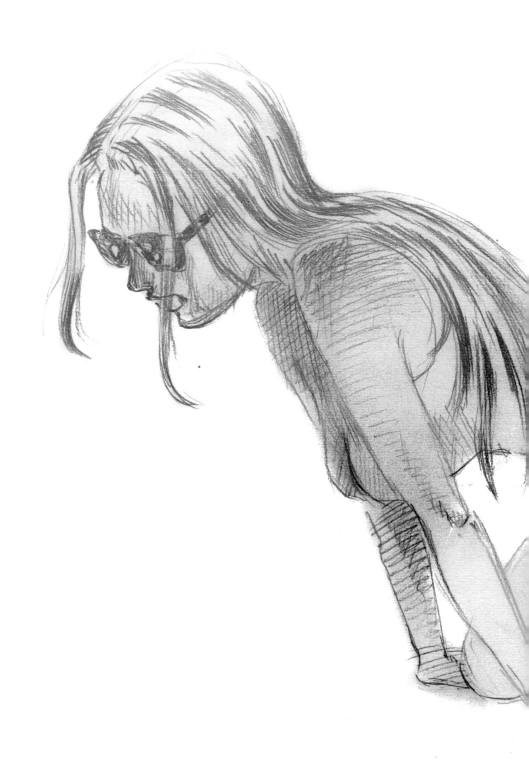

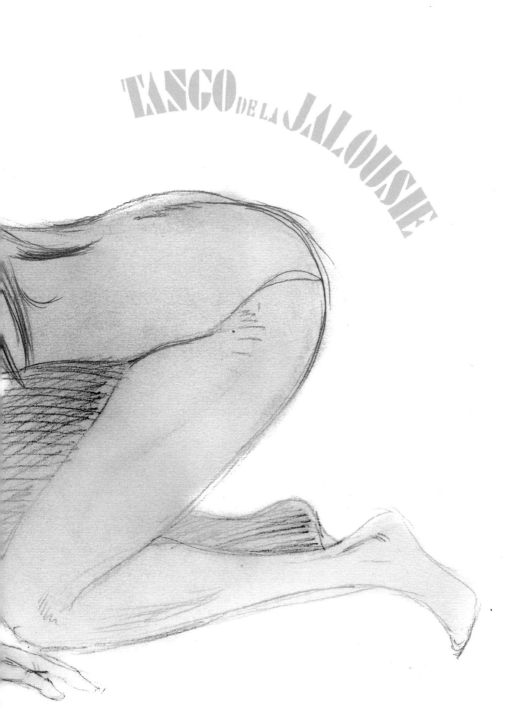

TANGO DE LA JALOUSIE

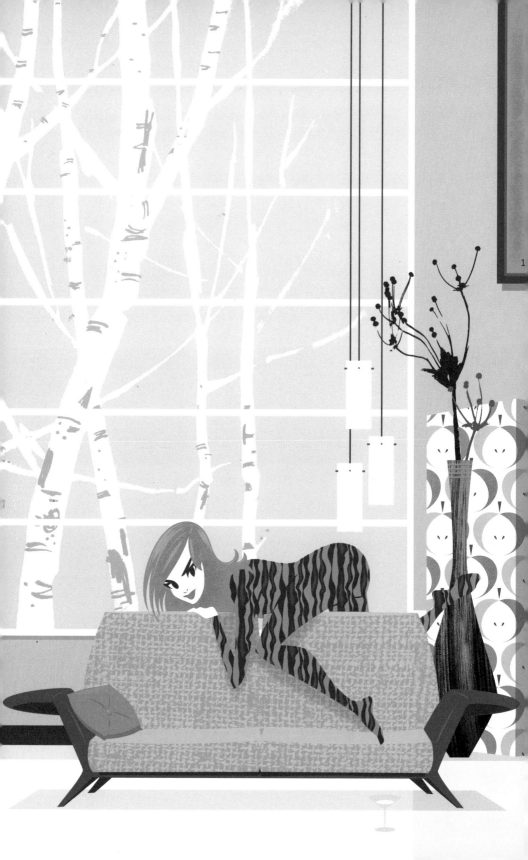

The

"Blonde Venus"

133

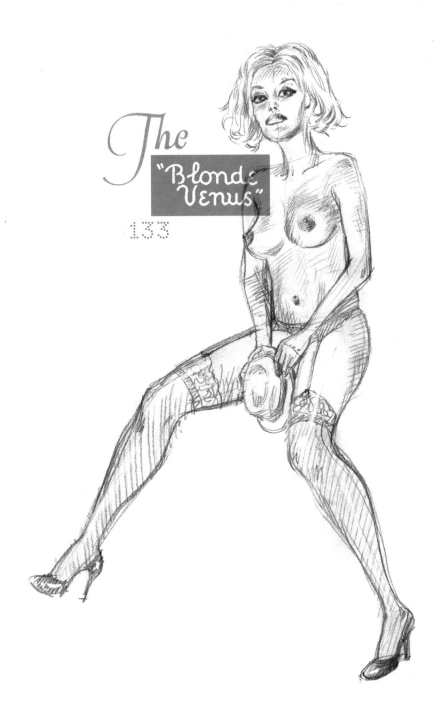

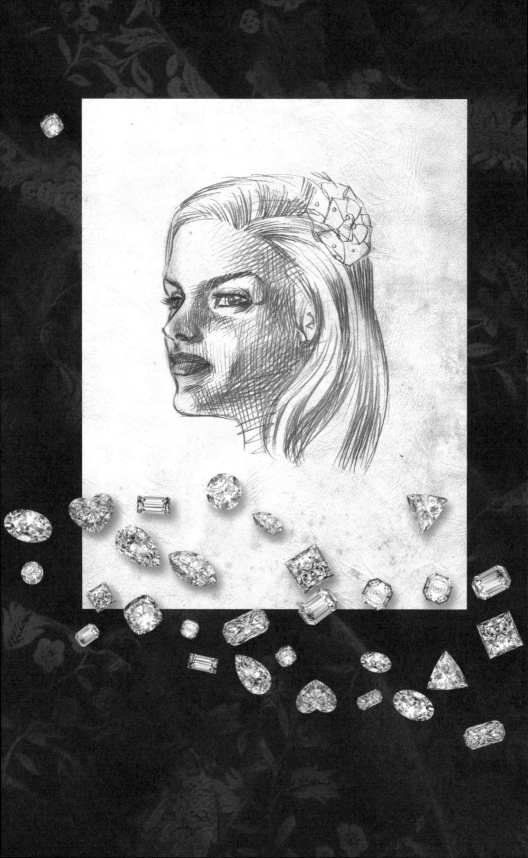

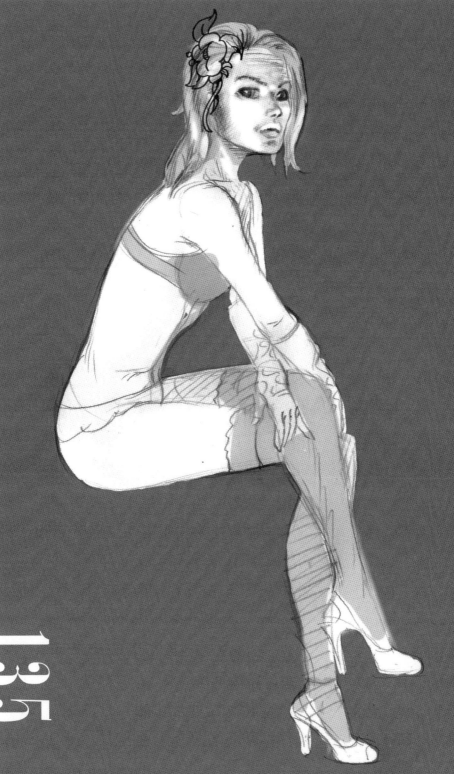

135

Artistes
appearing
to-night 136

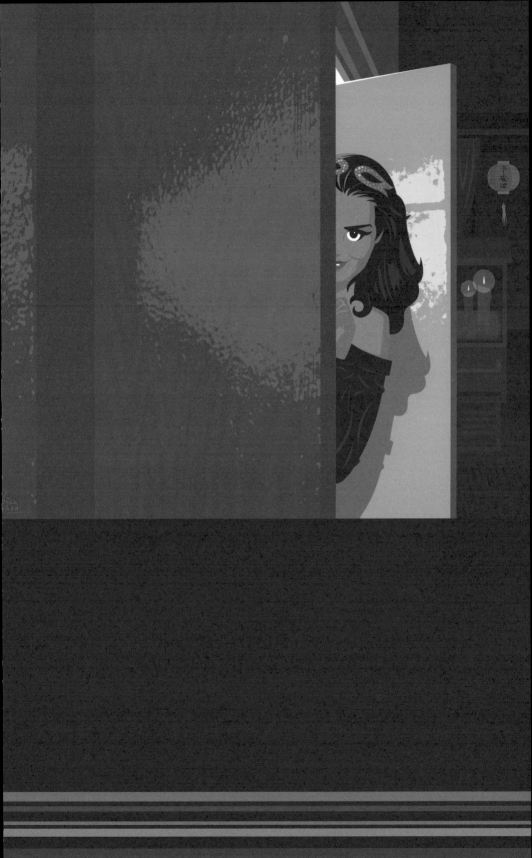

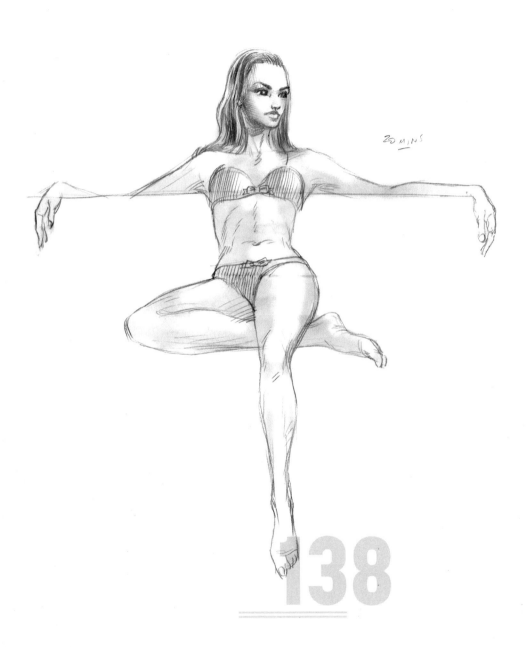

20 MINS

138

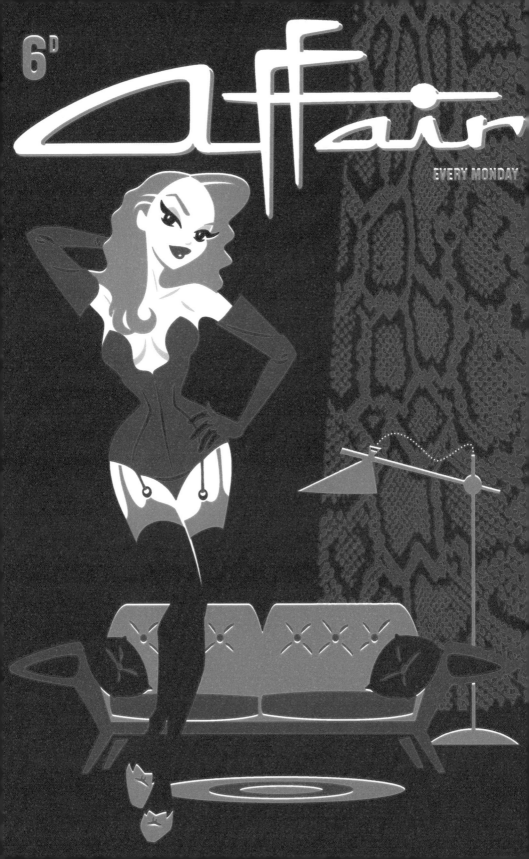

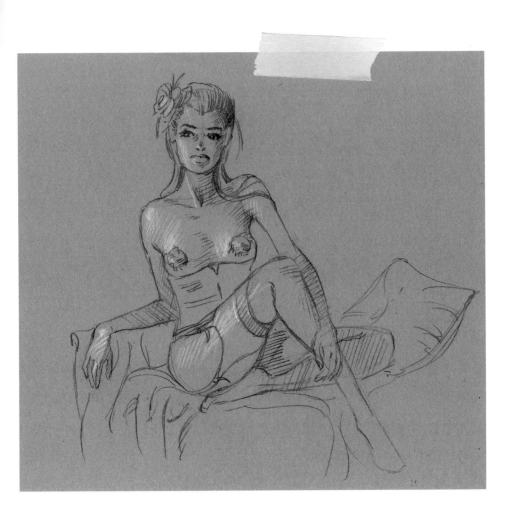

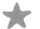 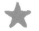 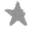

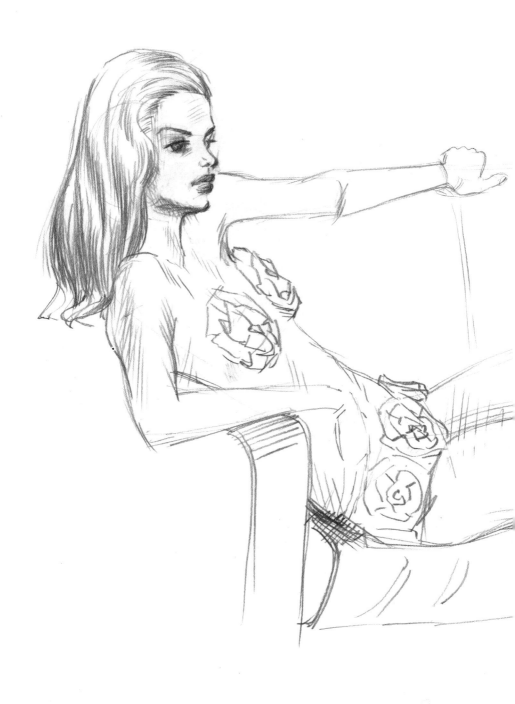

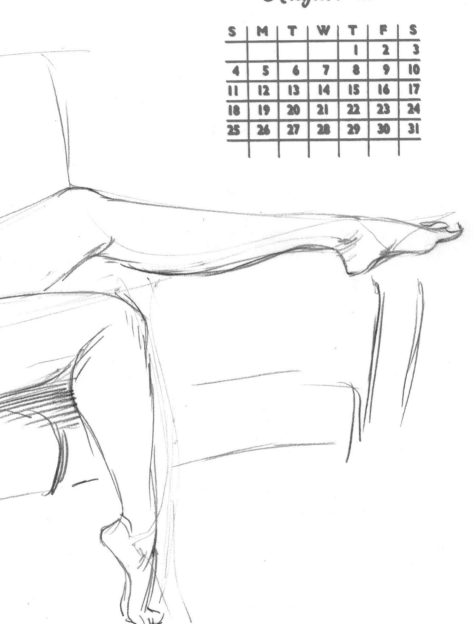

August 1957

S	M	T	W	T	F	S
				1	2	3
4	5	6	7	8	9	10
11	12	13	14	15	16	17
18	19	20	21	22	23	24
25	26	27	28	29	30	31

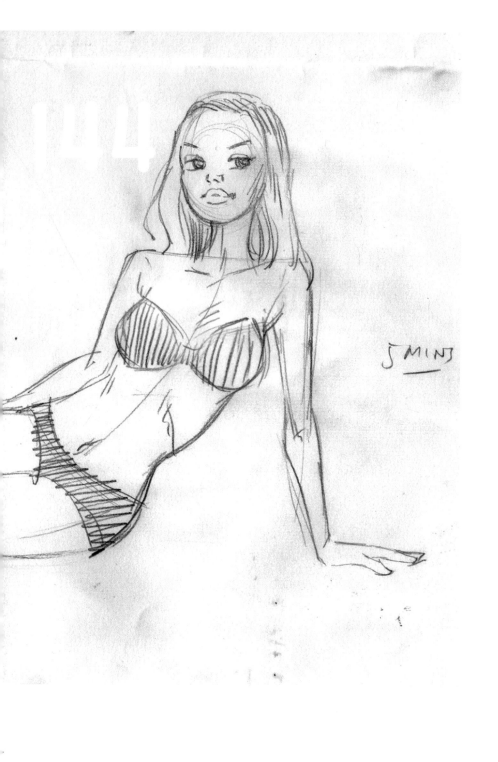

5 MINS

Peek a Boo

Soho Cabaret ♥ 145

Amorous Captive

VOLUME TWO

a
HANK STARR
thriller

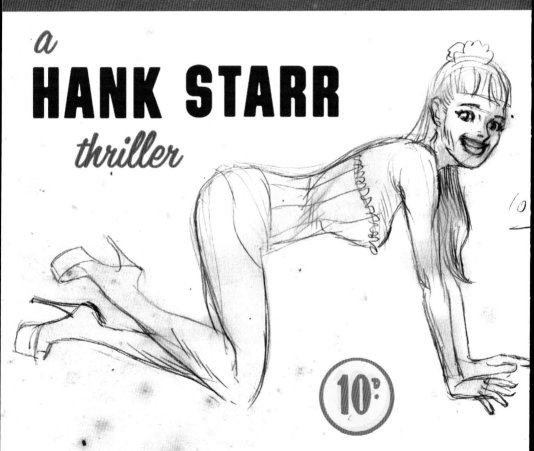

10ᴰ

ALL IN PICTURES

Sultry Avenger

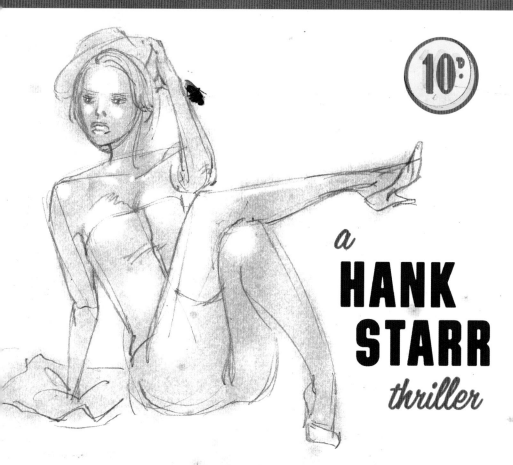

10ᴰ

a
**HANK
STARR**
thriller

ALL IN PICTURES

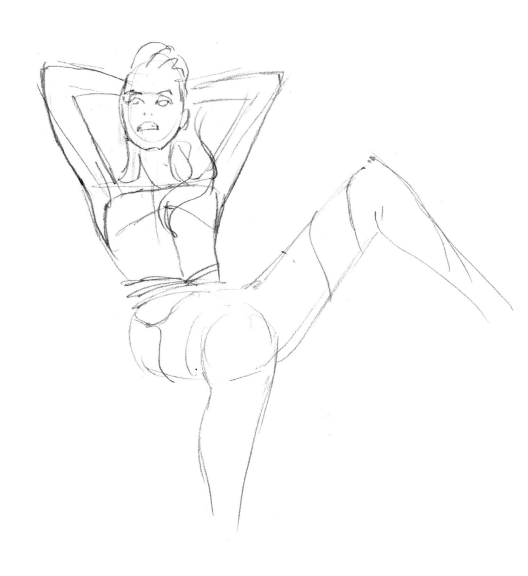

№ 148

#149

JEEPERS

for men

1'-

Starring Sadie

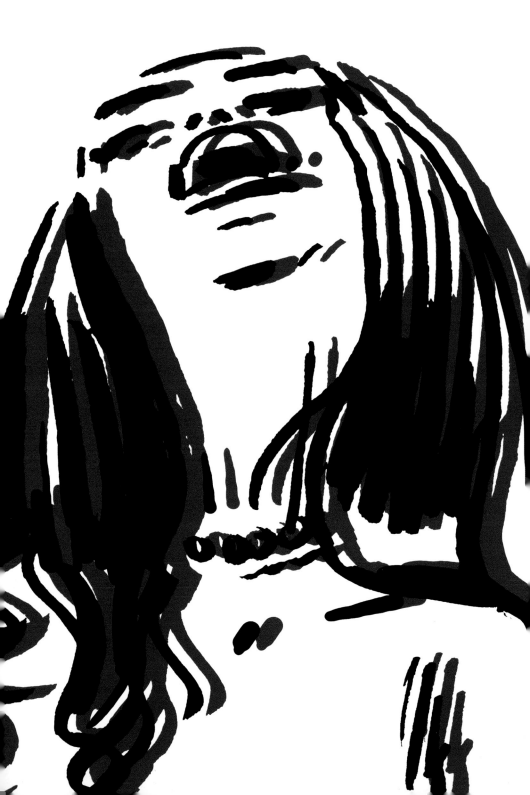

MADAME X
BRUTAL MODERNISM
IN THE PRIVACY OF YOUR OWN HAUS

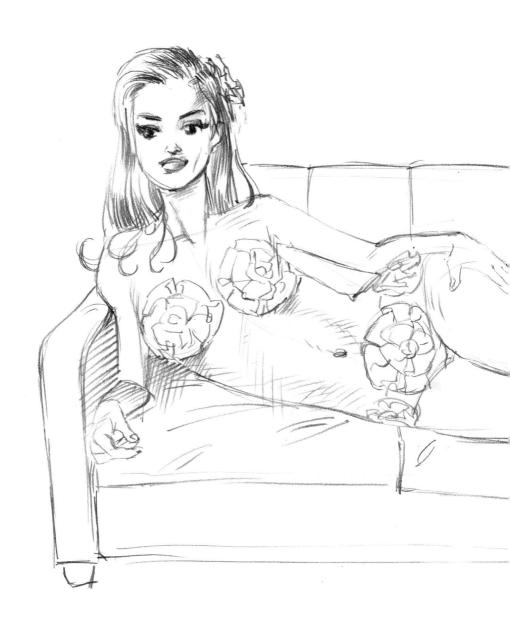

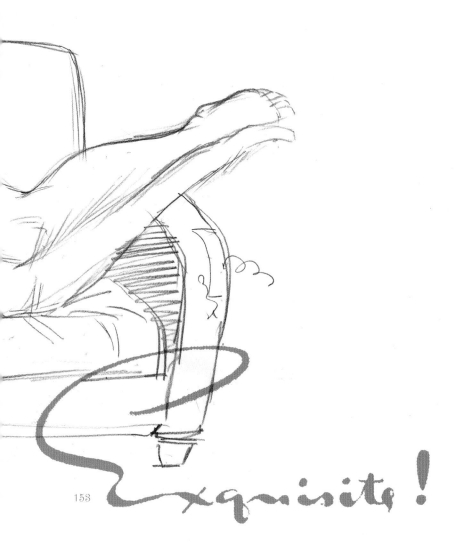

153 Exquisite !

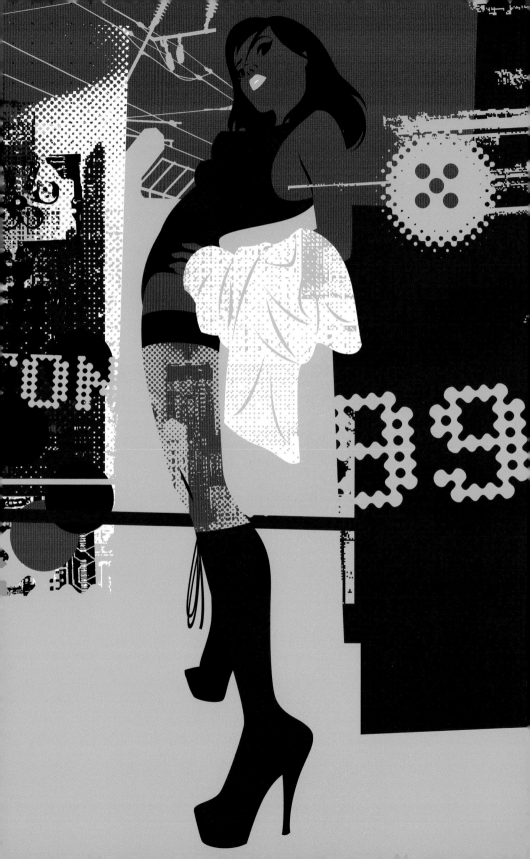

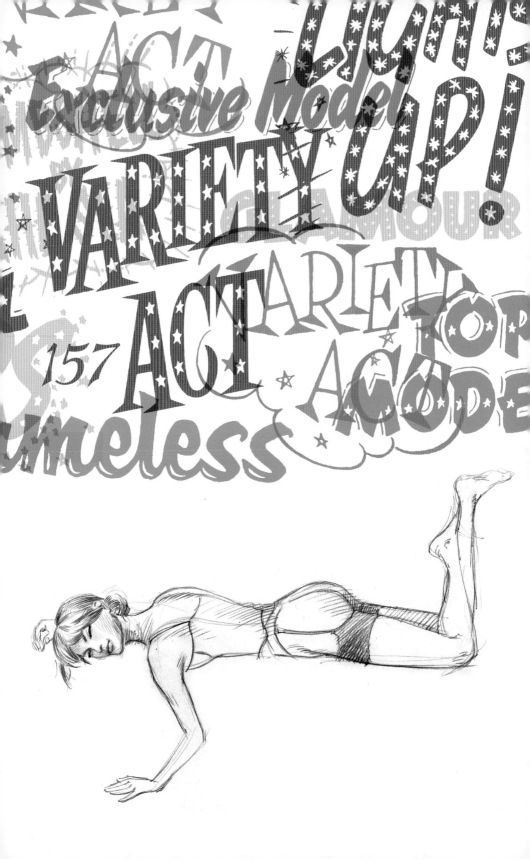

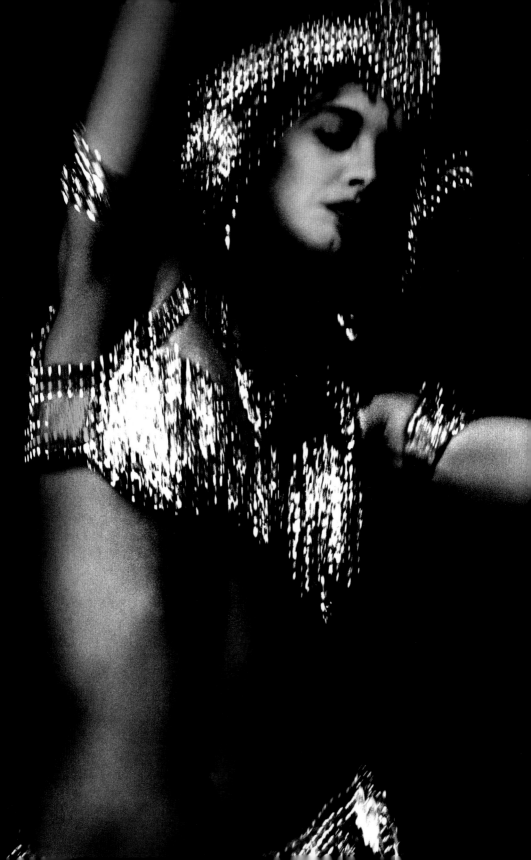

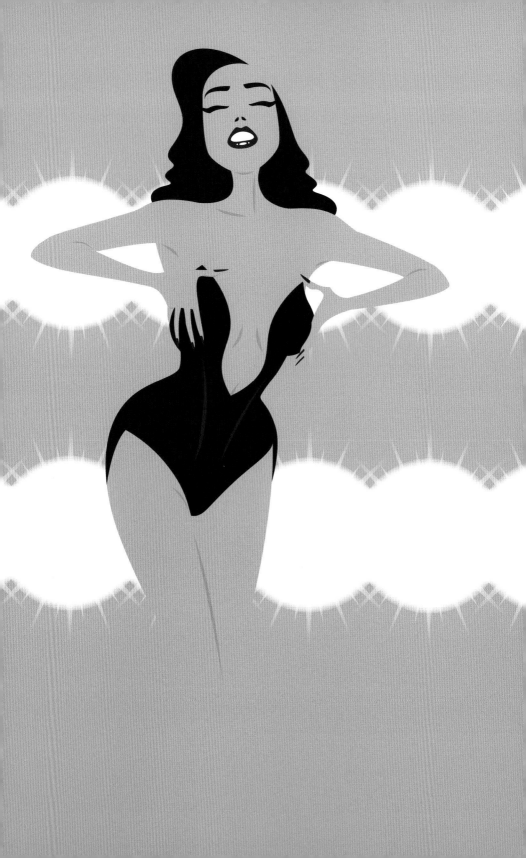

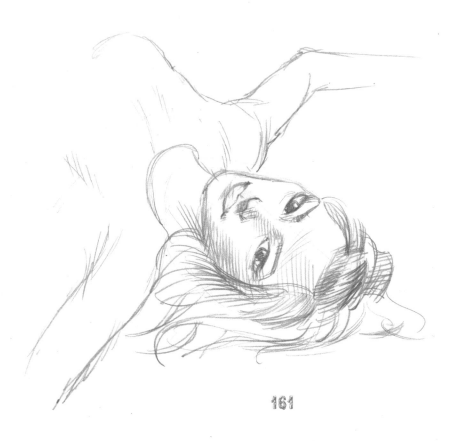

161

Artistes Appearing

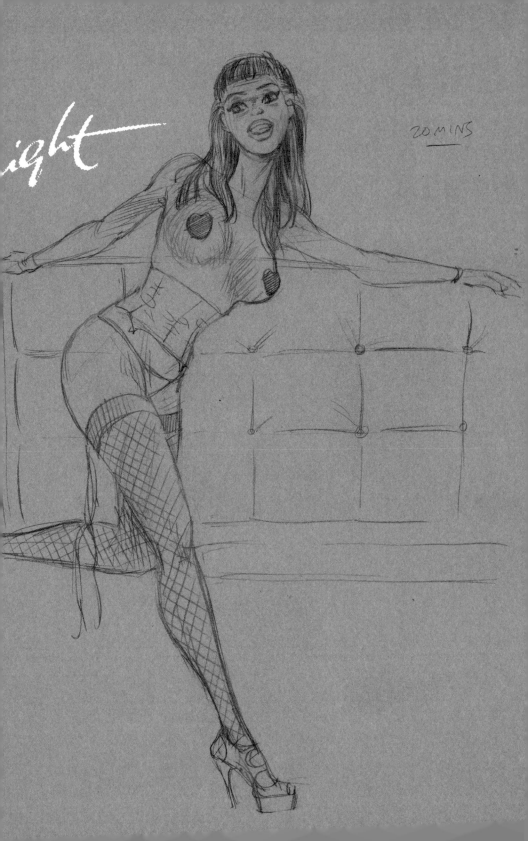

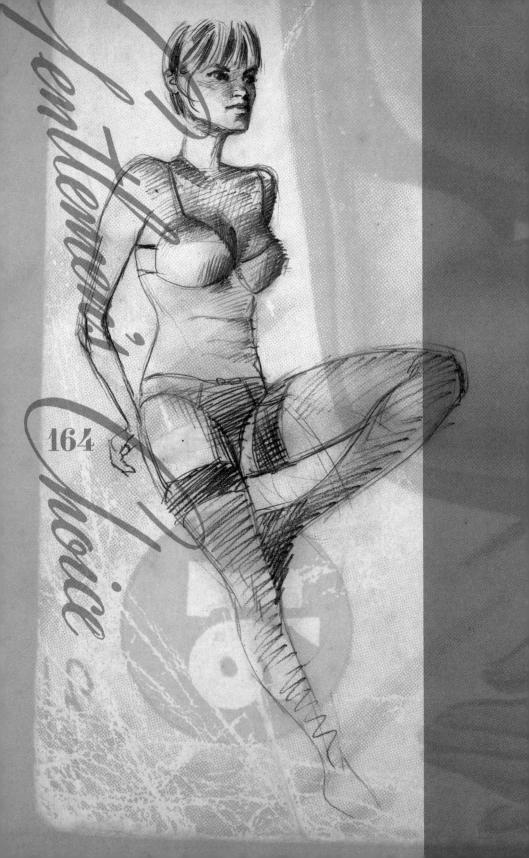

164

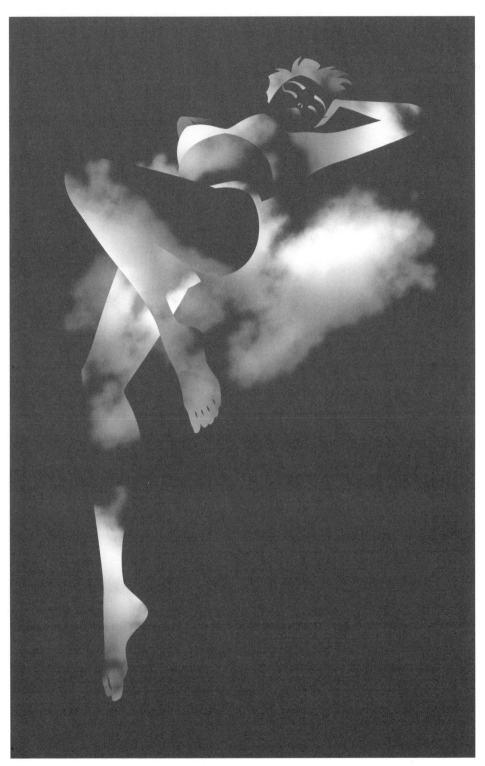

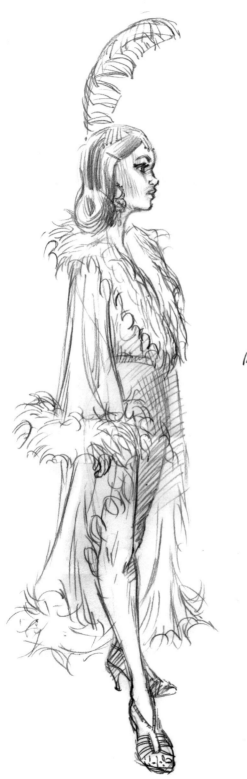

Rian

166

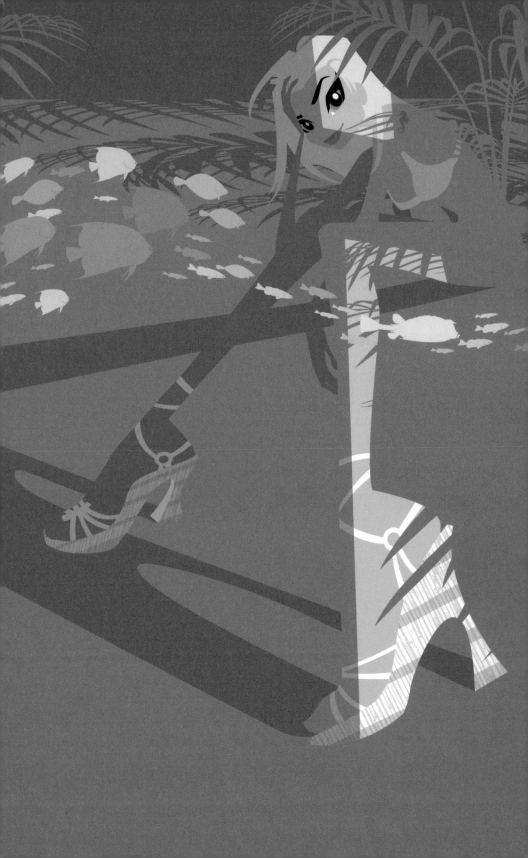

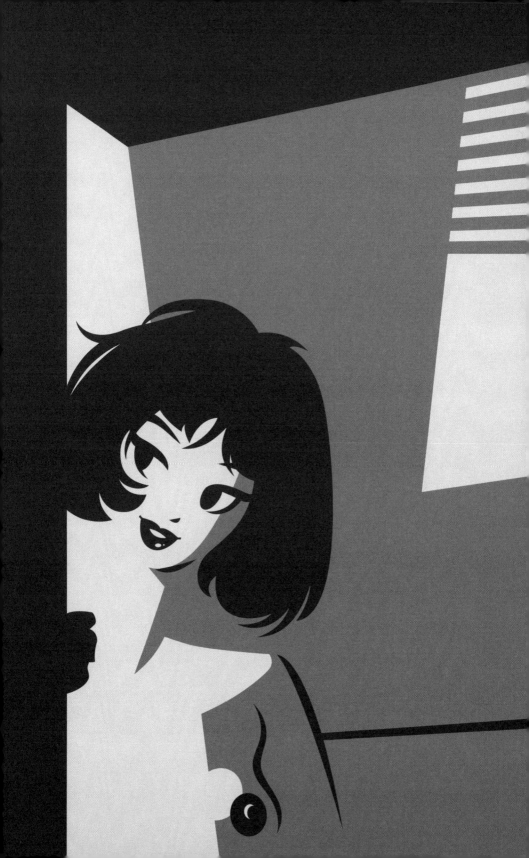

J. Roussel
of Paris

Button High —
Button Low

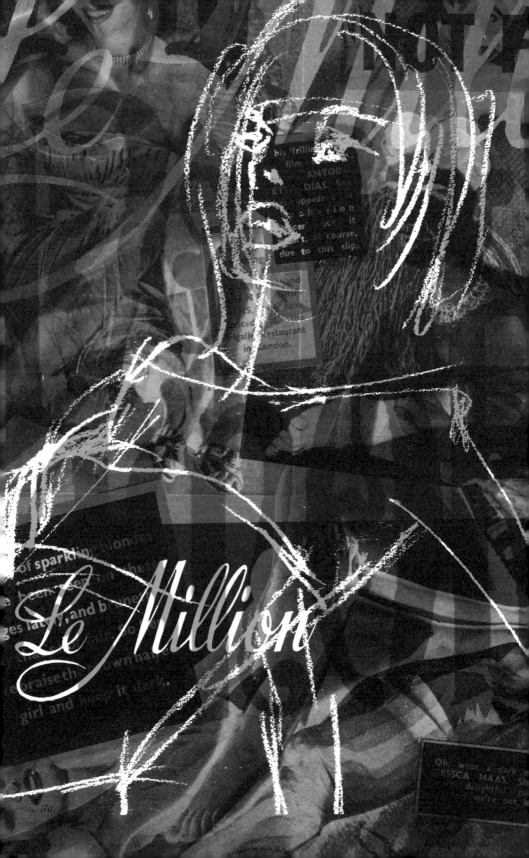

Le Million

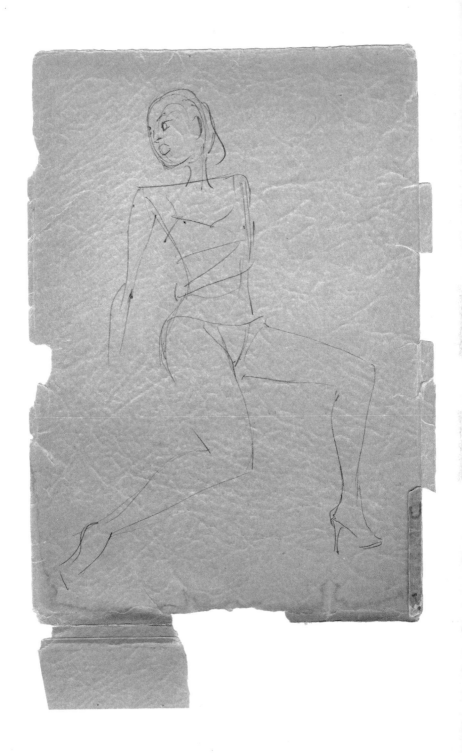

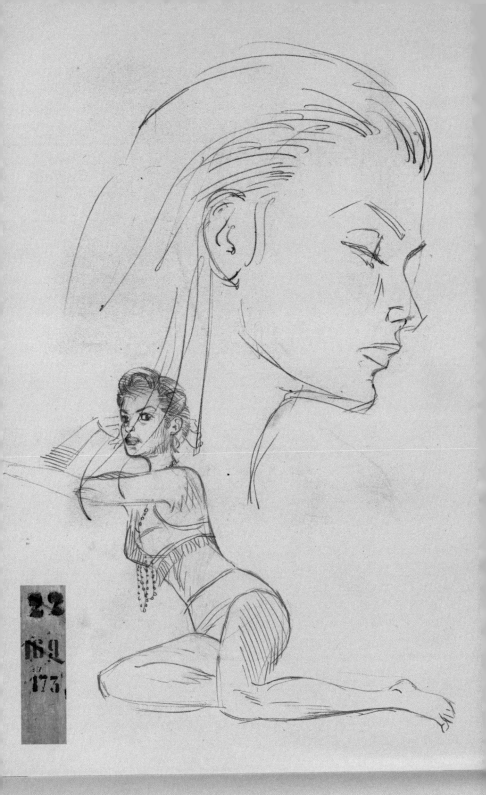

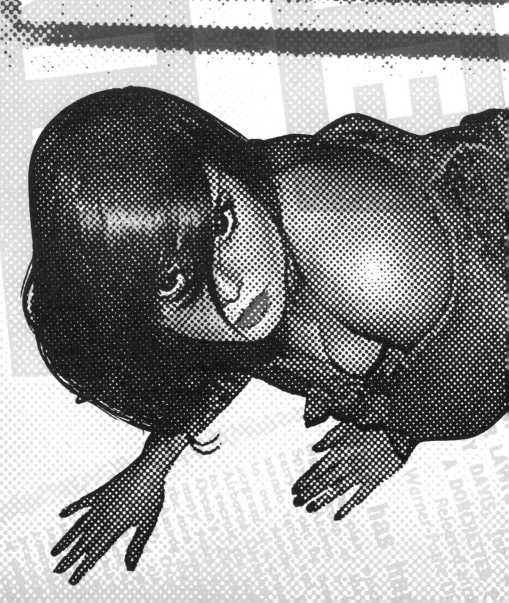

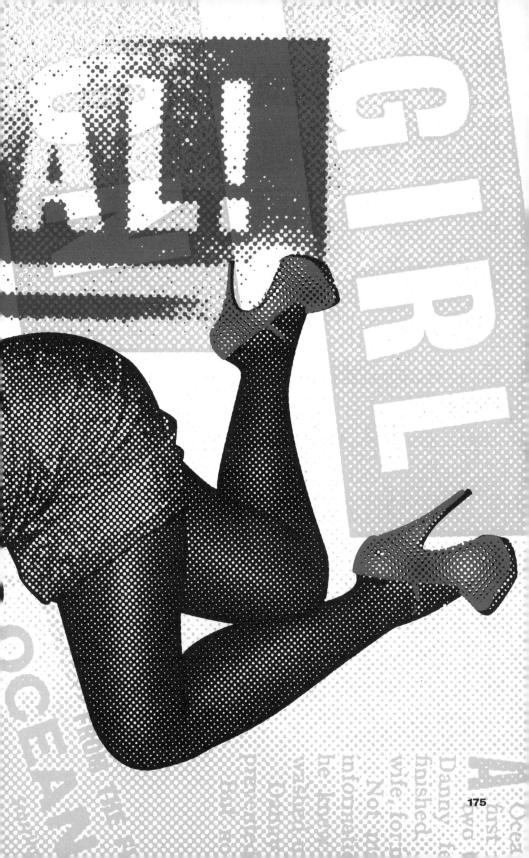

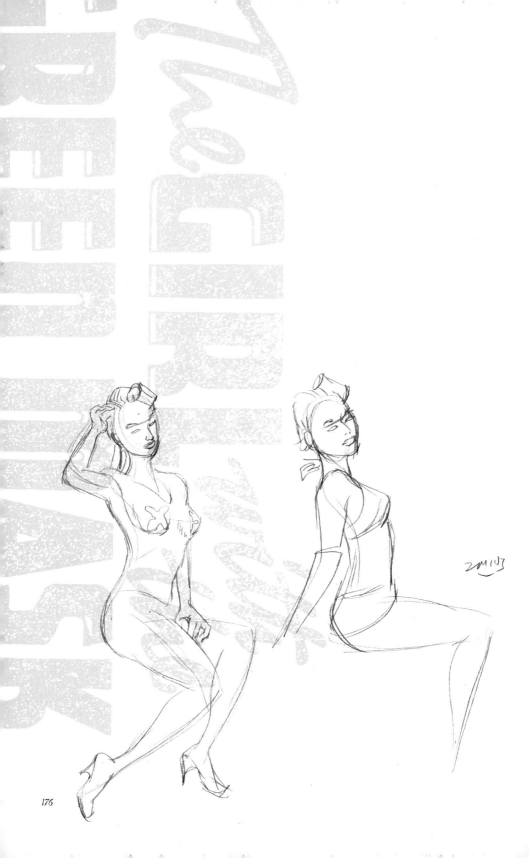

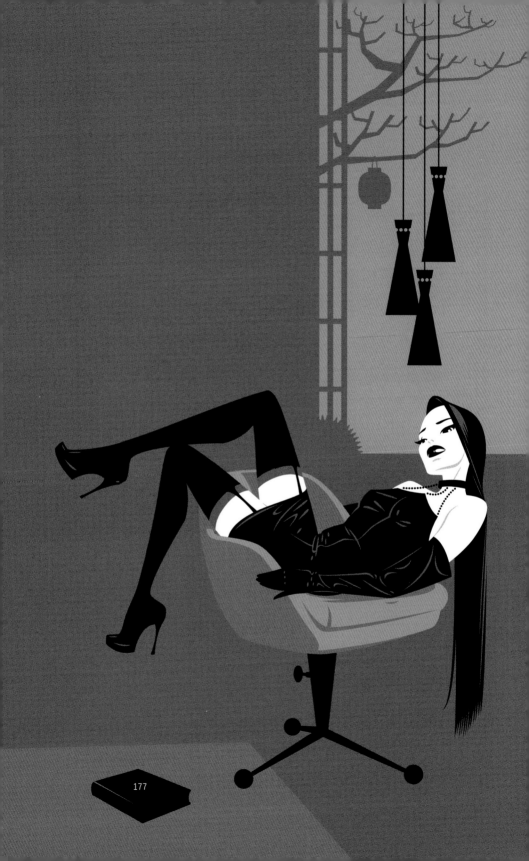

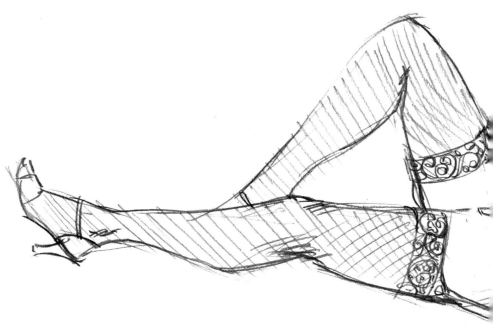

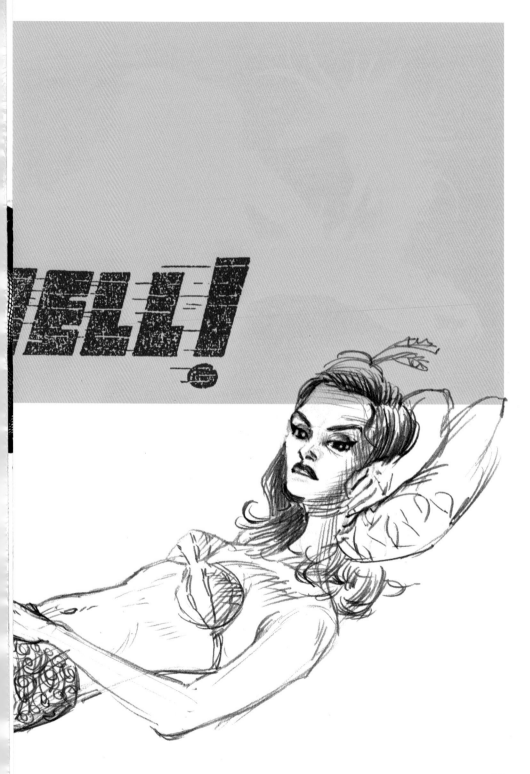

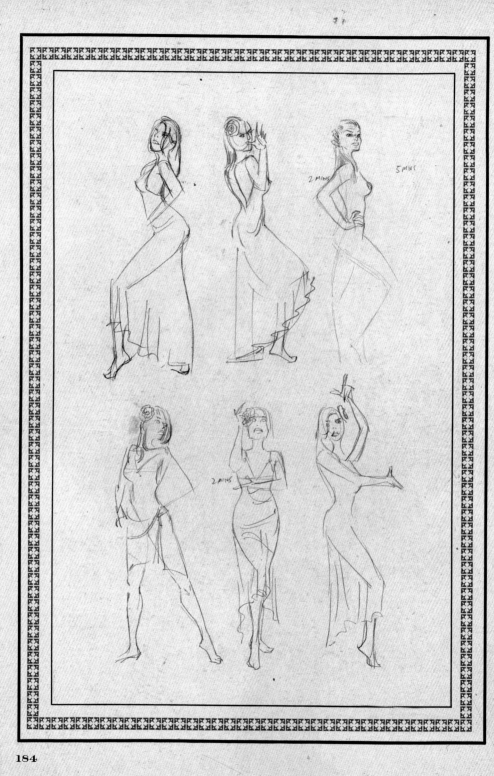

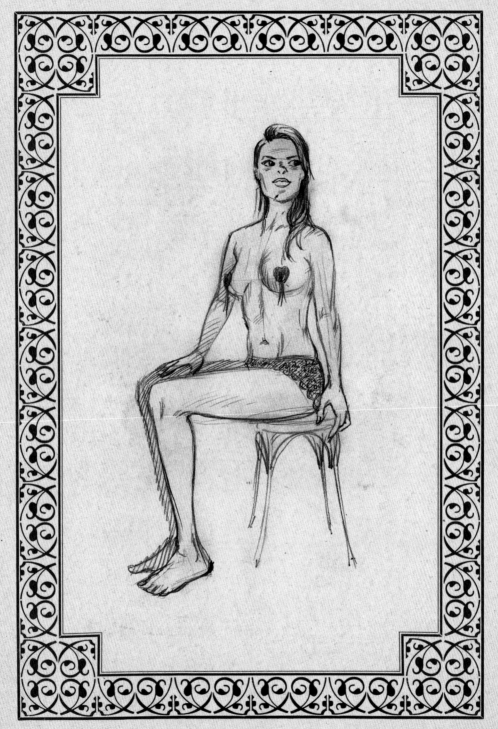

185

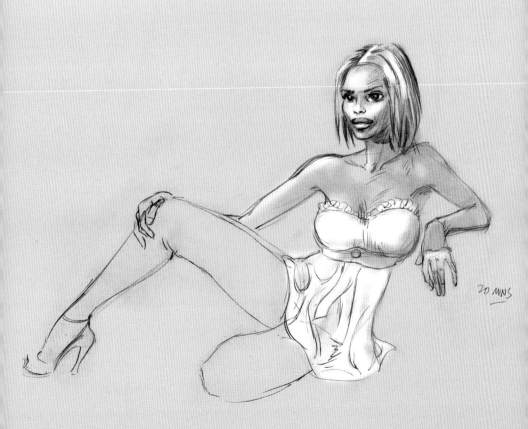

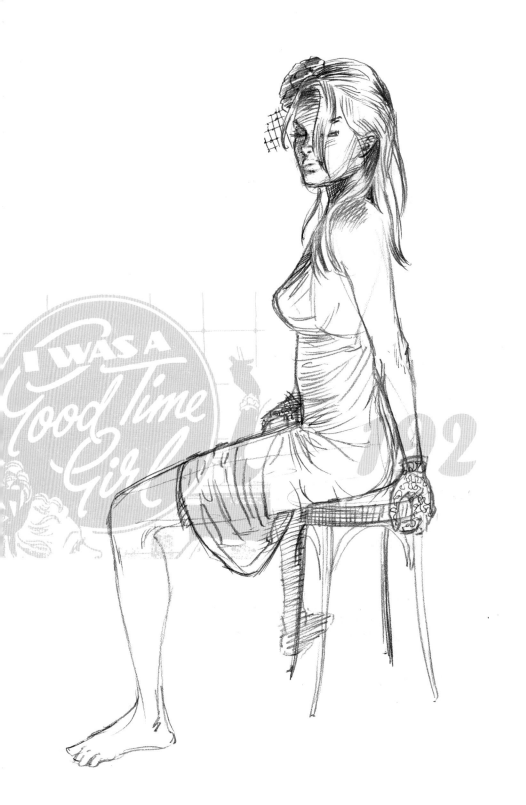

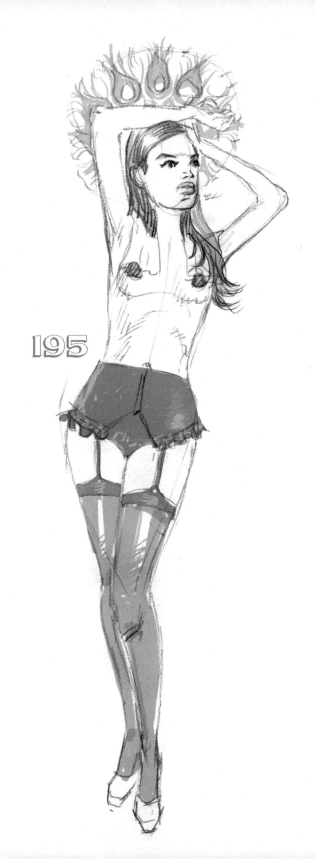

P . 3 .
FANTAISIE
74,245 à 75,204

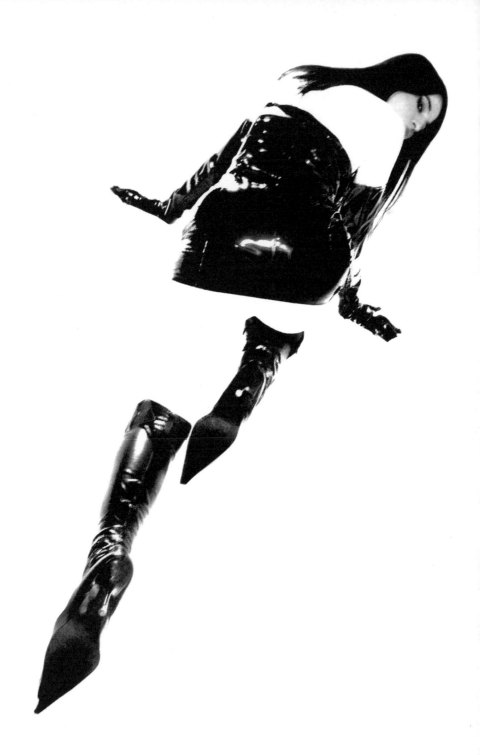

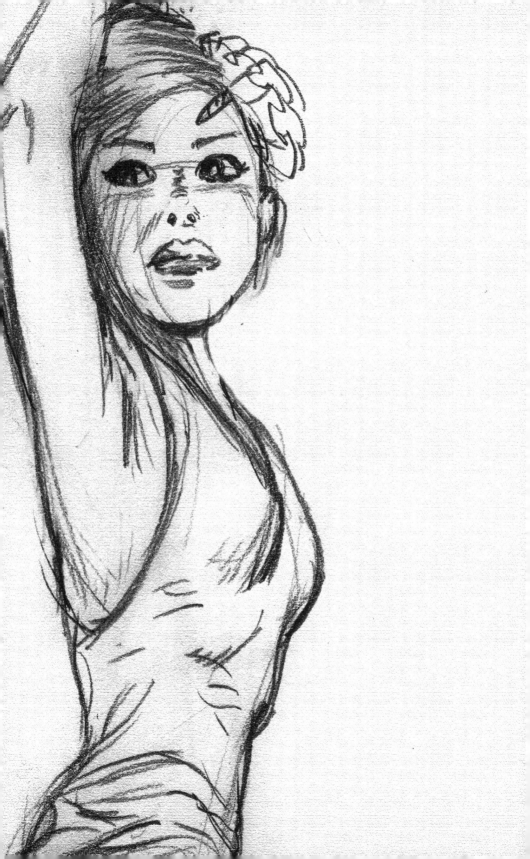

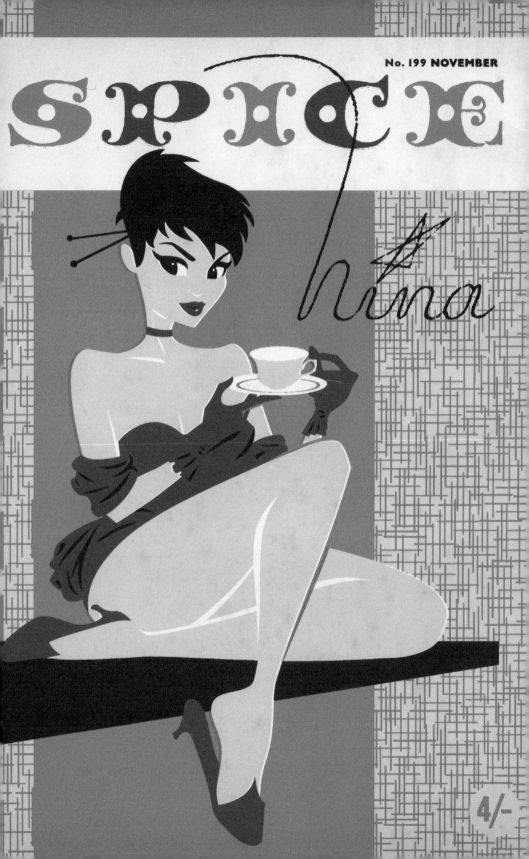

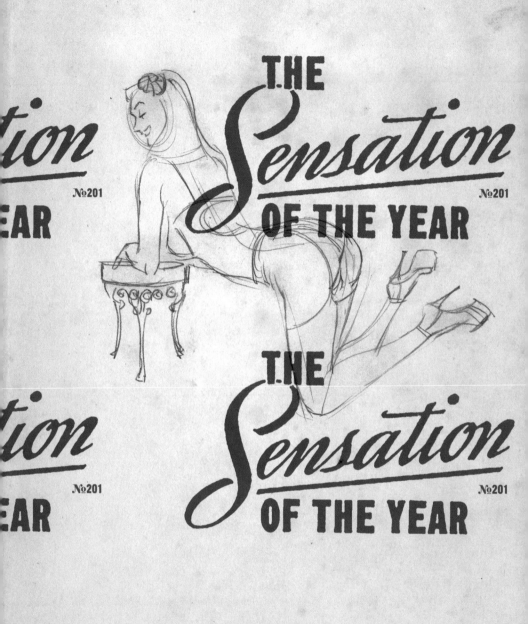

'Private LIVES'

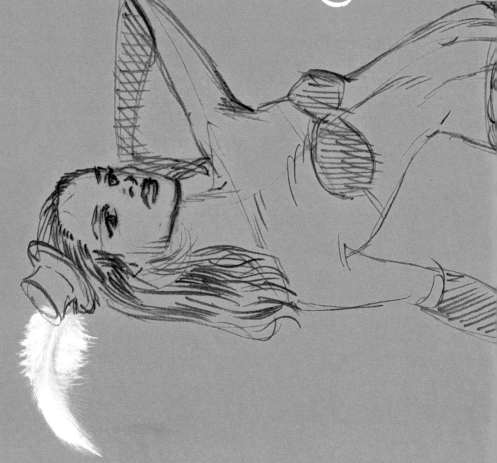

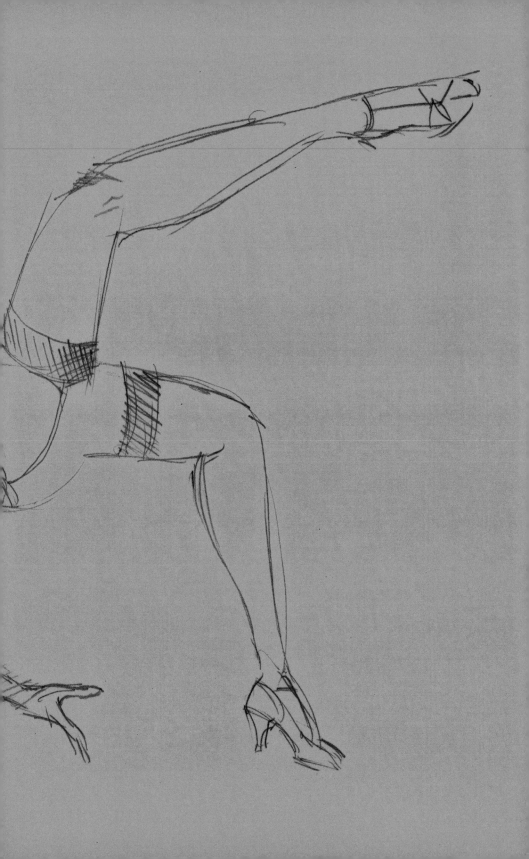

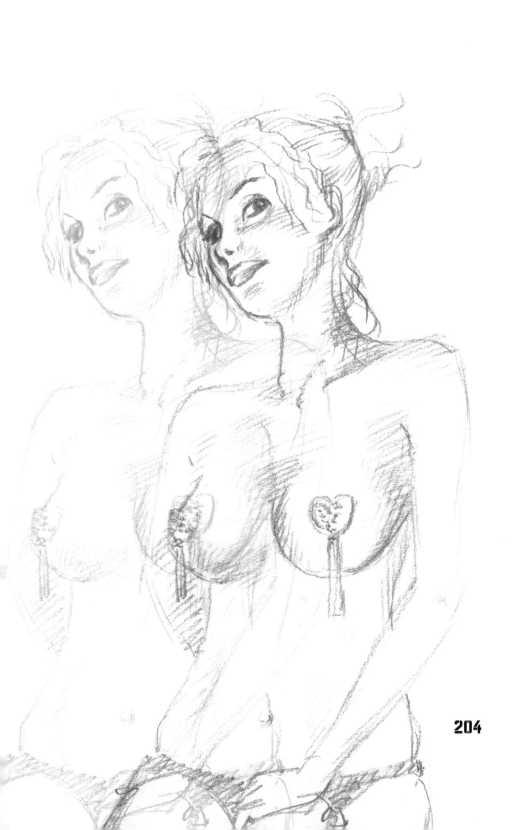

204

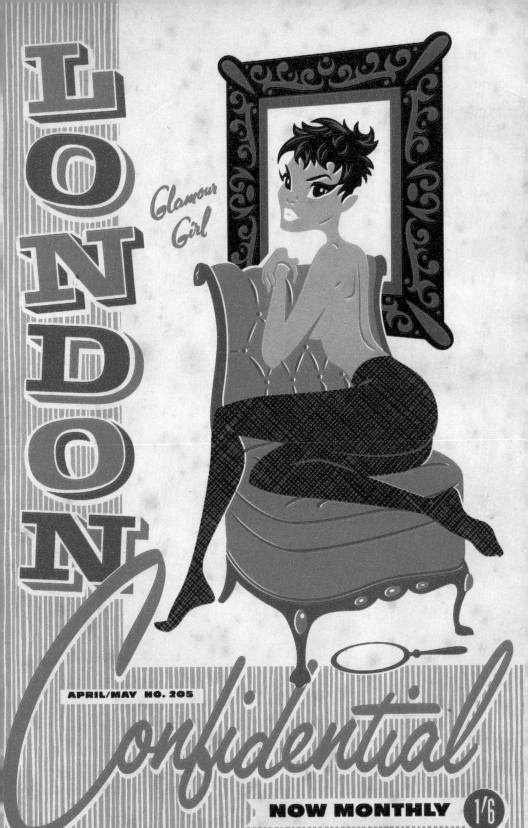

Simple
lice

206

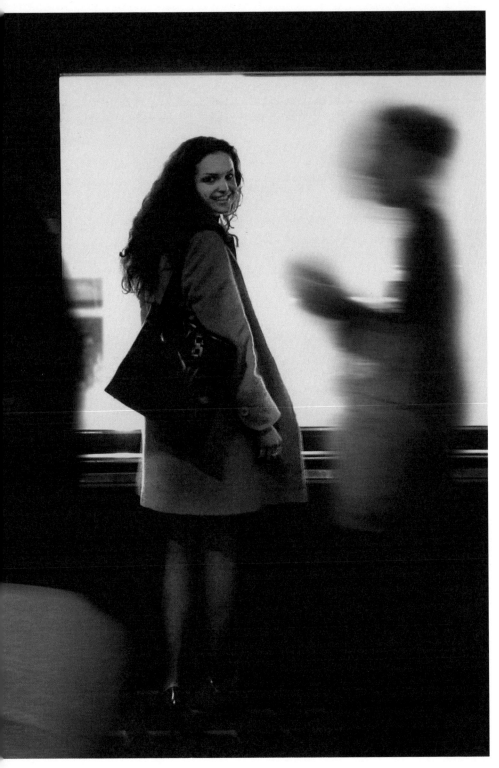

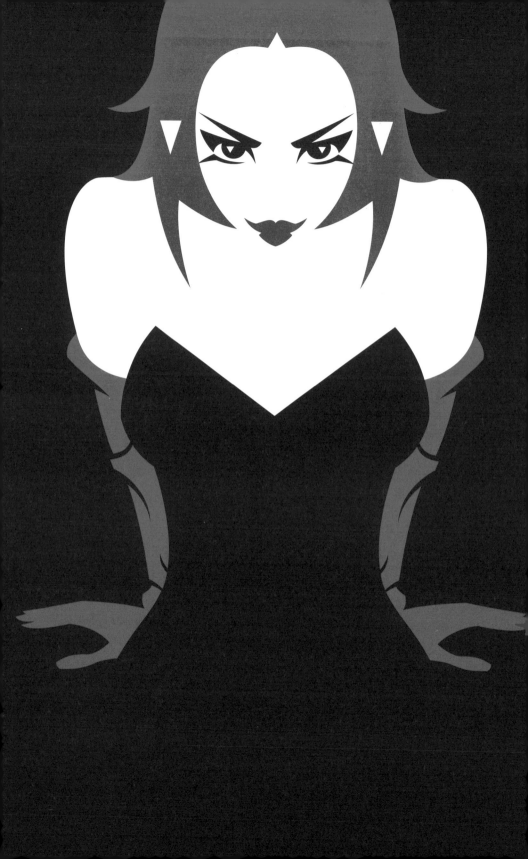

The Latest Dancing Sensation

ISSUE 210

6ᴰ

EVERY WEDNESDAY

Purrfect!

MARCH 4th, 1954

THE NATIONAL FEMININE

Grrr!

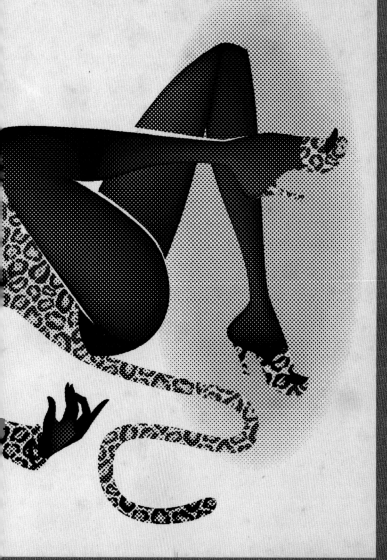

IN THIS ISSUE

FILM SERIAL

THE WEAK and the WICKED

DRAMATIC!
SENSATIONAL!!

Vol 7, No. 5 AUGUST

GLAMOUR

SENSATION

1'-

Man Crazy

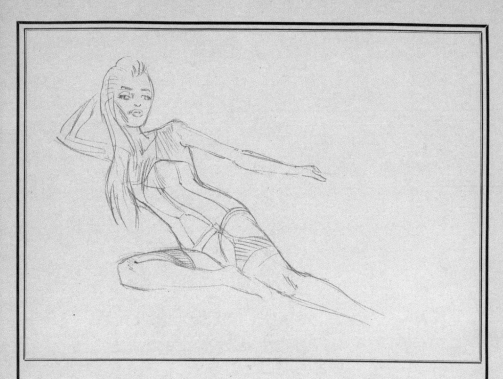

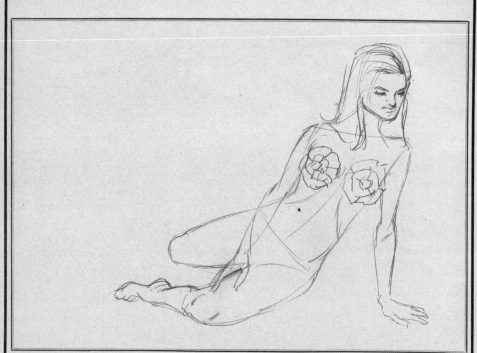

213

1101101100

1101010101

00101011100

01000110101

10101001011

01000110101

011

0101011

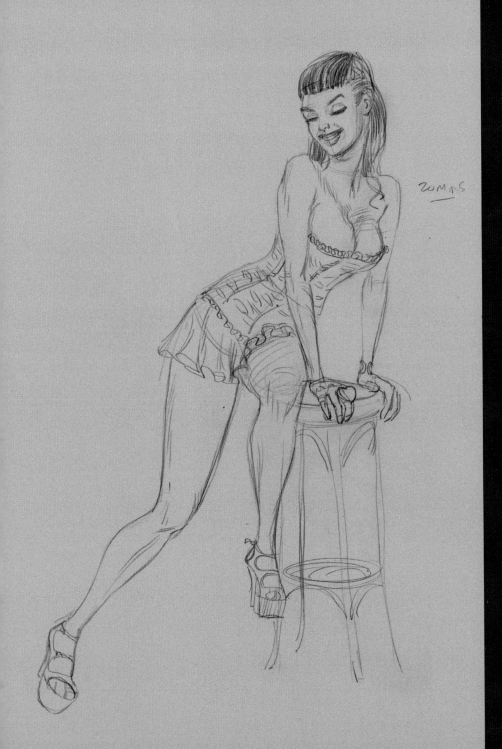

20MNS

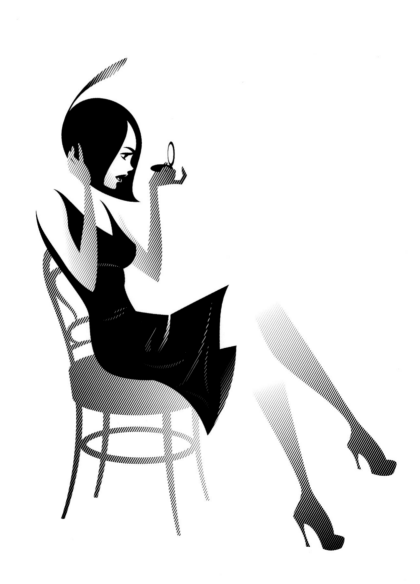

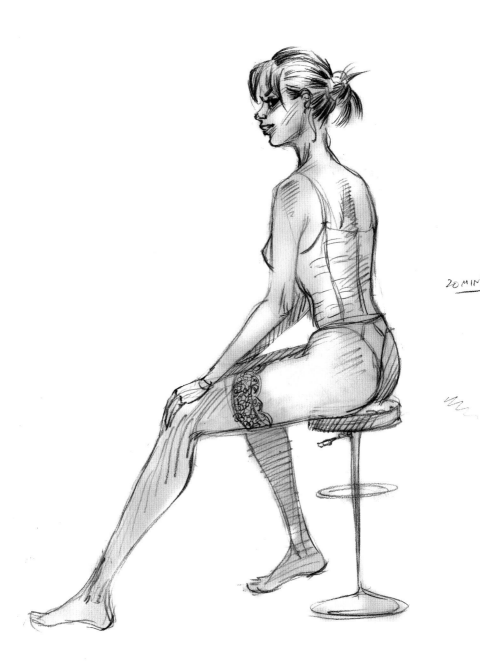

20MINS

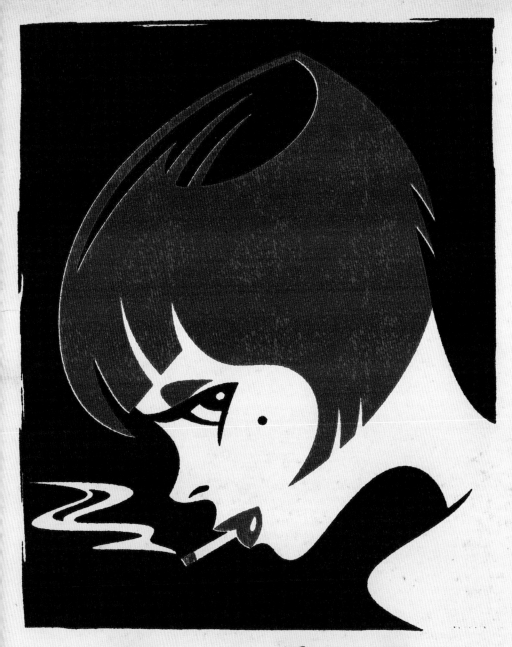

GIGOLETTE

OPERETTA IN TRE ATTI DI CARLO LOMBARDO · GIOVACCHINO FORZANO

MUSICA DI FRANZ LEHÁR

CASA EDITRICE MUSICALE · CARLO LOMBARDO · MILANO VIA ZEBEDIA 11 · TEL. 8-150

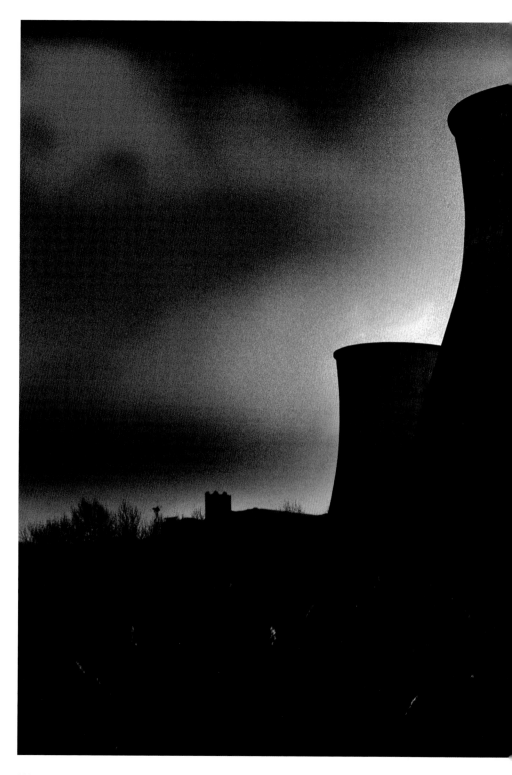

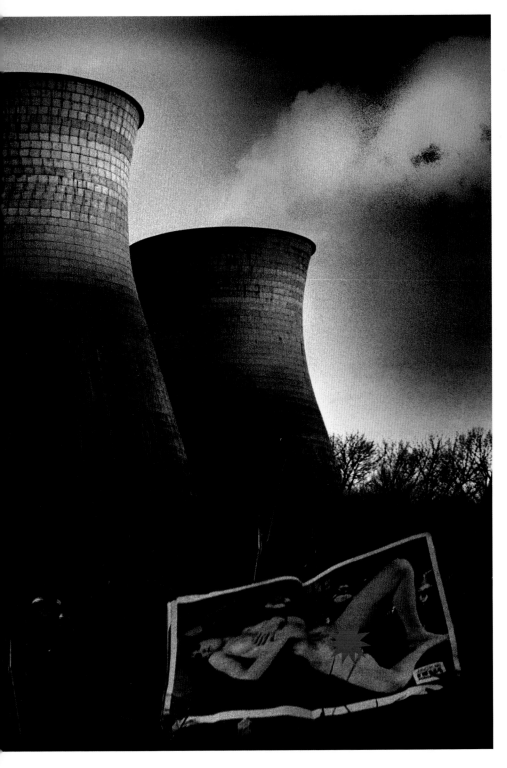

THIS MONTH'S
PIN=UP

2min

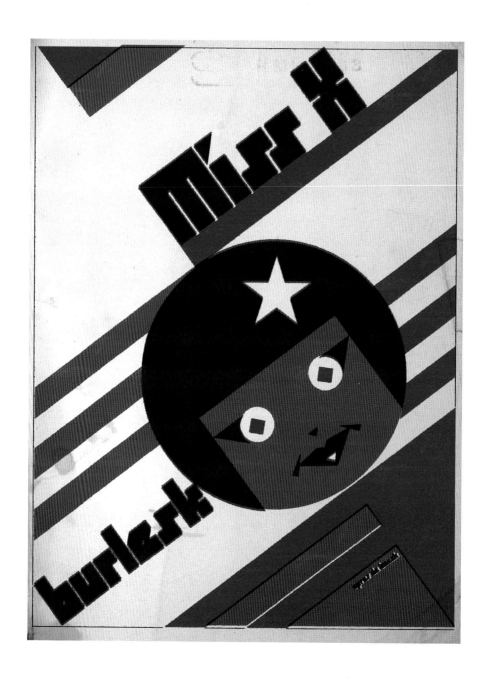

224

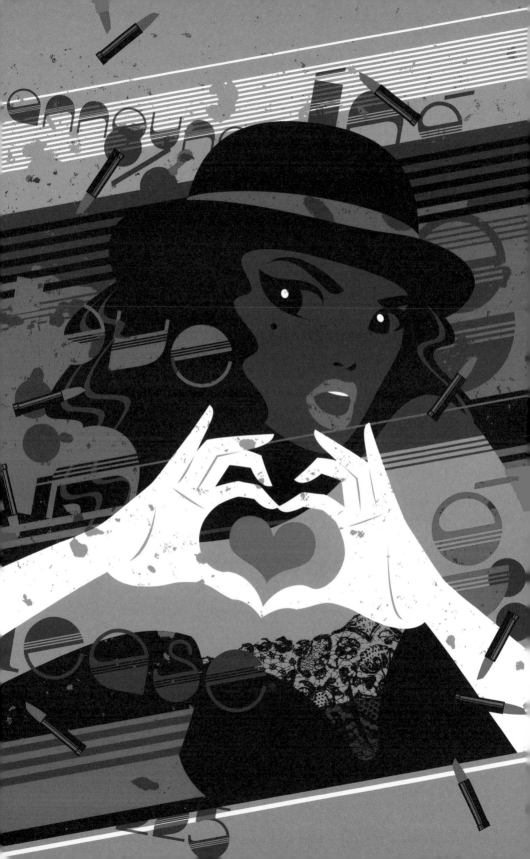

Stocking
the
Stocking

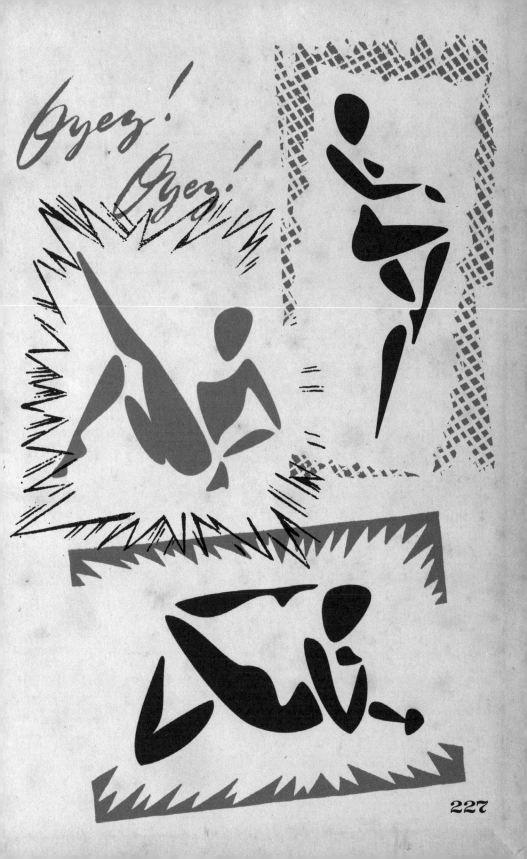

227

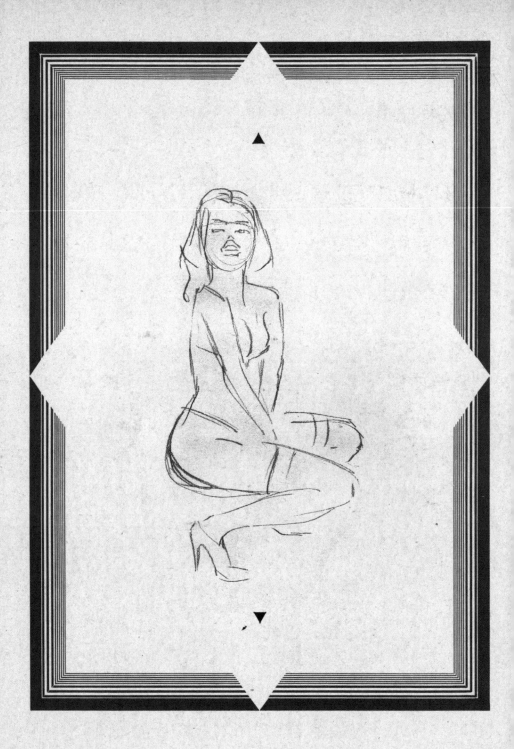

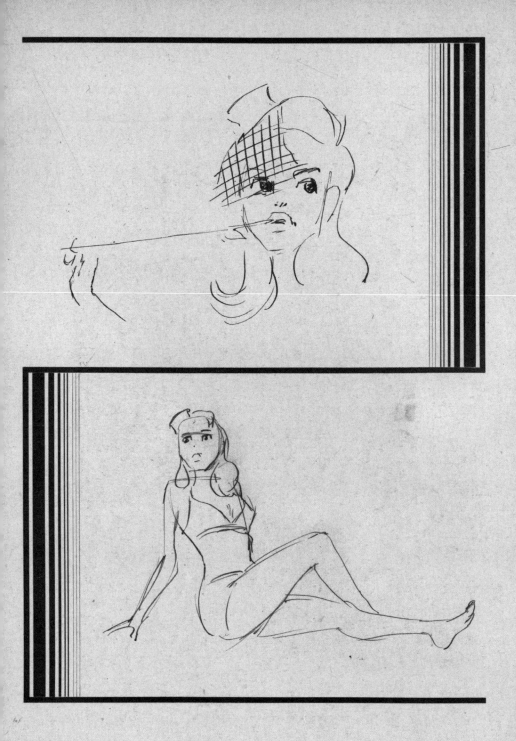

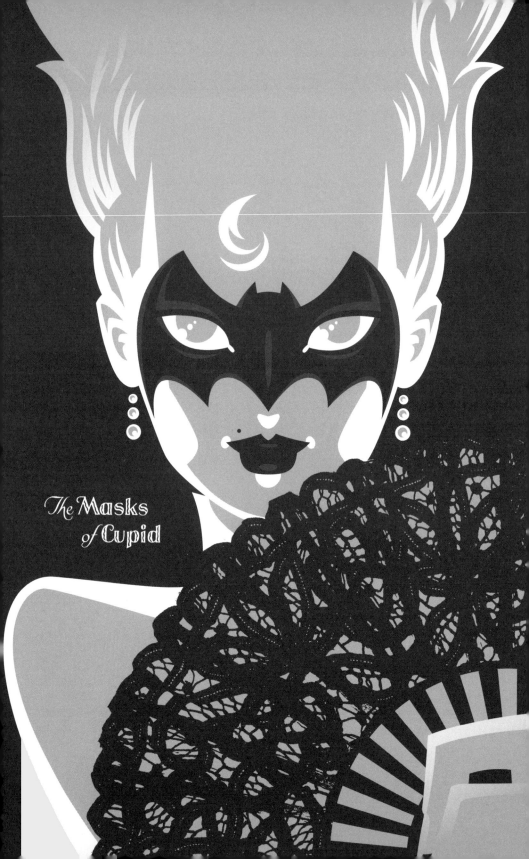

The Masks
of Cupid

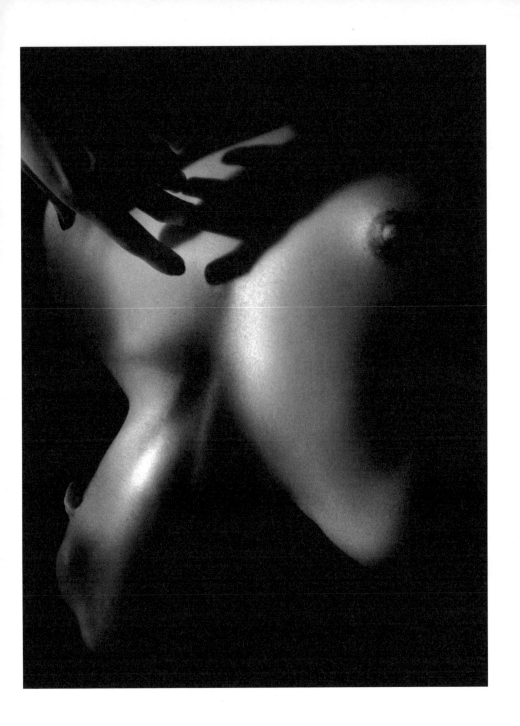

231

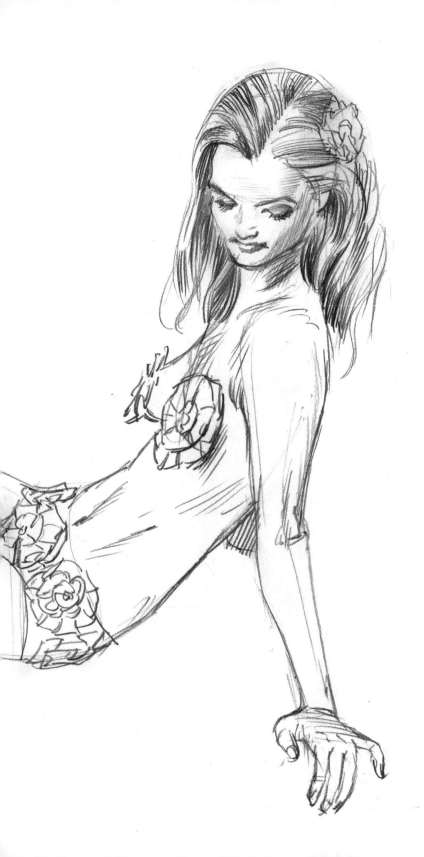

233

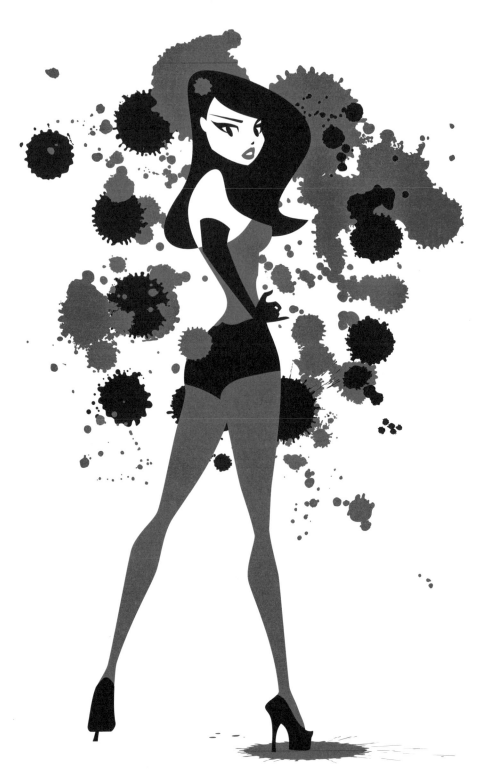

SEPTEMBER • ISSUE 235 52 PAGES • A 'TITILLATING' PUBLICATION

YOWZA!

YOWZA

Inside: **GIRL ROULETTE**

PHOTO-STORY:
Lost Island of Man-Stealing Amazons

STRIPTEASE

Burlesque-a-gogo

EXPOSED!
Sin in the Suburbs

ONLY
3/-

This month's cover girl:
GABY

PIN-UPS ✱ STORIES ✱ CARTOONS

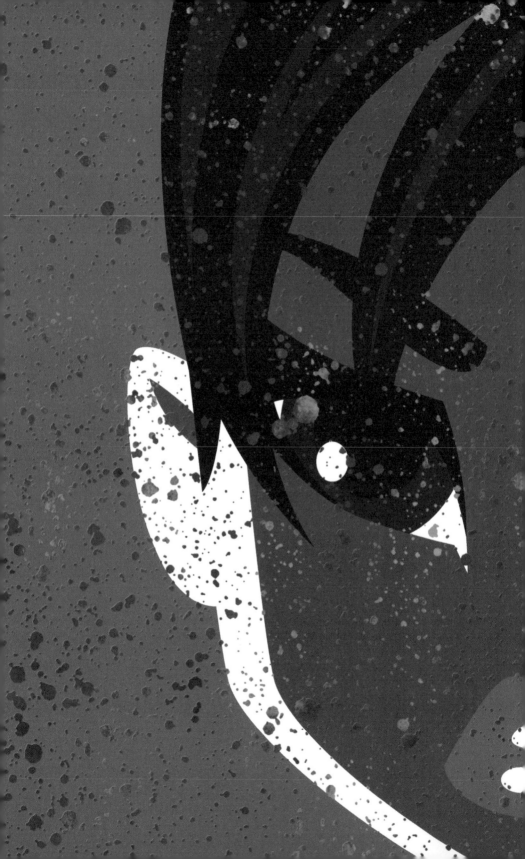

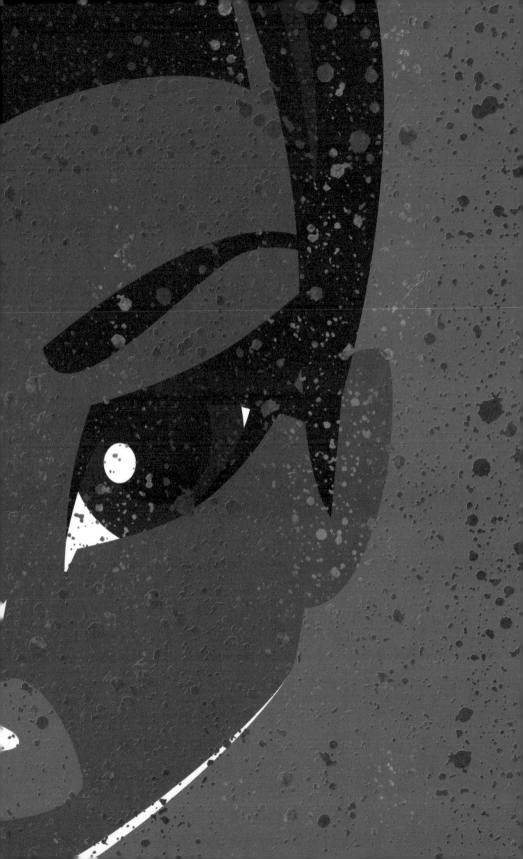

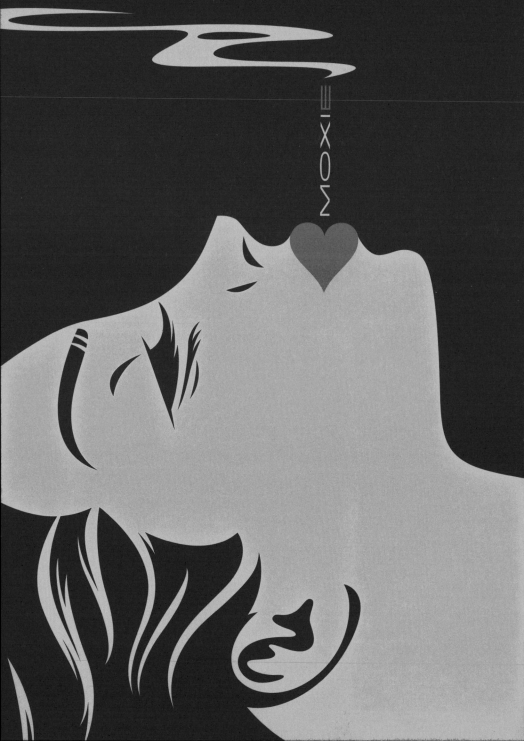

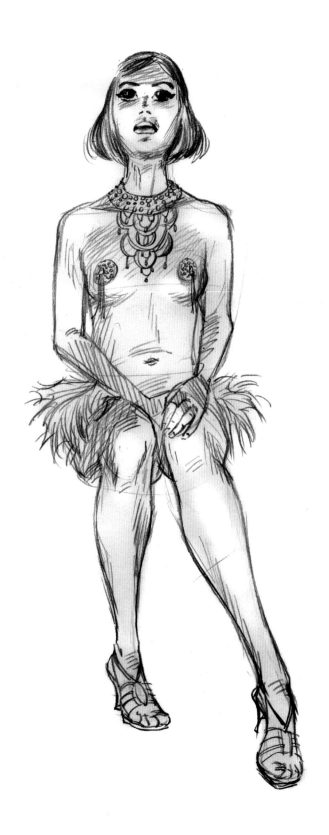

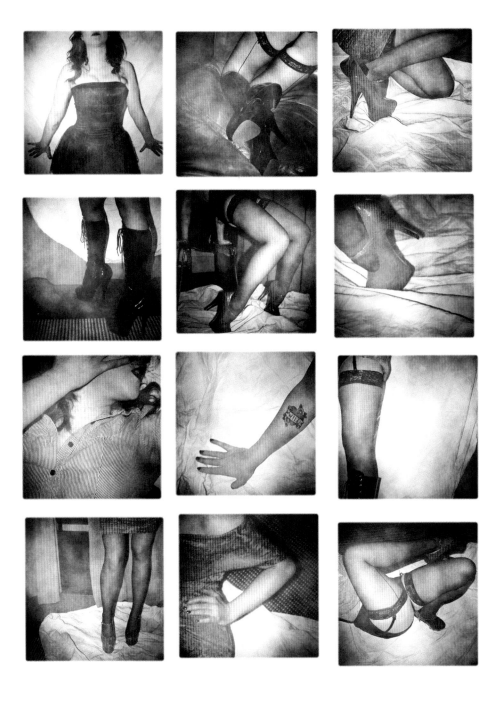

242

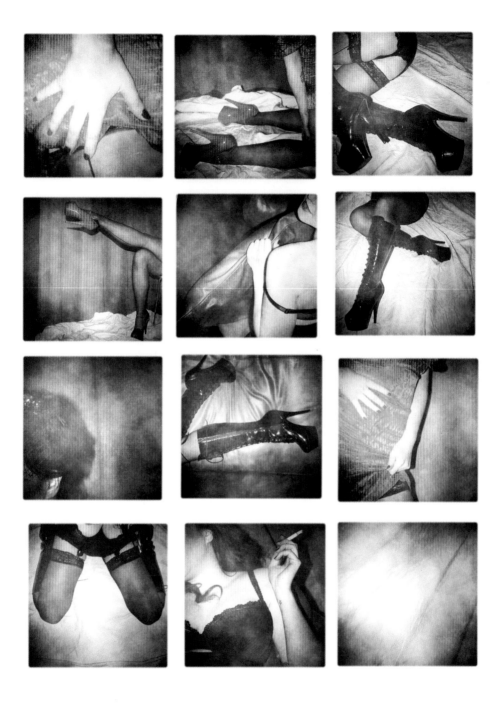

243

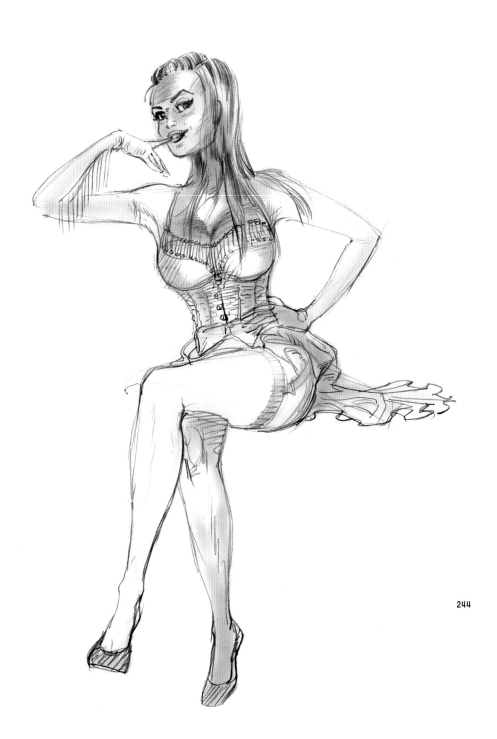

244

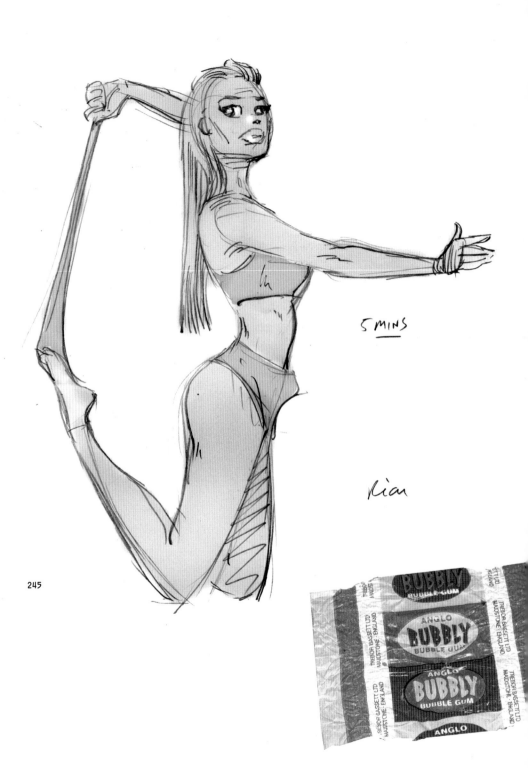

5 MINS

Ria

245

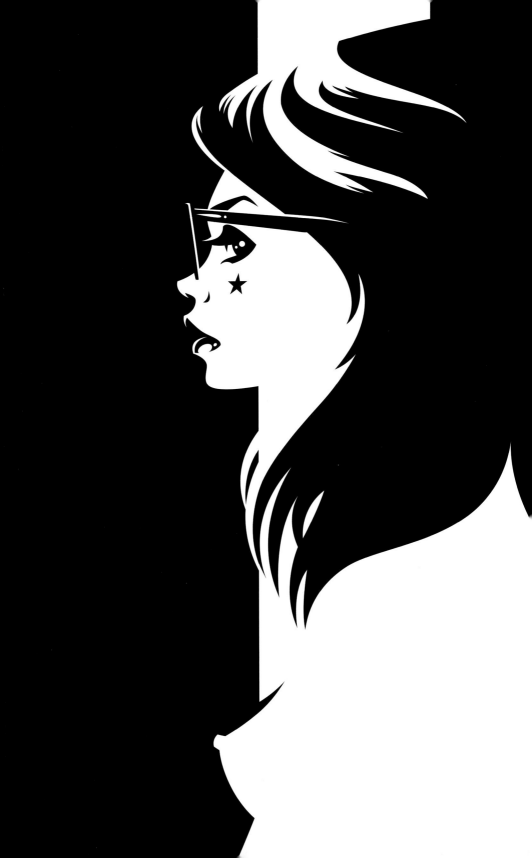

ISSUE 247 MAY 5/-

MODERN LIVING FOR THE DISCERNING GENTLEMAN

bachelorpad

THE CAD in PARIS
PHOTOGRAPHY for GENTLEMEN
JAZZ... NICE!
BOOTLEG BURLESQUE

This issue's COVER STAR:
SIENA SIXPENCE

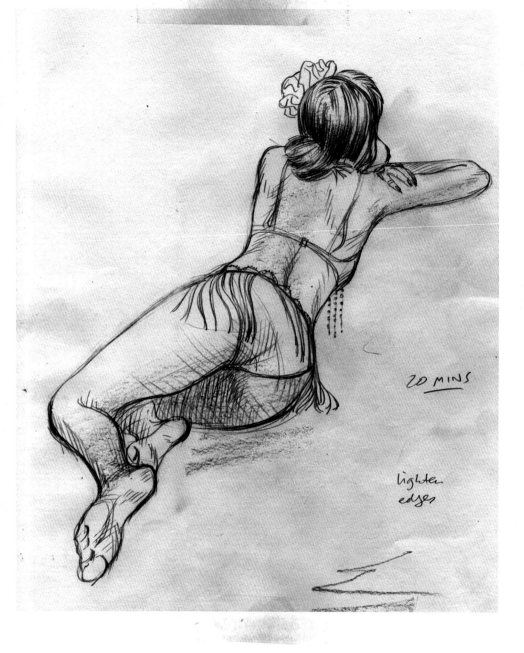

20 MINS

lighter
edges

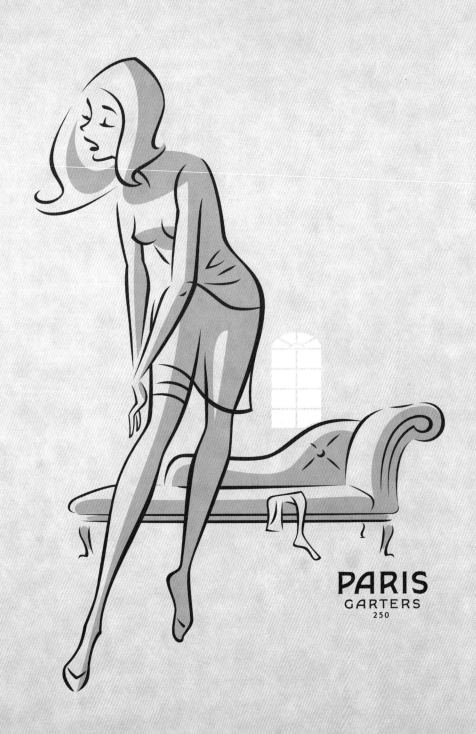

PARIS
GARTERS
250

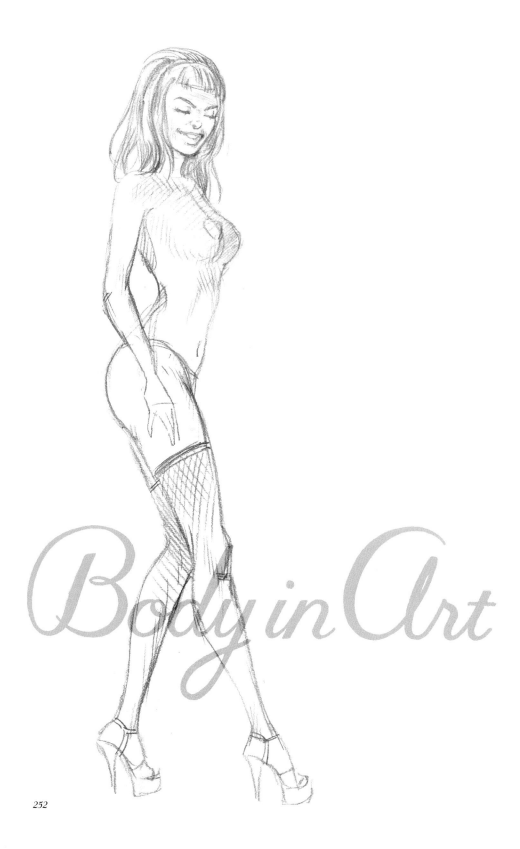

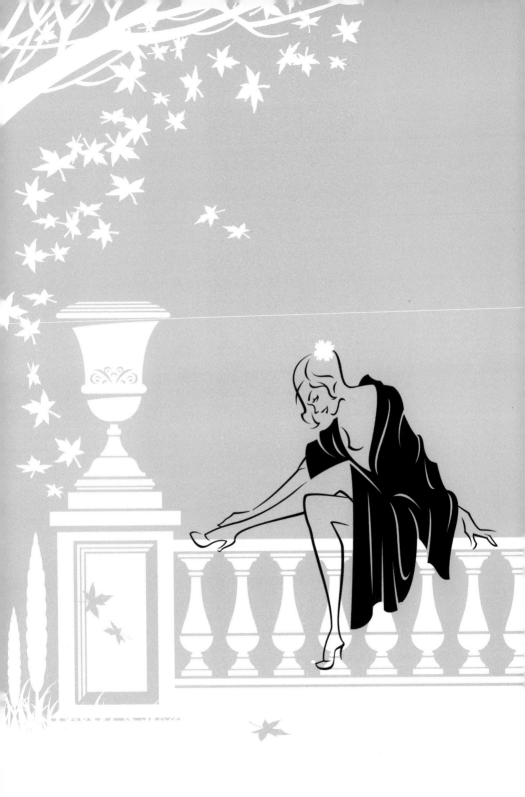

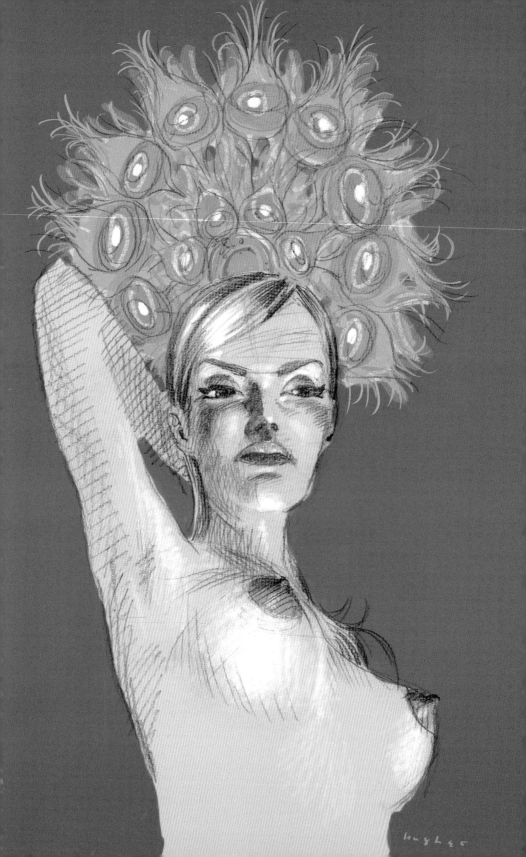

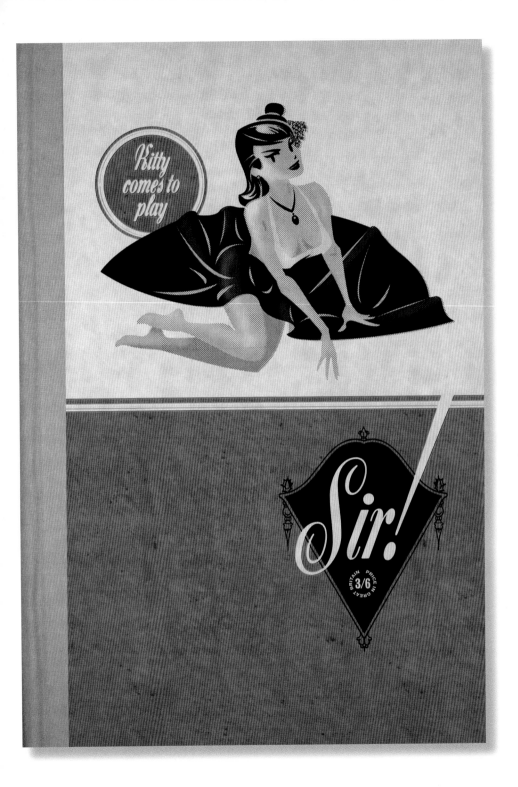

Kitty comes to play

Sir!

3/6 PRICE IN GREAT BRITAIN

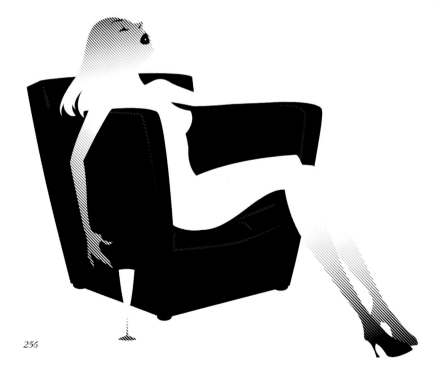

LOST SOULS IN BOHEMIA

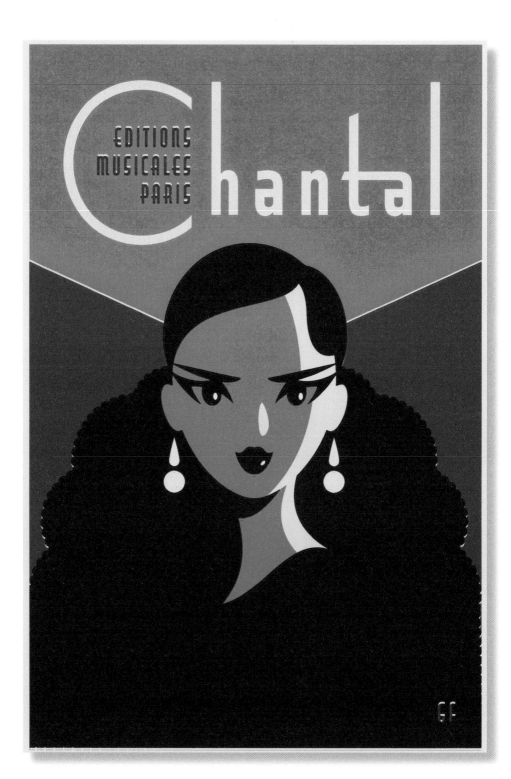

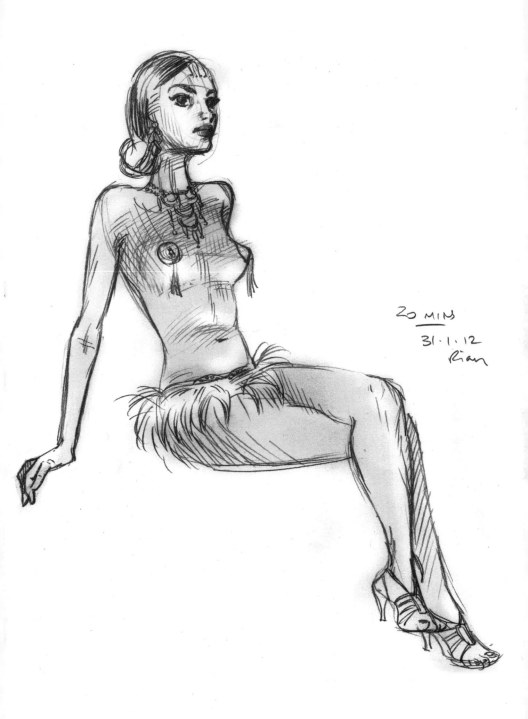

20 MINS
31·1·12
Rian

260

Nyloned

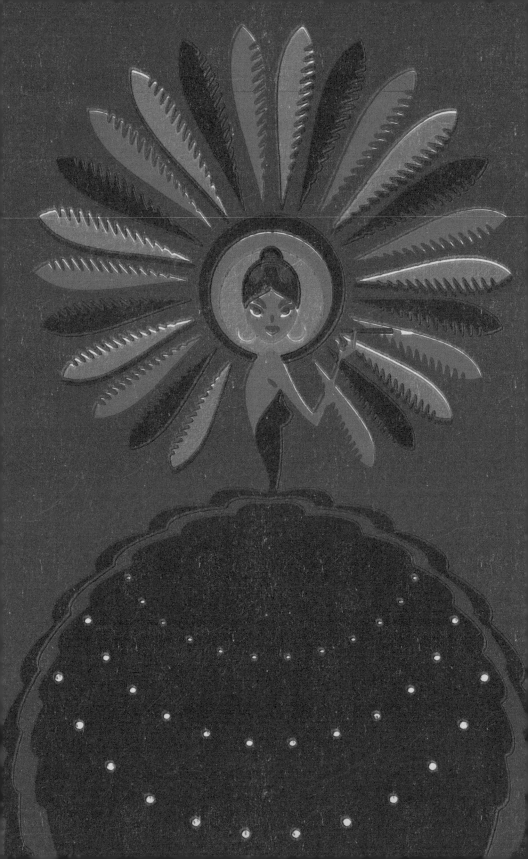

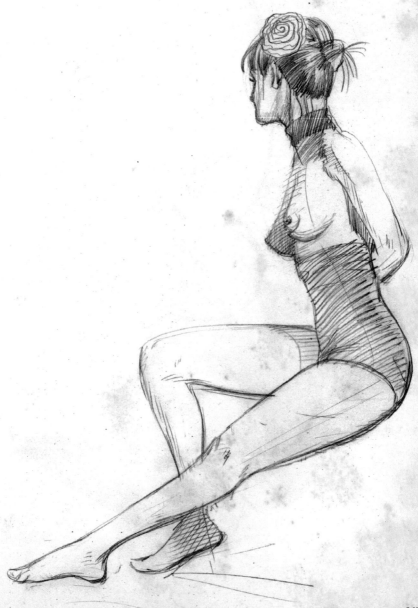

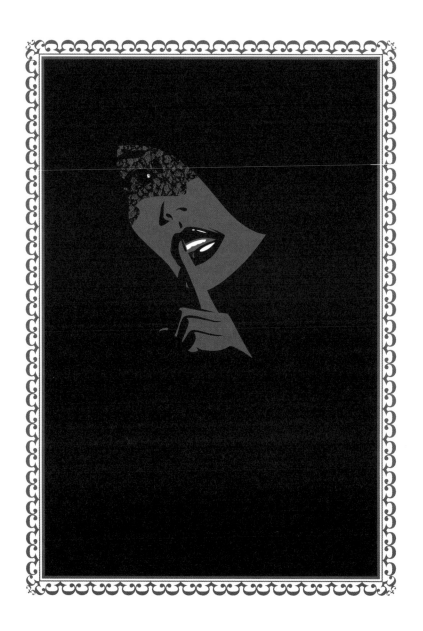

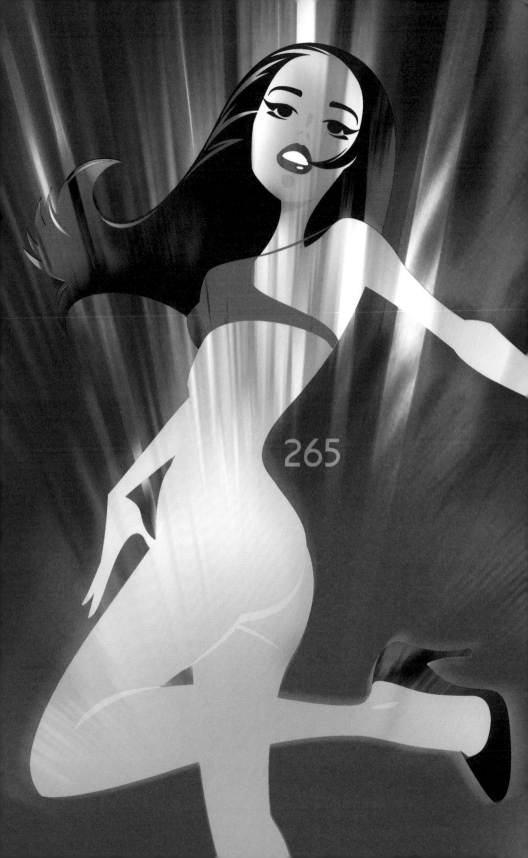

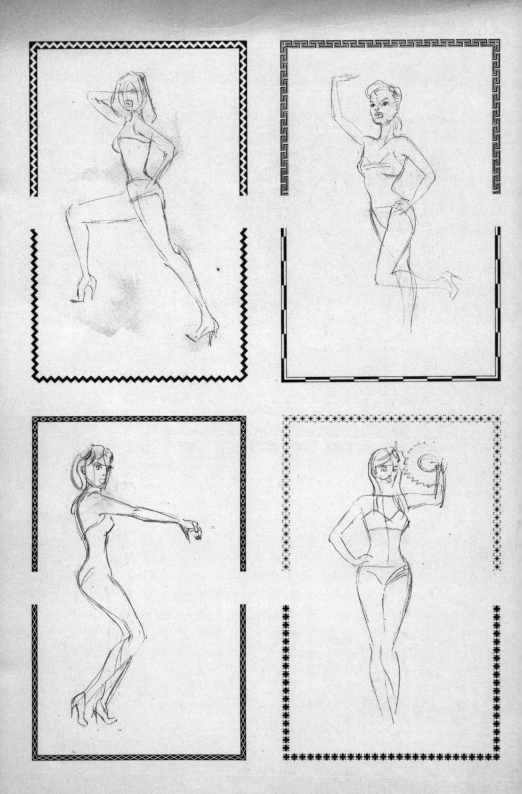

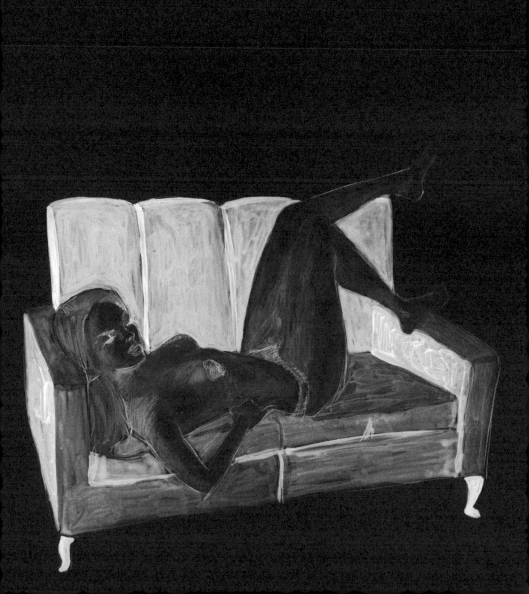

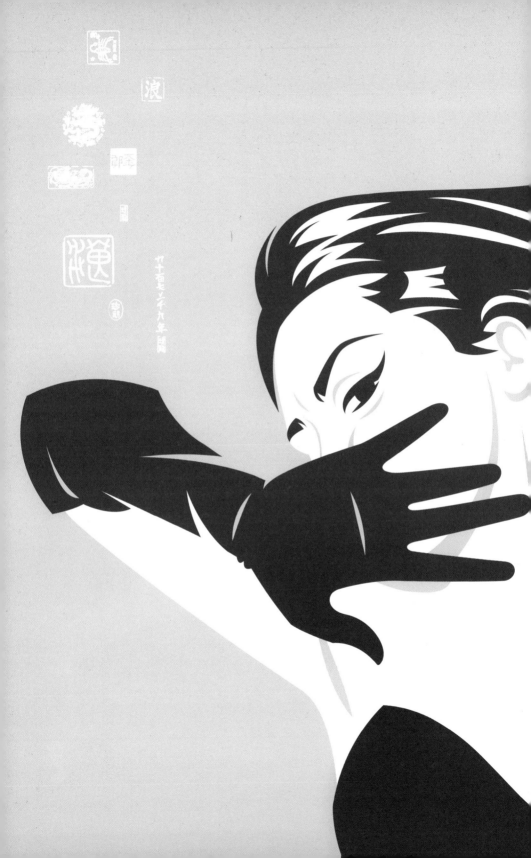

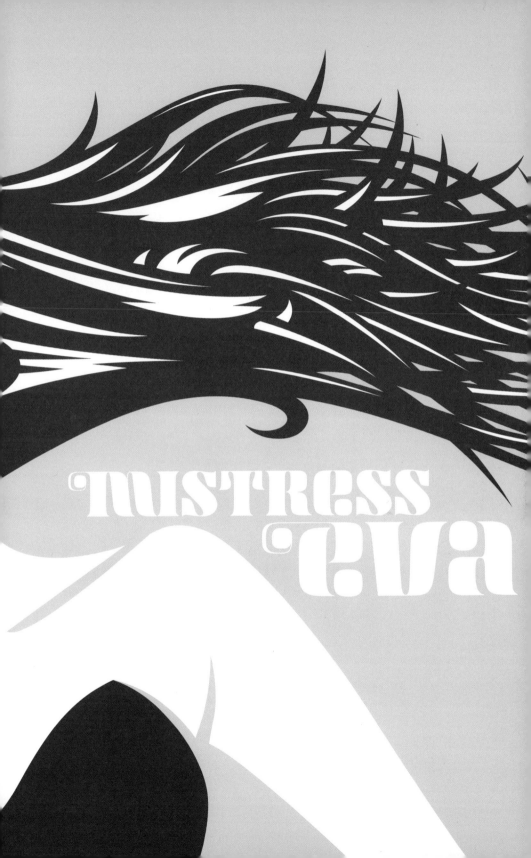

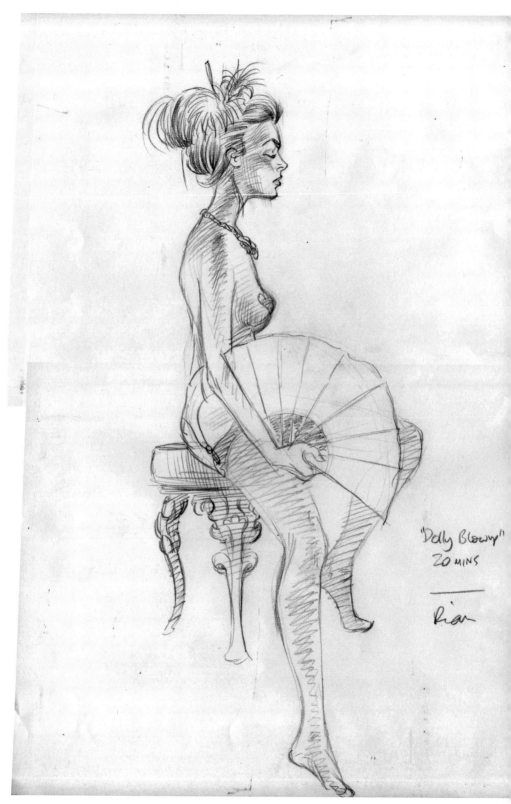

"Dolly Blowey"
20 MINS
———
Rian

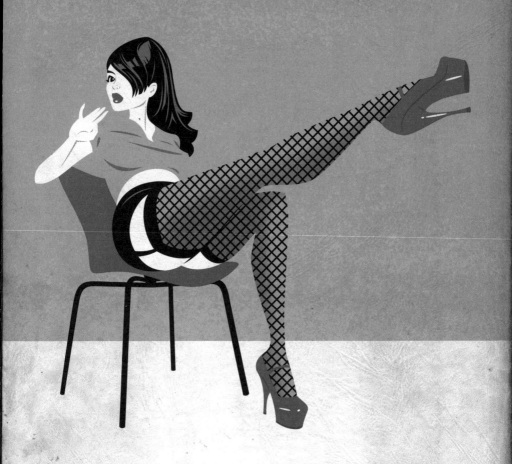

SECRET
Invitation 271

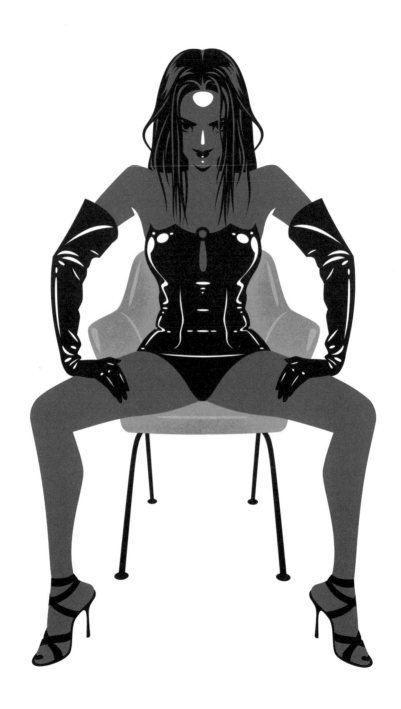

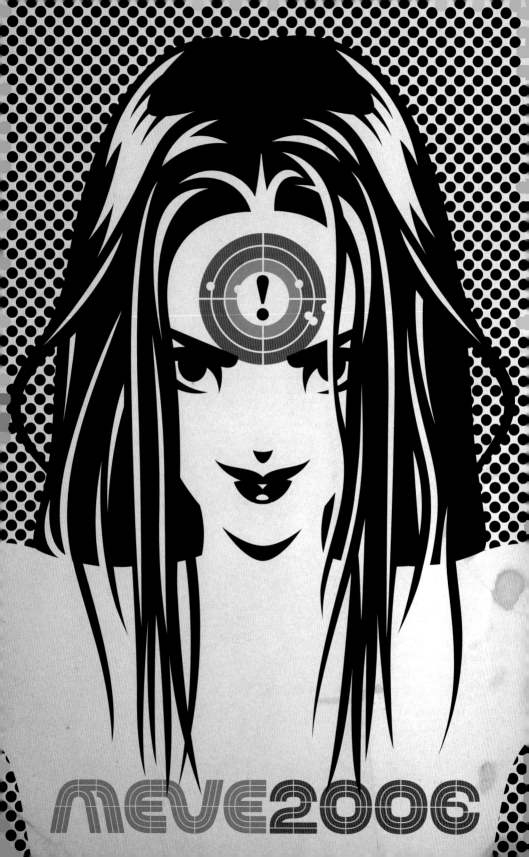

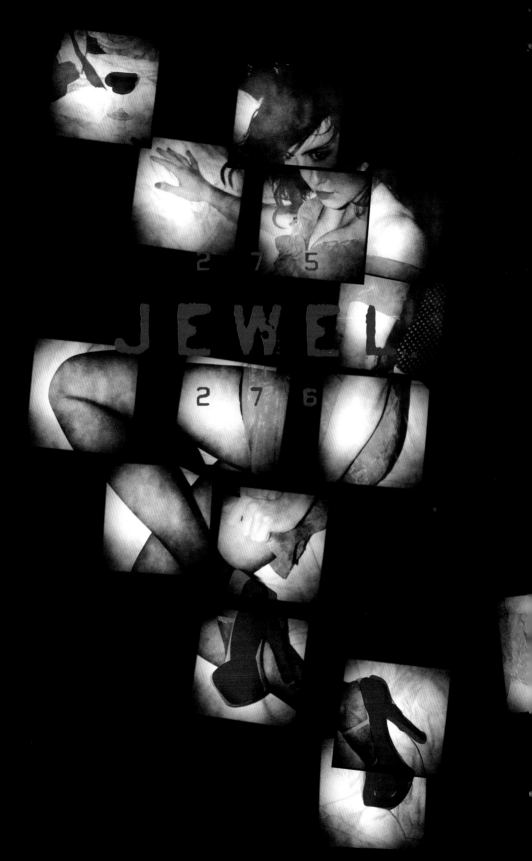

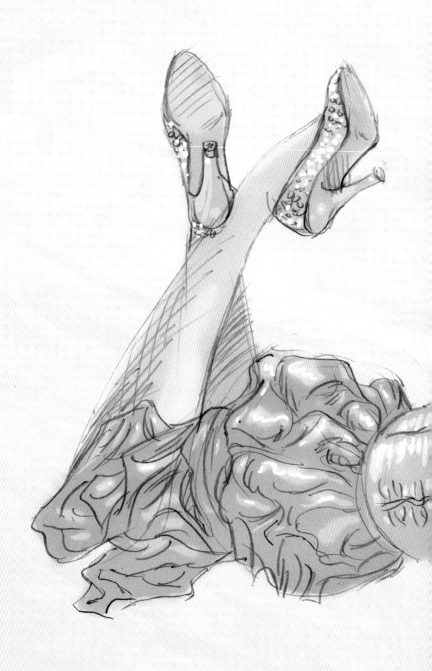

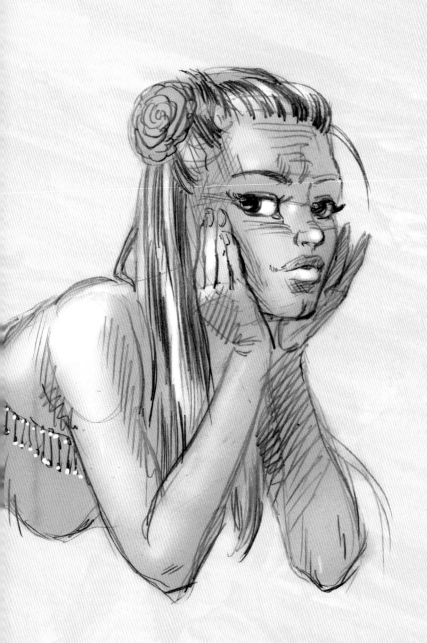

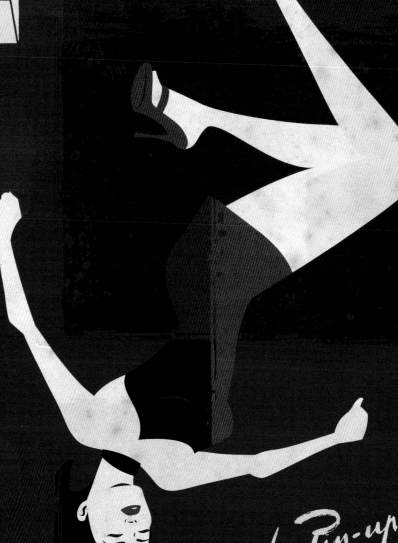

La Pin-up

DÉSHABILLABLE

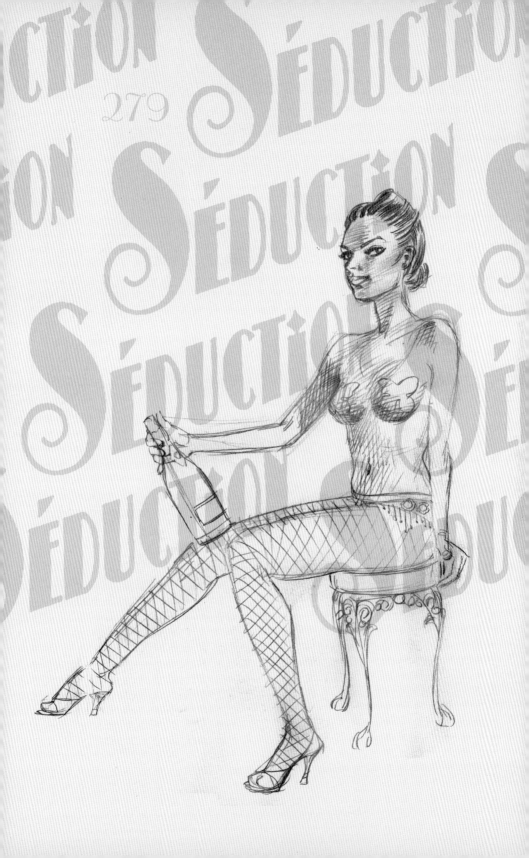

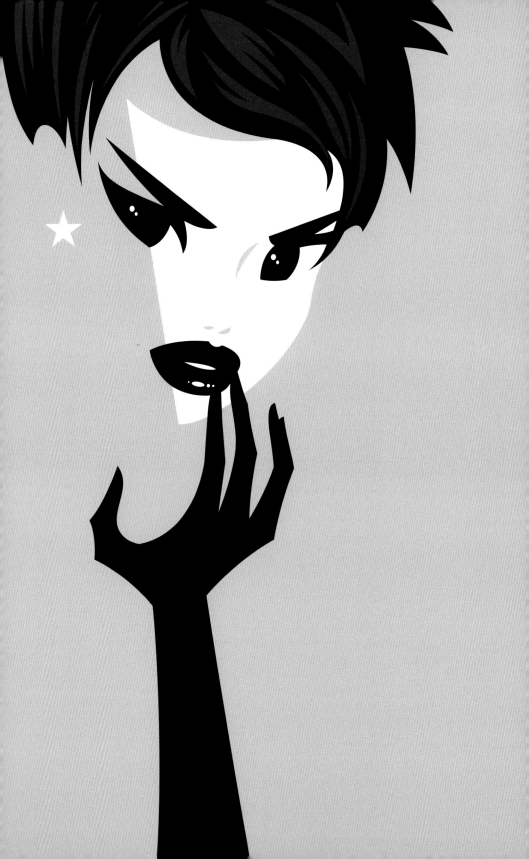

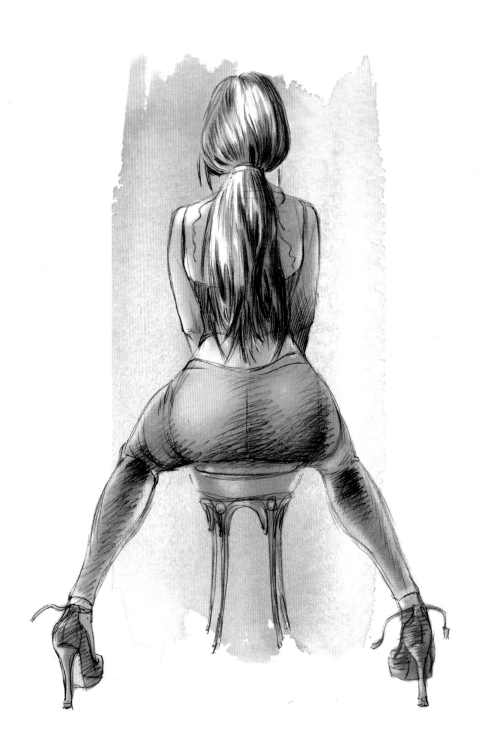

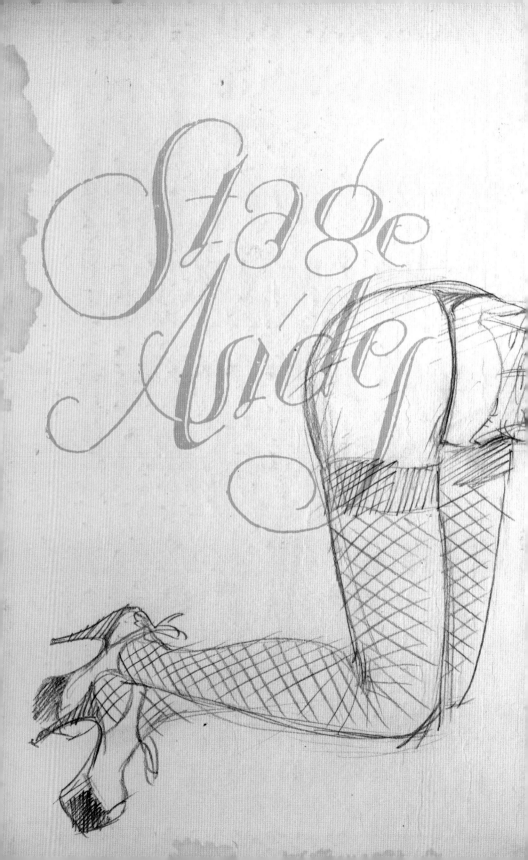

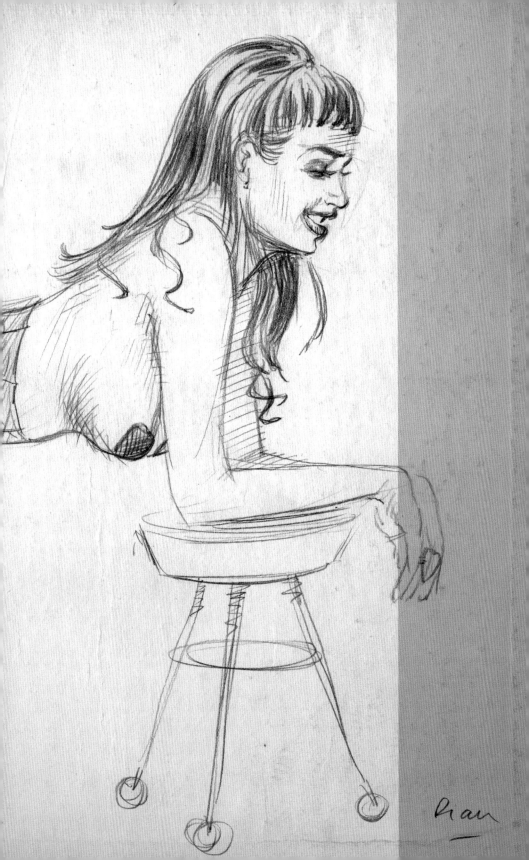

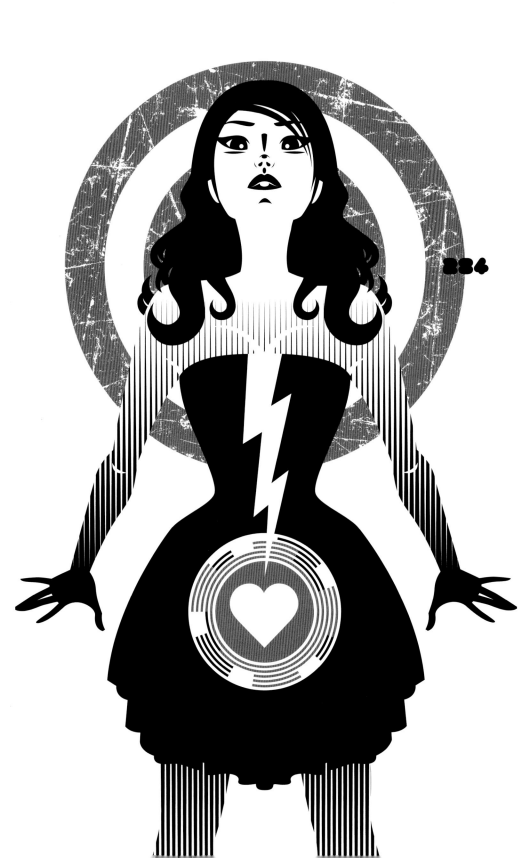

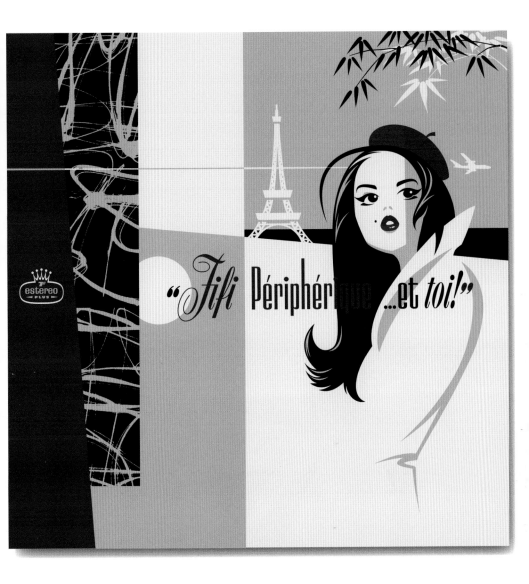

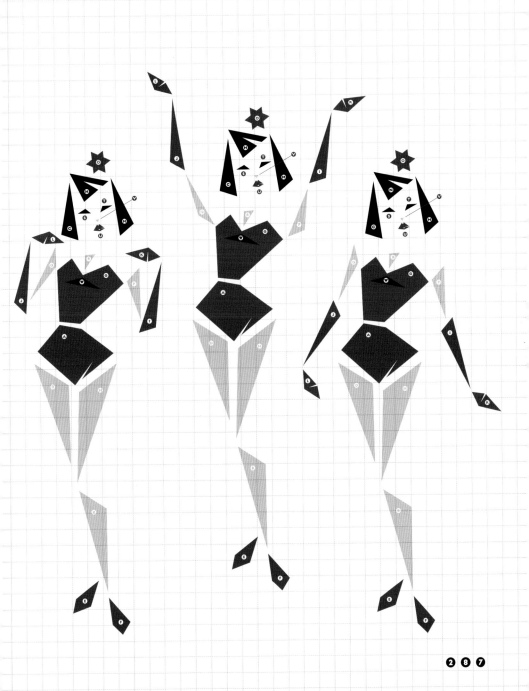

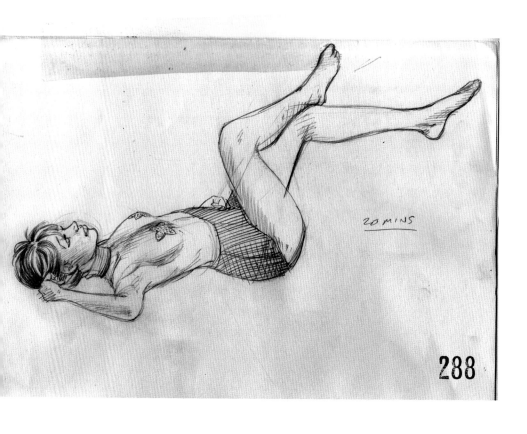

20 MINS

288

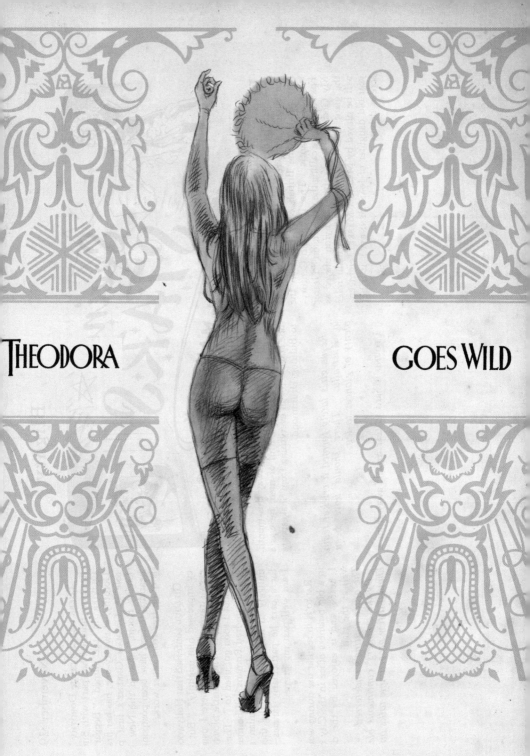

THEODORA

GOES WILD

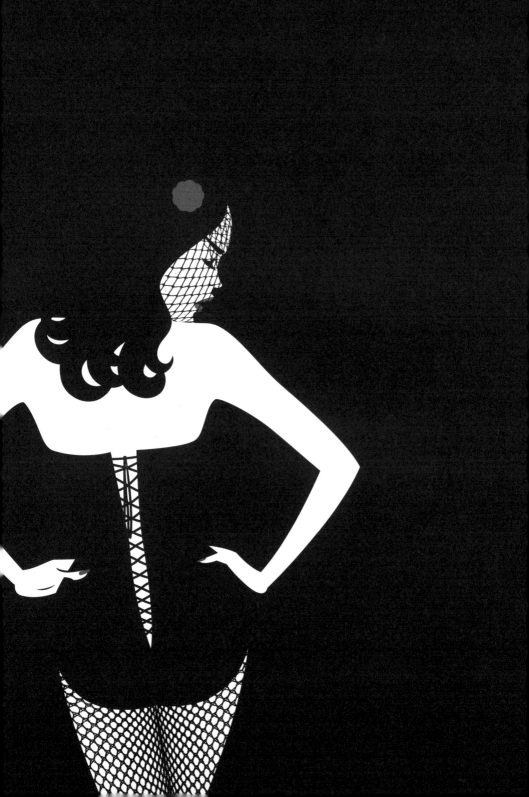

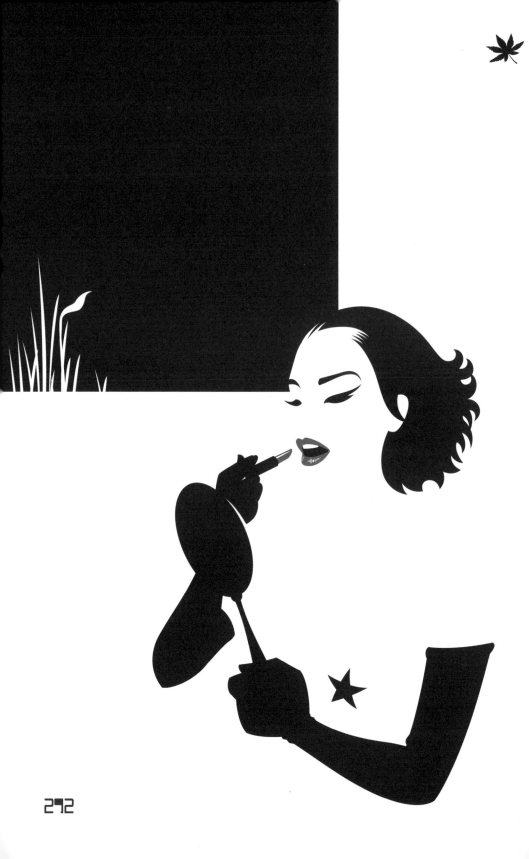

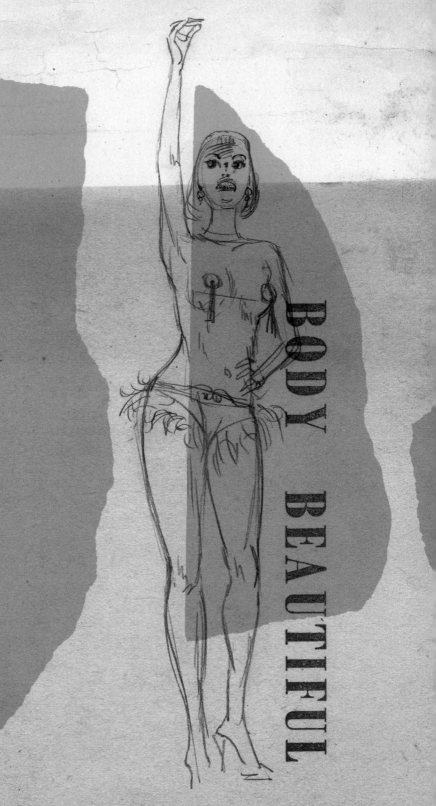

293

BODY BEAUTIFUL

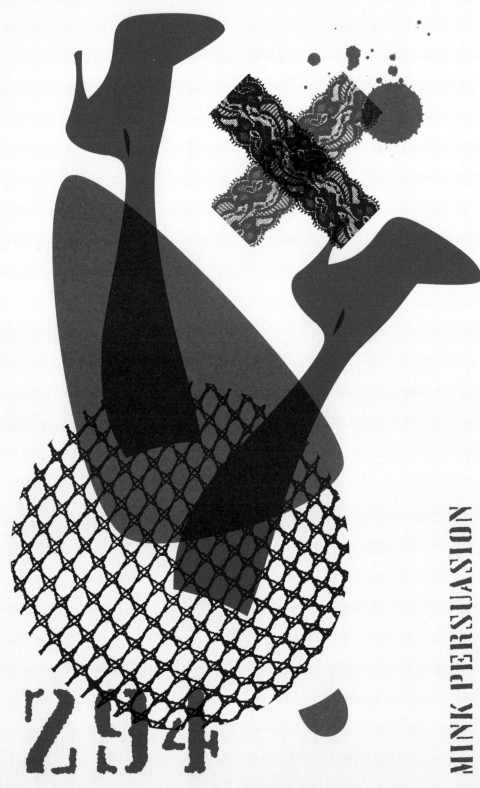

MINK PERSUASION

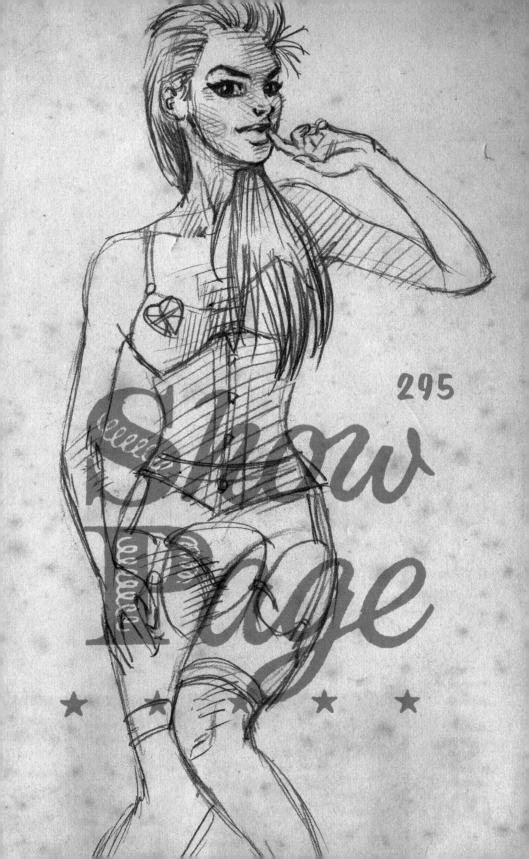

295

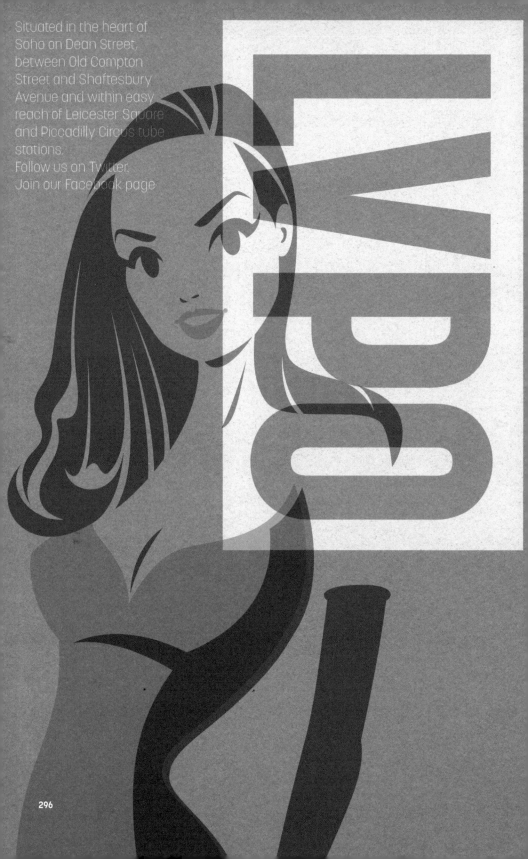

Situated in the heart of Soho on Dean Street, between Old Compton Street and Shaftesbury Avenue and within easy reach of Leicester Square and Piccadilly Circus tube stations.
Follow us on Twitter.
Join our Facebook page

296

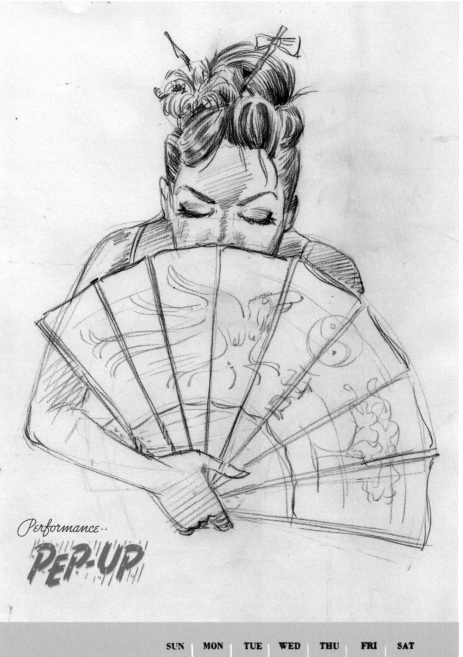

Performance...
PEP-UP

	SUN	MON	TUE	WED	THU	FRI	SAT
	1	2	3	4	5	6	7
	8	9	10	11	12	13	14
	15	16	17	18	19	20	21
January	22	23	24	25	26	27	28
	29	30	31	—	—	—	—

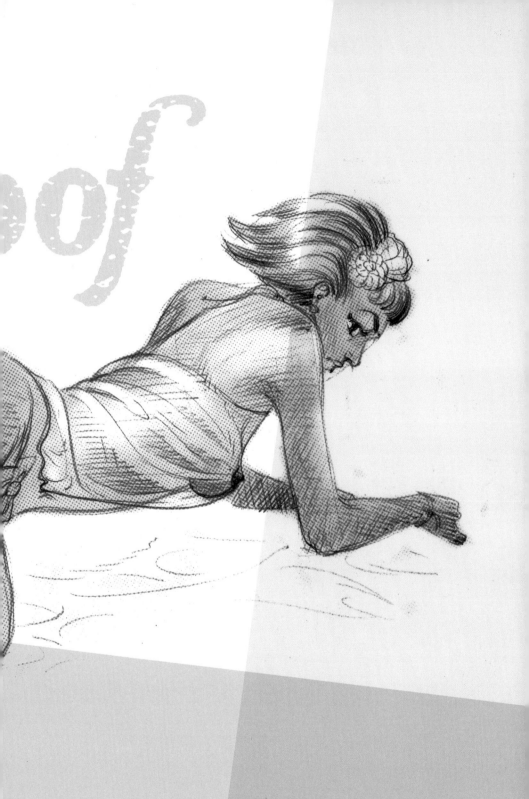

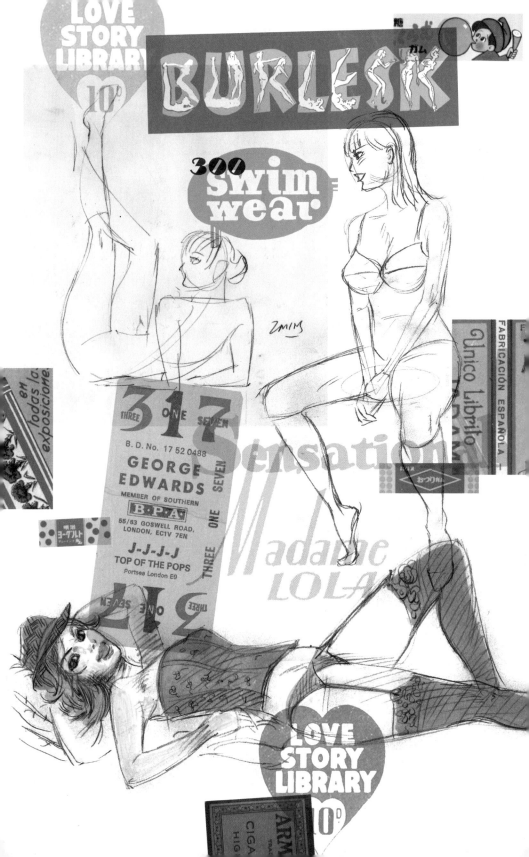

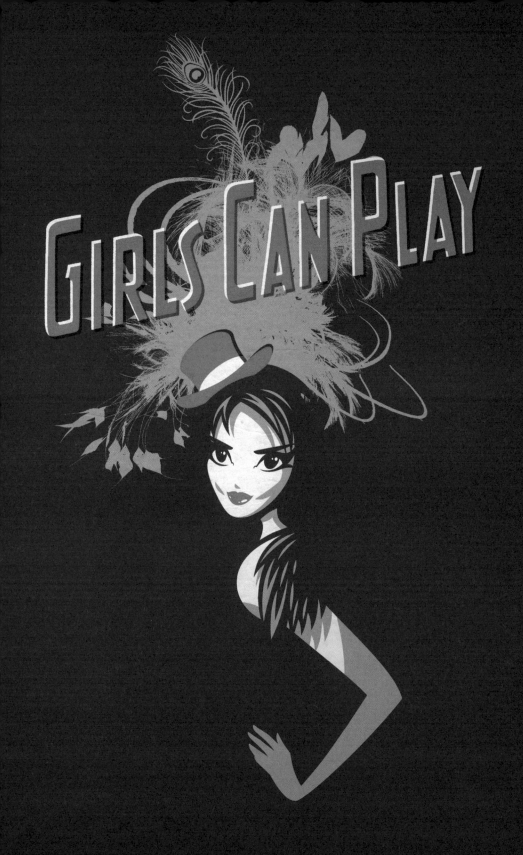

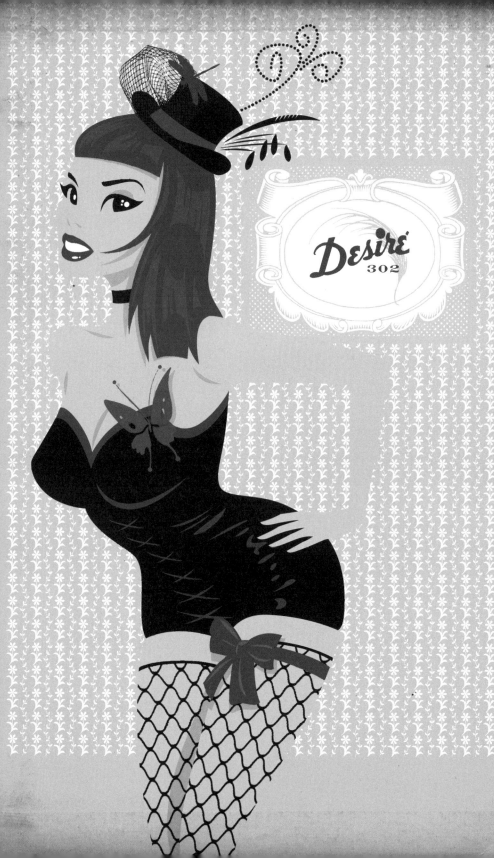

Desiré
302

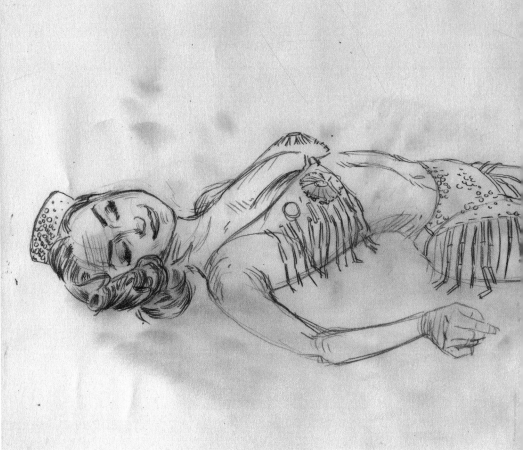

303

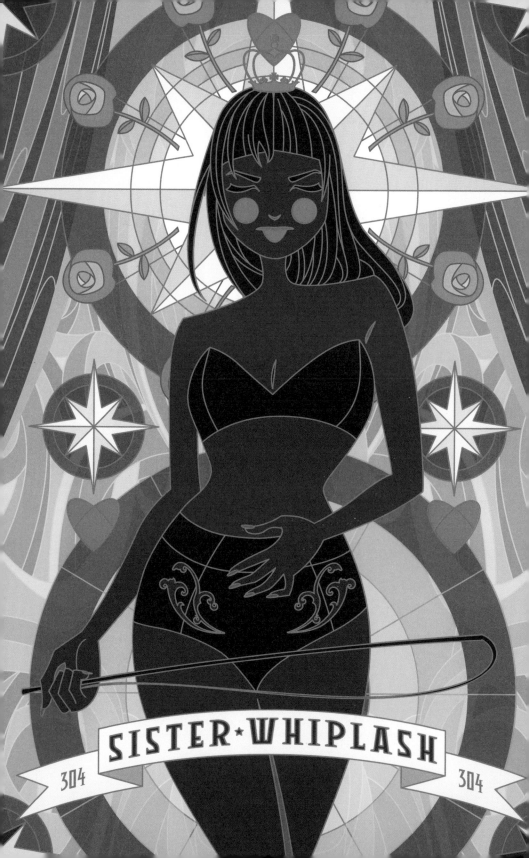

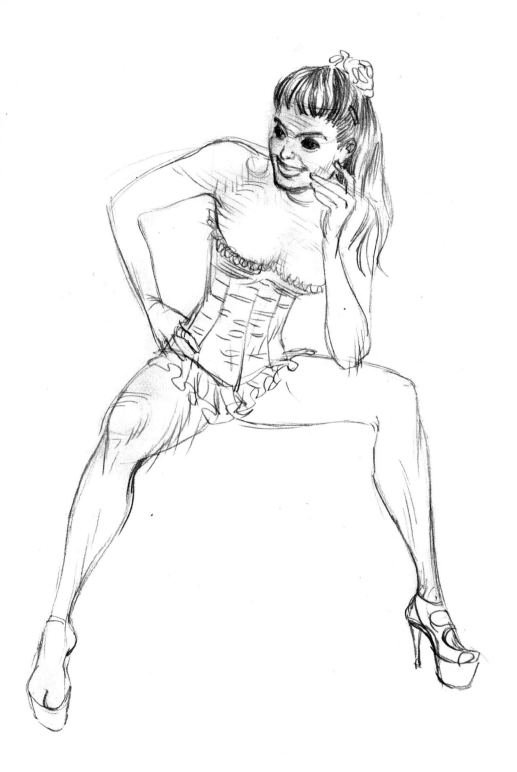

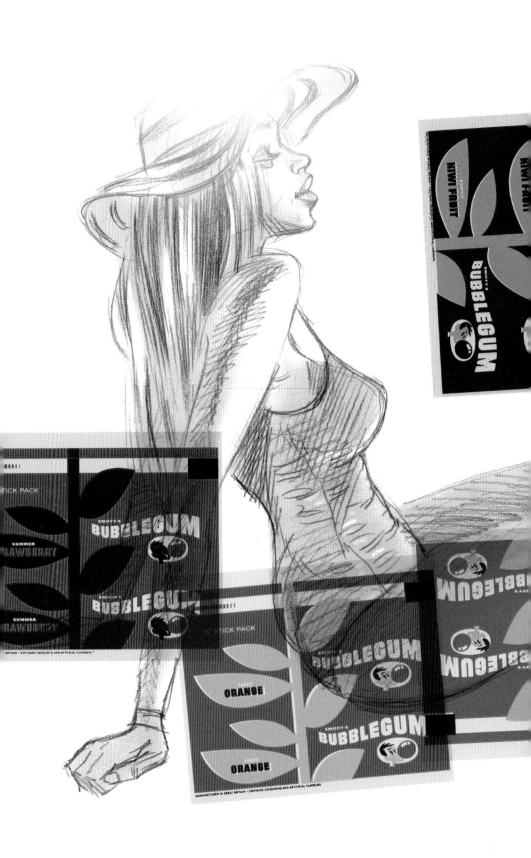

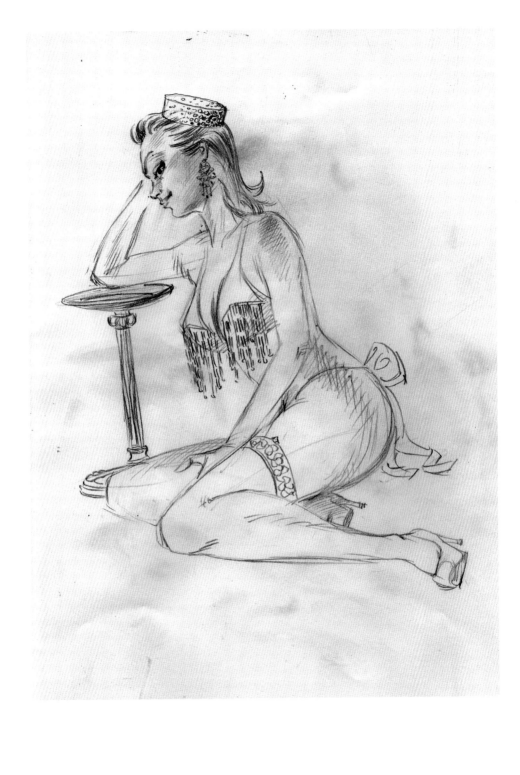

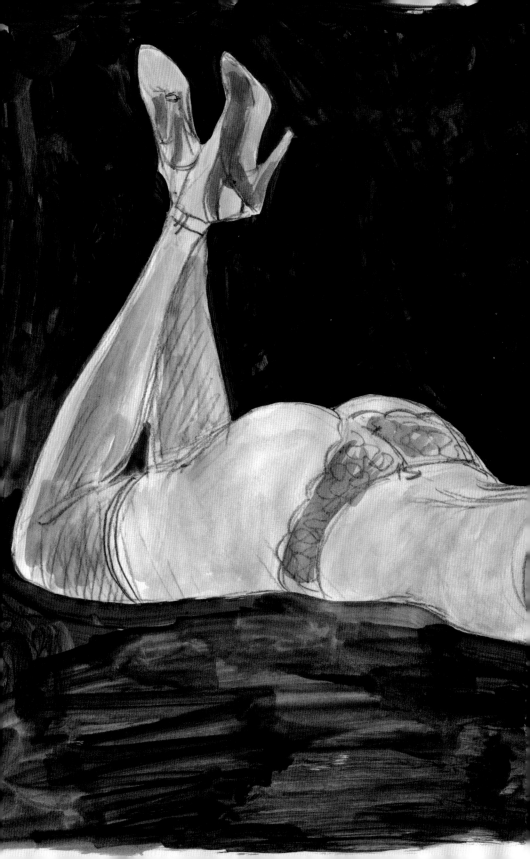

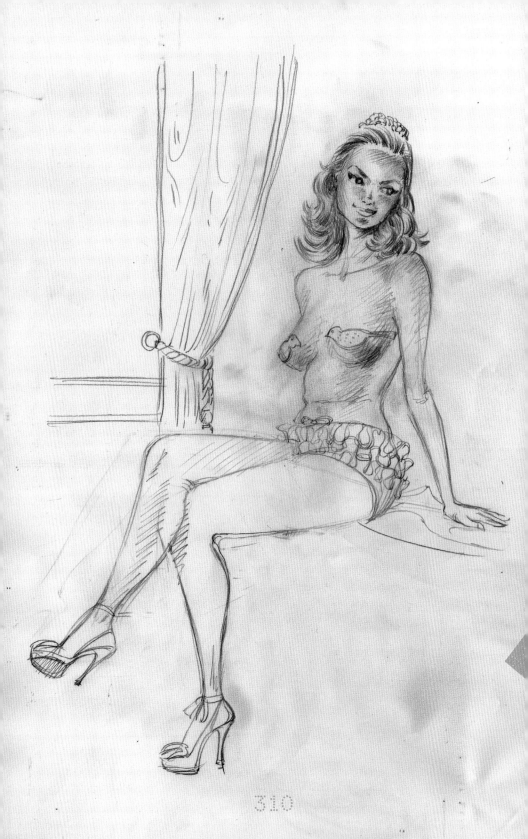

310

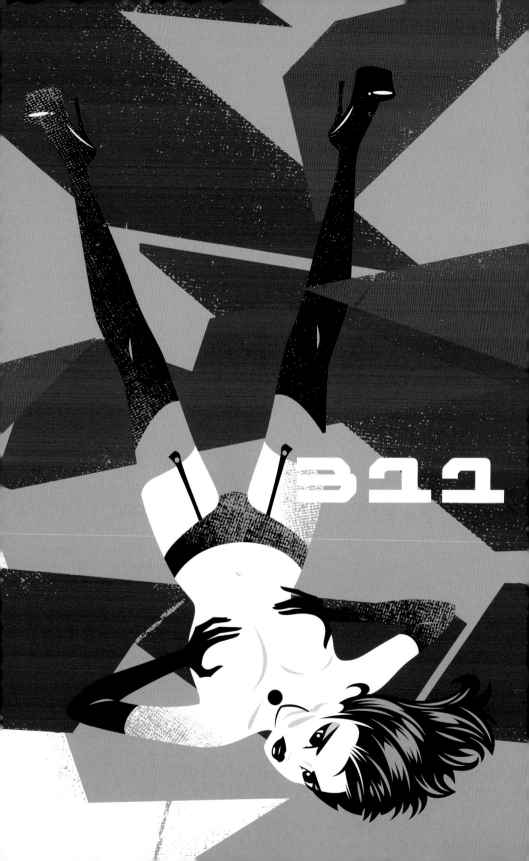

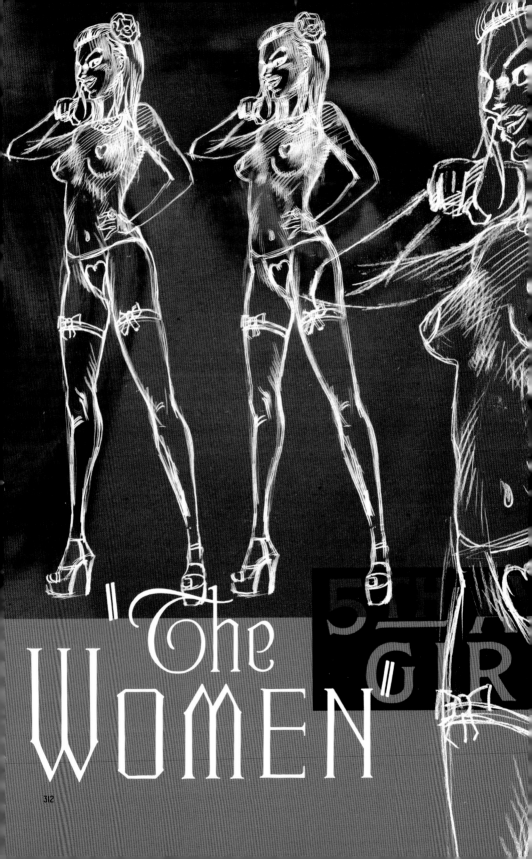

"The
WOMEN

312

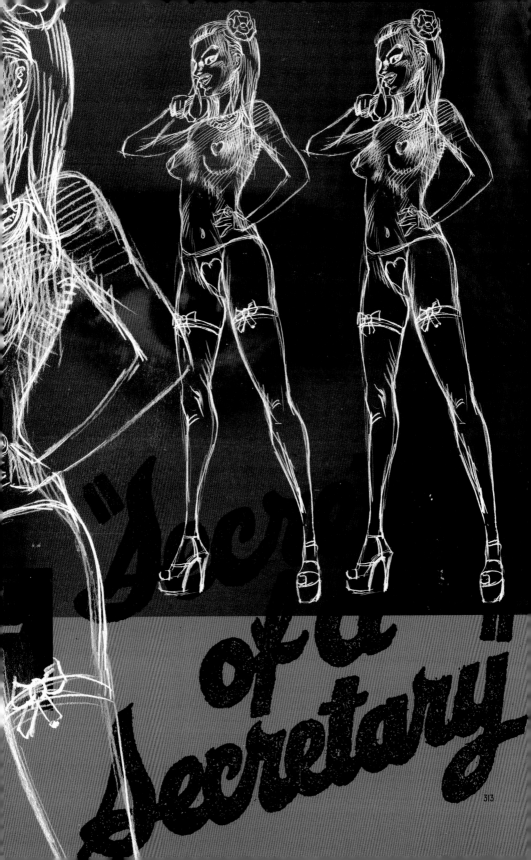

"Secret of a Secretary"

313

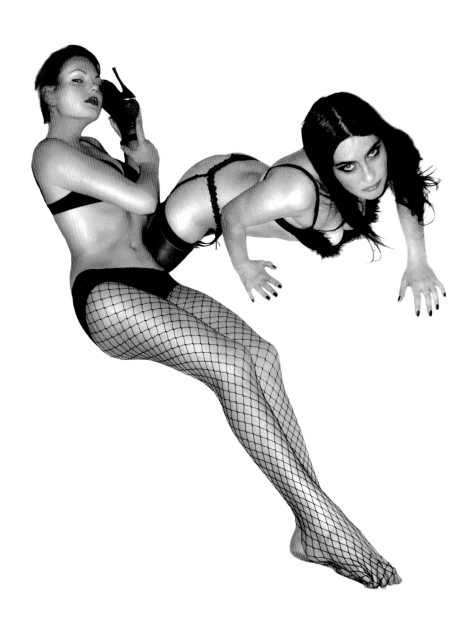

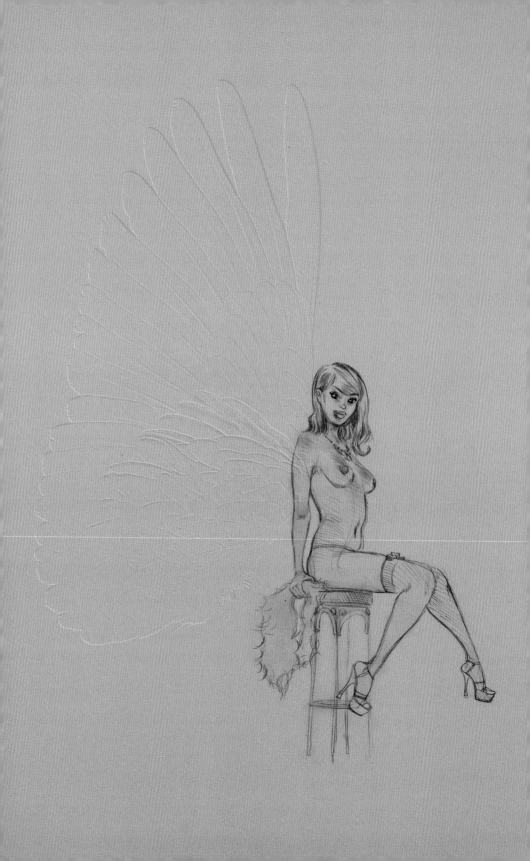

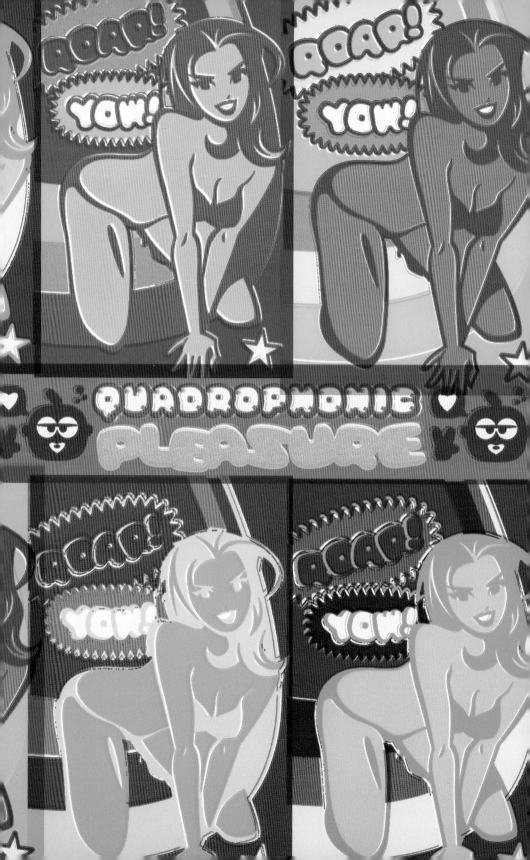

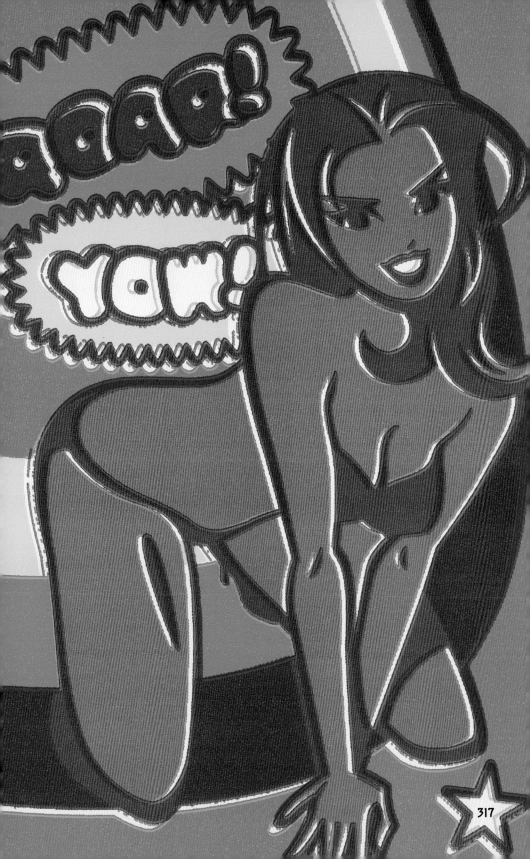

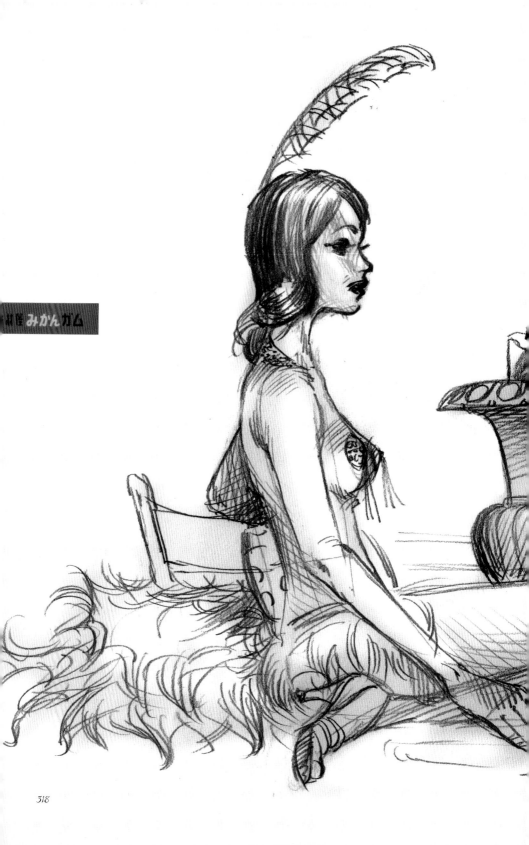

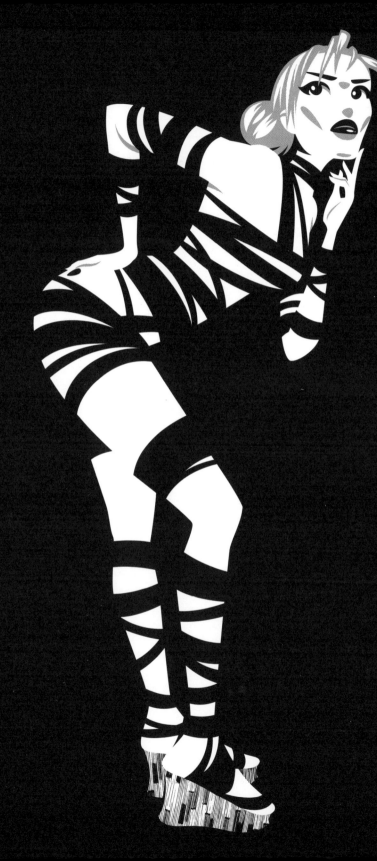

№321

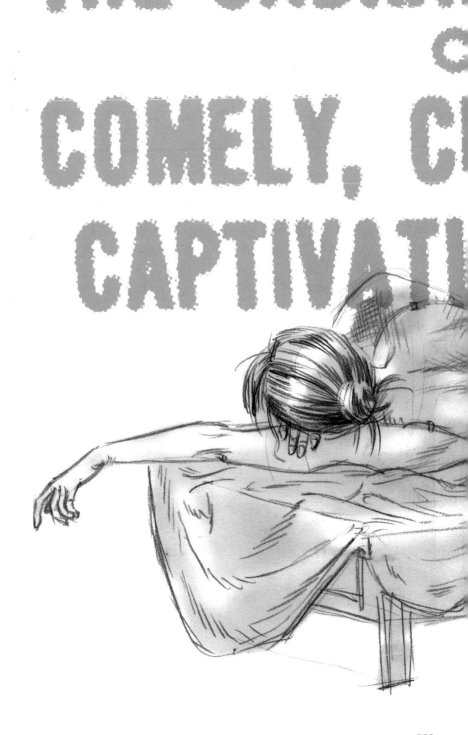

ED PARADE

RVACEOUS,
G CUTIES

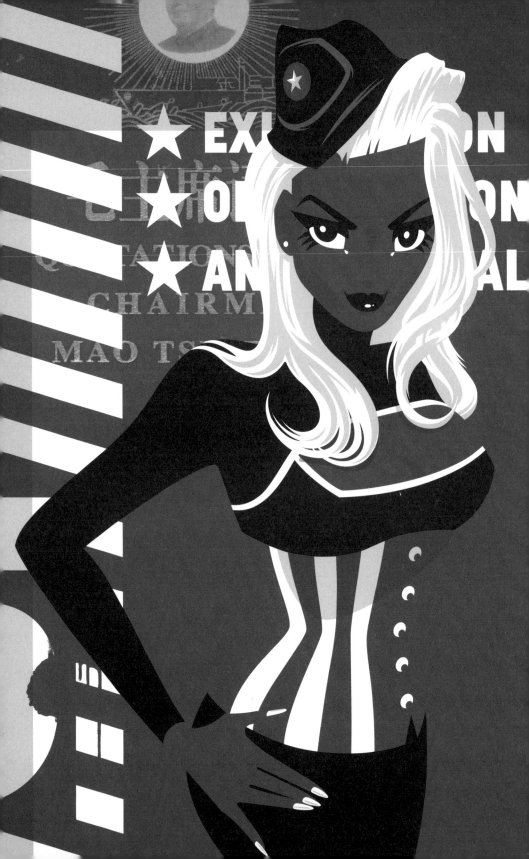

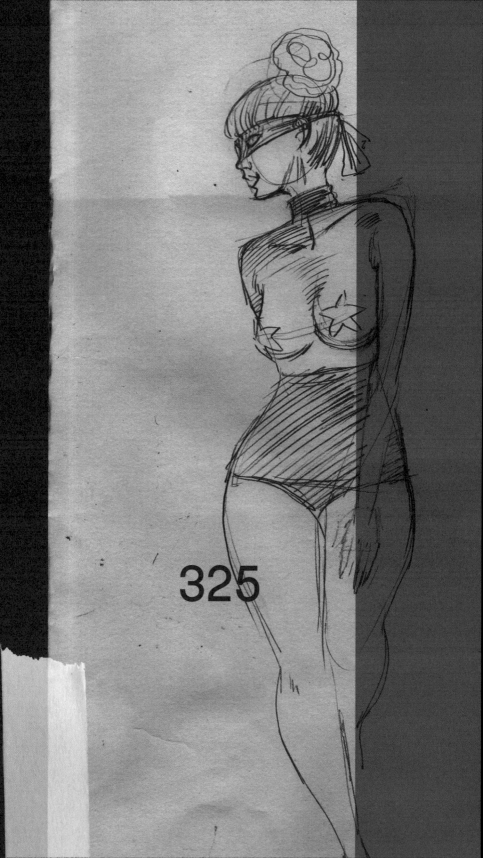

325

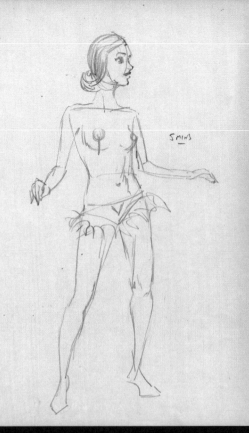

5MINS

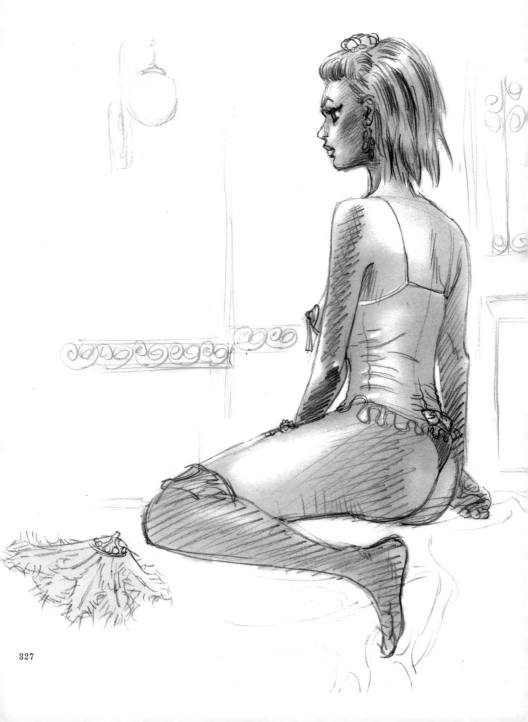

327

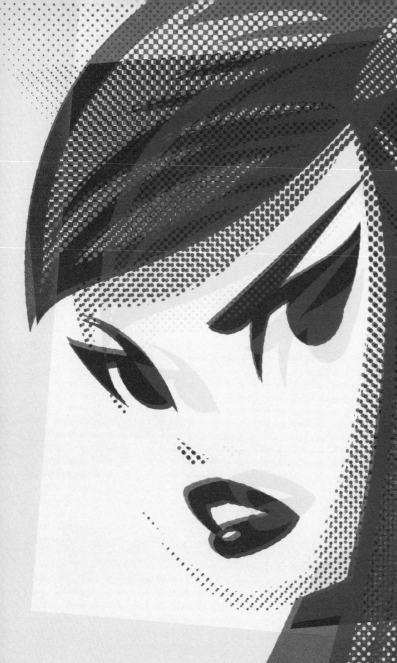
"The LOVE Parade"

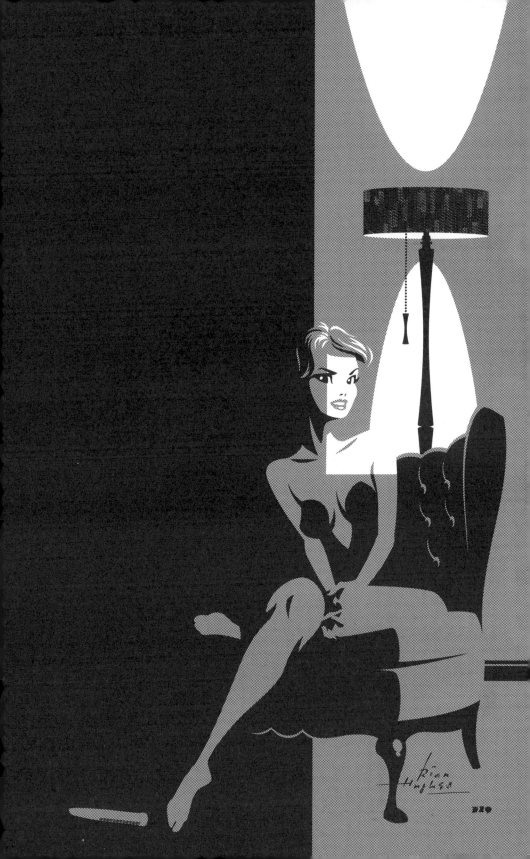

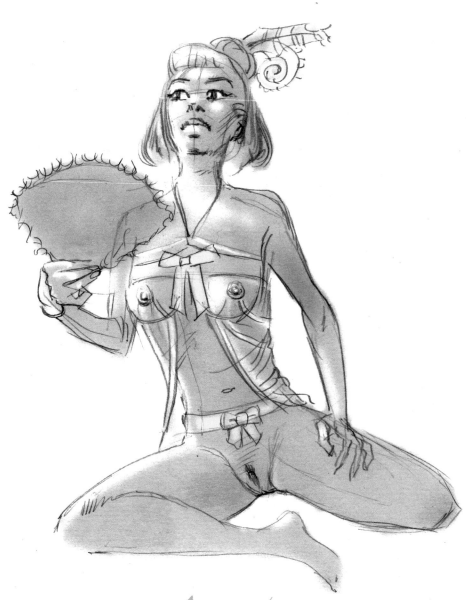

evening
modes

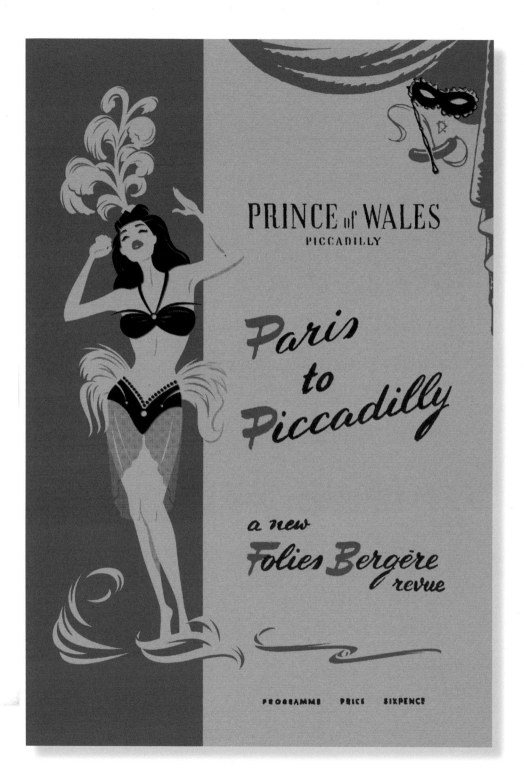

PRINCE of WALES
PICCADILLY

Paris
to
Piccadilly

a new
Folies Bergère
revue

PROGRAMME PRICE SIXPENCE

Black Lipstick

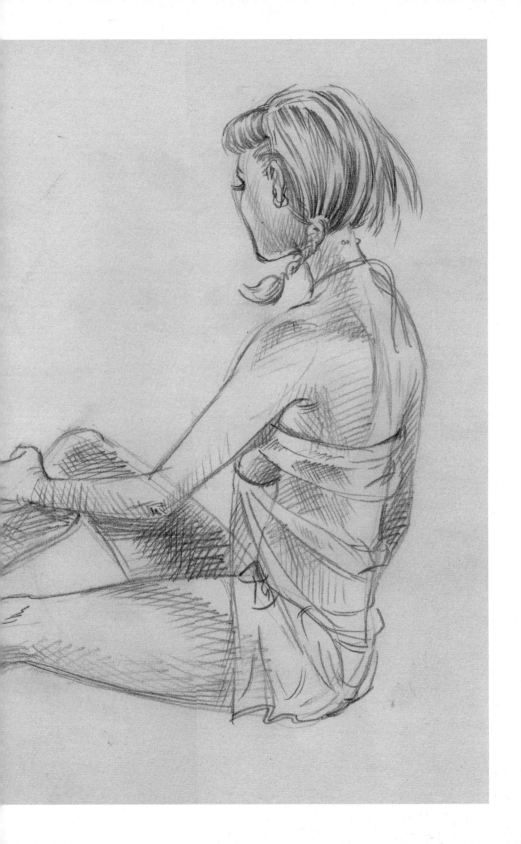

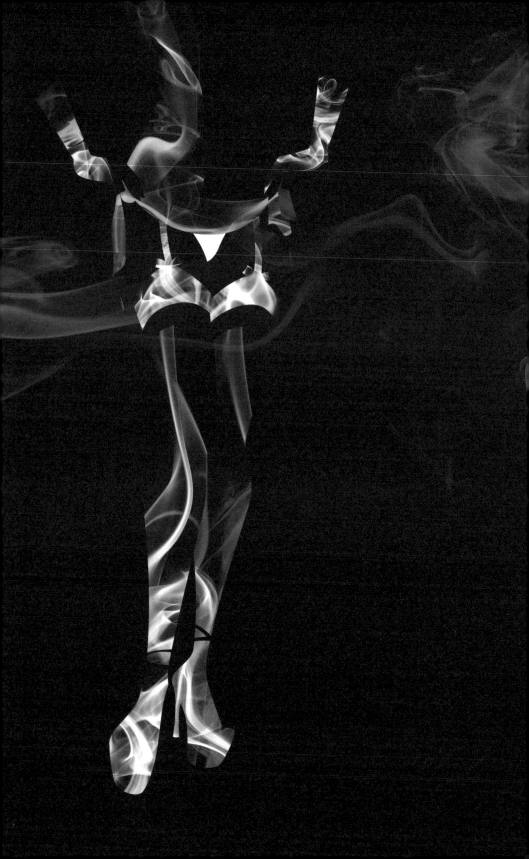

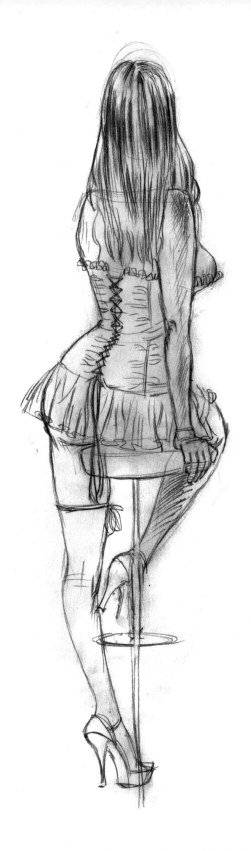

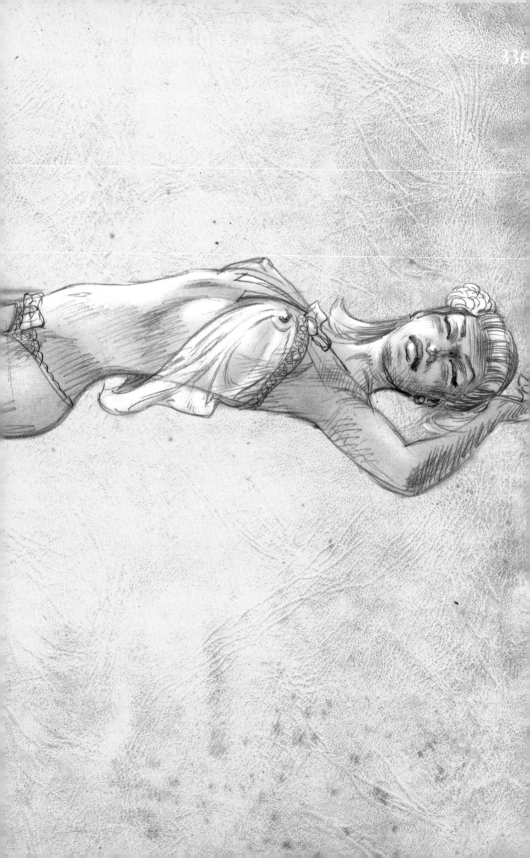

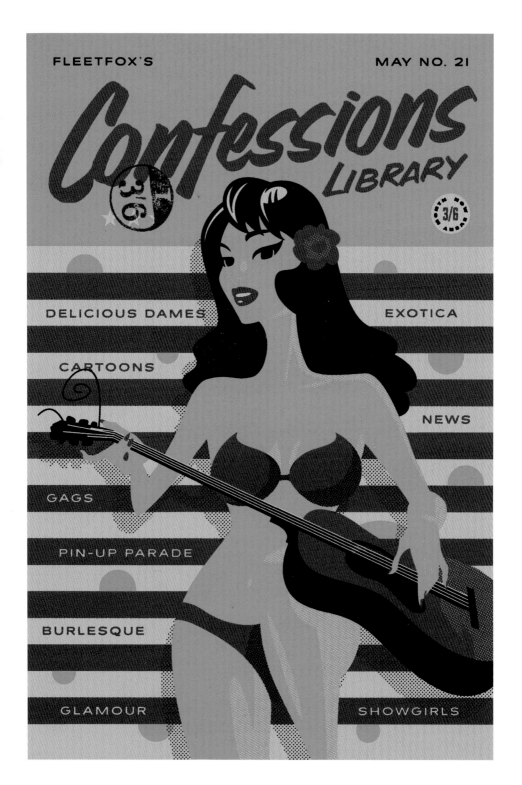

FLEETFOX'S

JANUARY NO. 17

Confessions

LIBRARY

3/6

3/6 TSP

CARTOONS

VIEW FORBIDDEN

THIS COPY IS

USED ADULT MAGAZINE CENTER

DANGEROUS DAMES

BACHELOR BAIT

NEWS

BEAT CHIC

GAGS

GIRLS

GLAMOUR

339

Le CODE de la BEAUTE

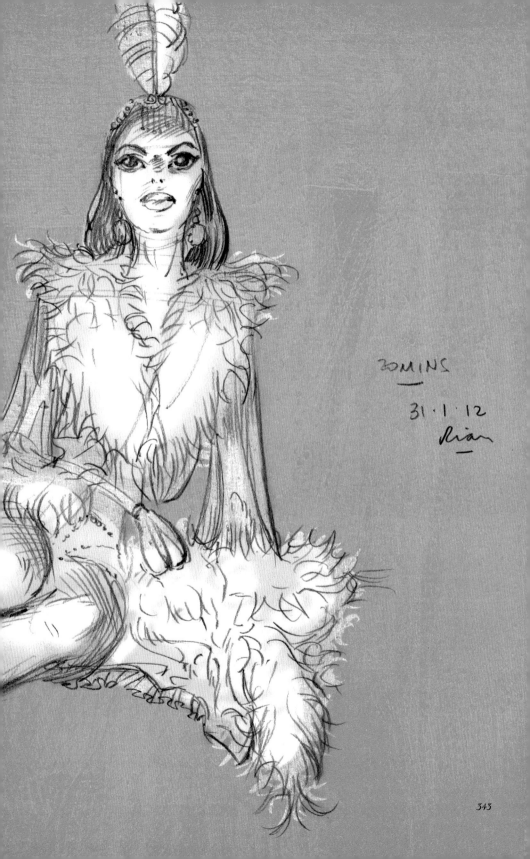

30MINS

31·1·12
Rian

343

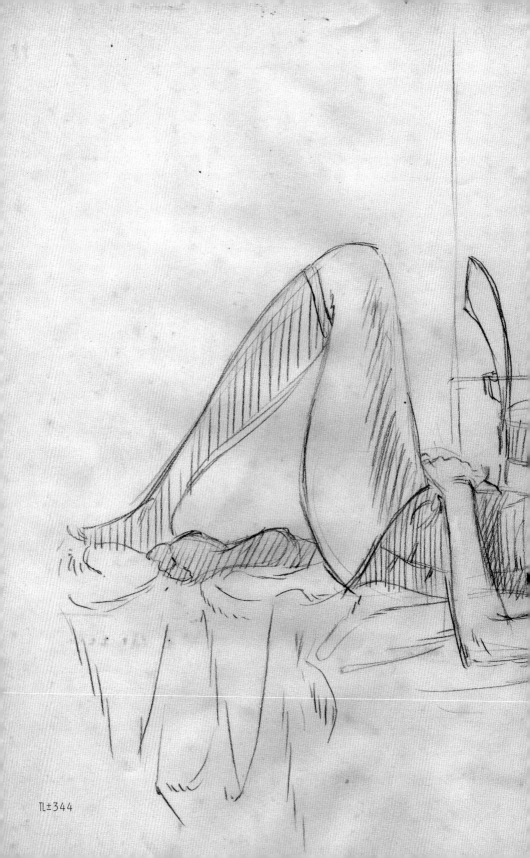

Л±344

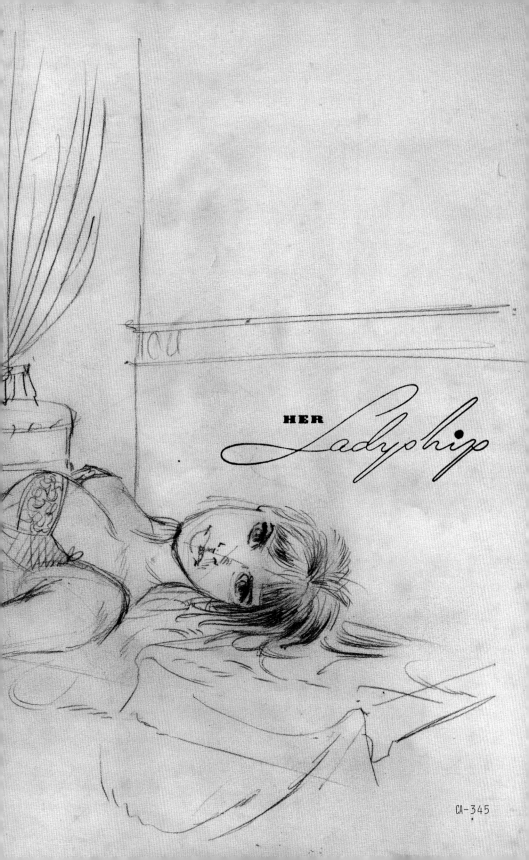

HER *Ladyship*

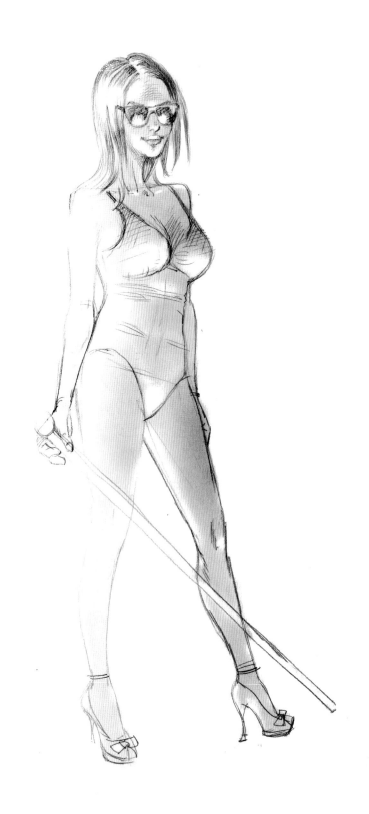

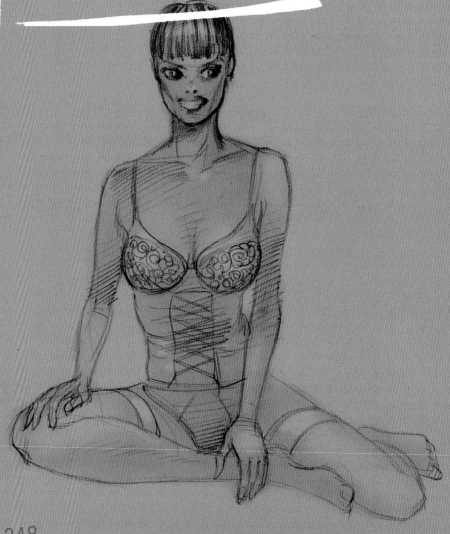

GORGEOUS GIRLS
STRIP-TEASE ARTISTS
SILK-STOCKING REVUE

348

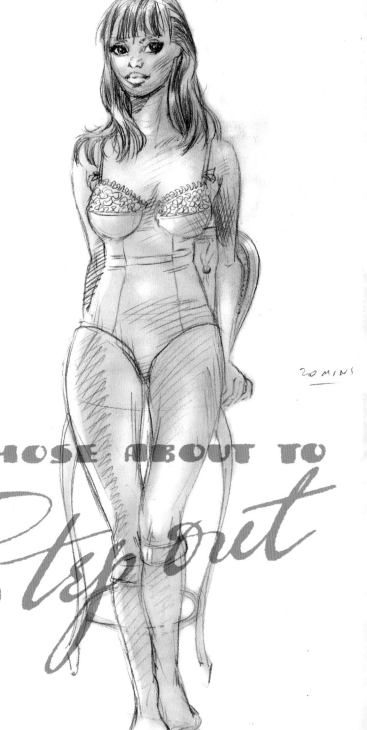

20 MINS

FOR THOSE ABOUT TO

Step out

#350

GOLDEN MEDALLION presents

FATALE-17

Pearl
Starlight

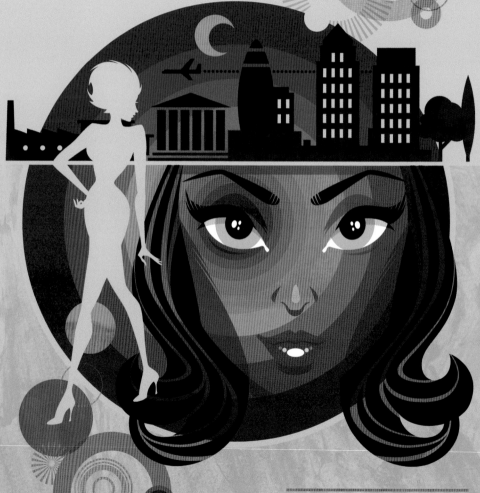

Lacosta
Devine

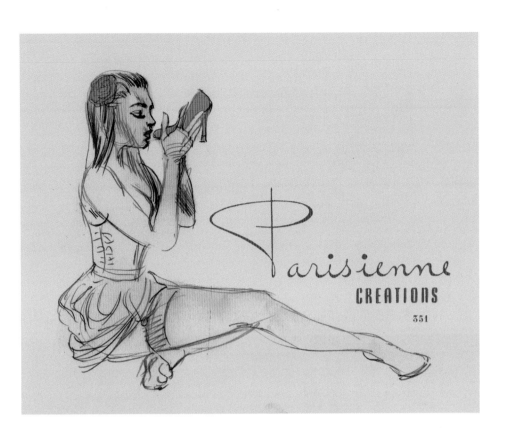

Parisienne
CREATIONS
351

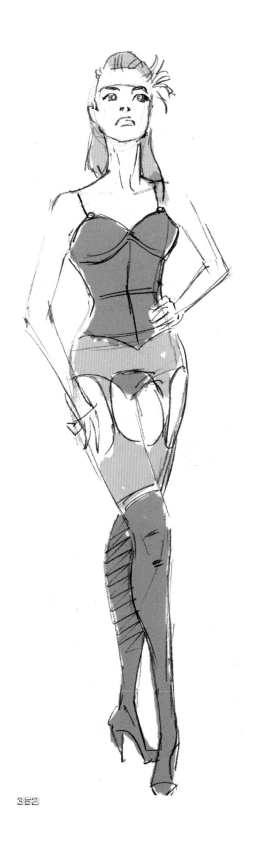

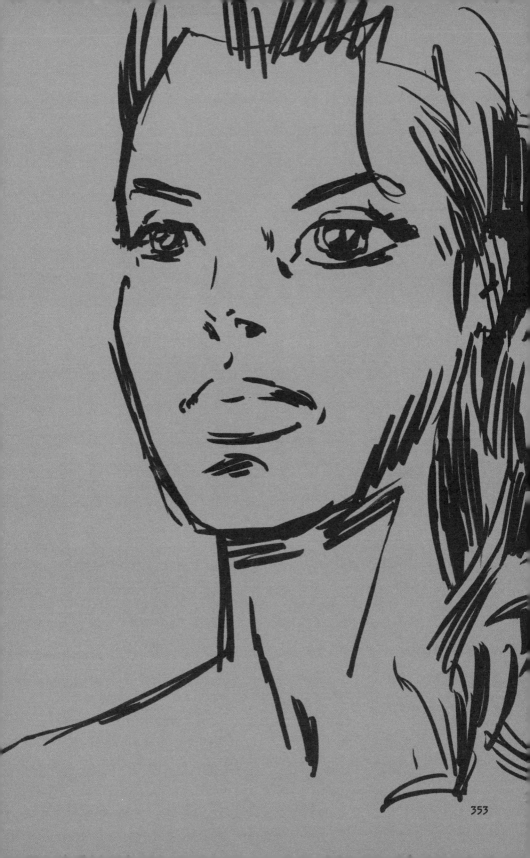

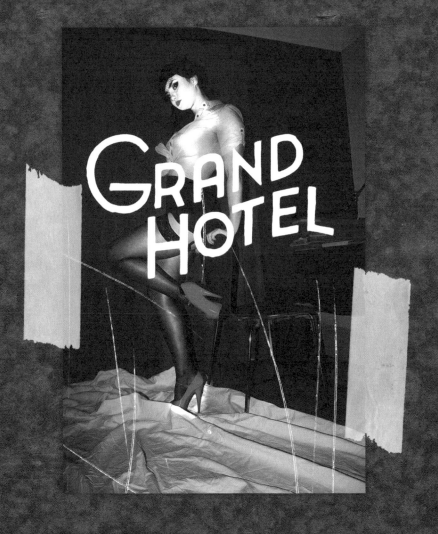

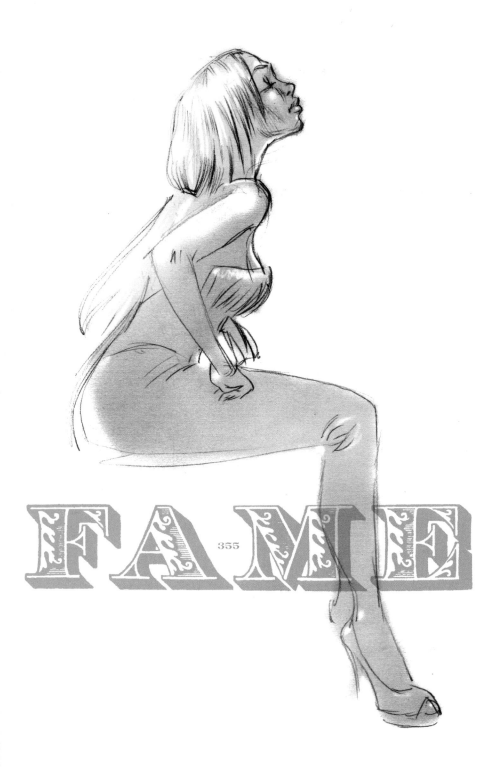

FAME

355

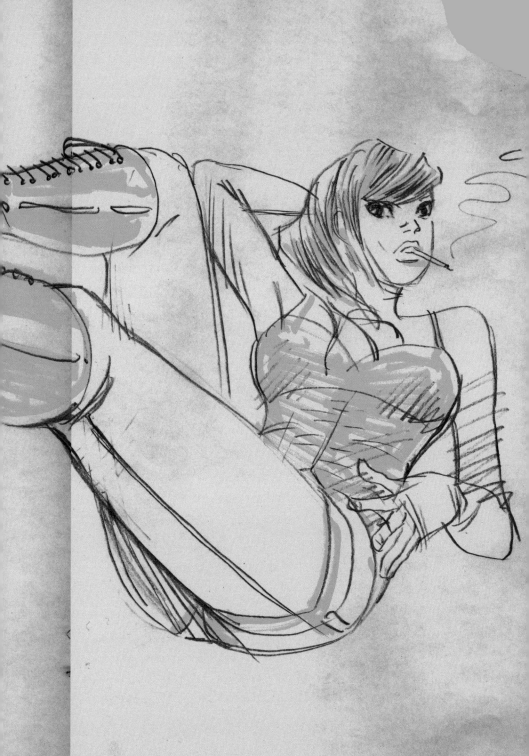

353

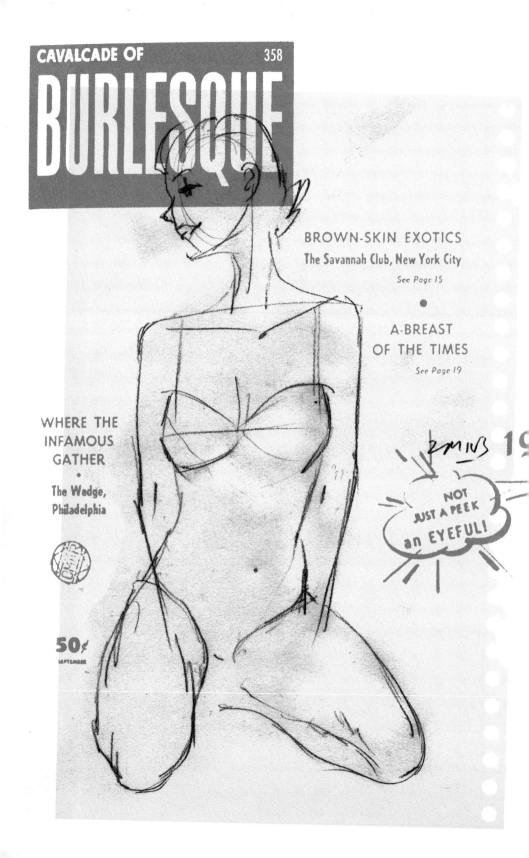

Soho House, 40 Greek Street
Soho, London
W1D 4EB
Tel: 020 7734 518
VAT Reg:653 3751 33

129 METIN M
- -
Tbl 314/1 Chk 6649 Gst 2
 RIAN HUGHES
 12
- -
2 AUBERGINE
1 COTTAGE PI
1 BROCOLI
2 WALNUT @ 6.
1 BRULEE
1 ENGLISH BRE
2 175 HSE RED

 Total
 12⁴% Service
 Total

 11.00 VAT
 Net TTL

LICENSED LONDON TAXI
RECEIPT ©

Transport for London

8·11·11

AMOUNT £ 14.00

ALWAYS USE TRADITIONAL LONDON TAXI-CABS
THANK YOU FOR YOUR BUSINESS

The End